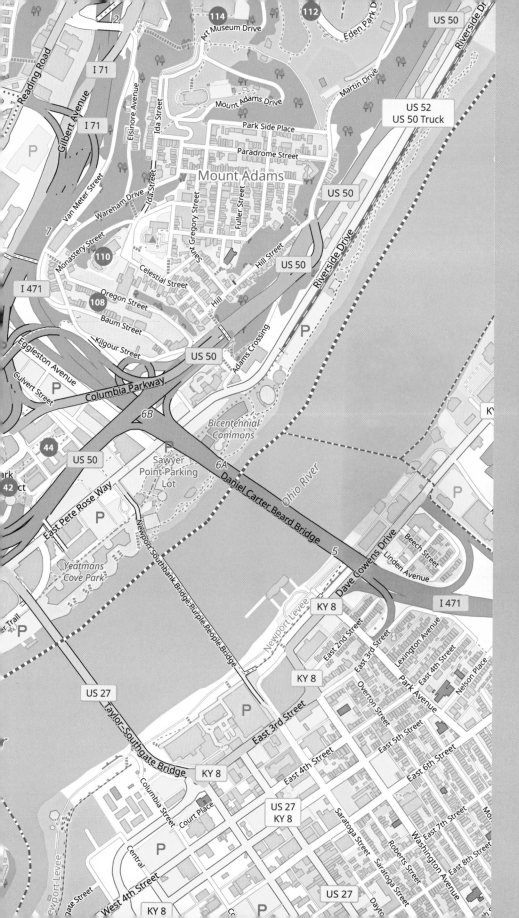

CINCINNATI THEN AND NOW

You can find most of the sites featured in the book on this outline map*

Numbers in red circles refer to the pages where sites appear in the book.

* The map is intended to give readers a very broad view of where the sites are located. Please consult a tourist map for greater detail.

D1088194

5/20

14
DAY
BOOK

CINCINNATI

THEN AND NOW®

First published in the United Kingdom in 2018 by
PAVILION BOOKS
an imprint of Pavilion Books Company Ltd.
43 Great Ormond Street, London, WC1N 3HZ, UK

"Then and Now" is a registered trademark of Salamander Books Limited,
a division of Pavilion Books Group.

ISBN: 978-1-911595-00-7

Reproduction by Rival Colour, UK
Printed by 1010 Printing International Ltd., China

10 9 8 7 6 5 4 3 2 1

DEDICATION

I dedicate this book to Kristin and Dashiell, my then and now and yet to come

ACKNOWLEDGMENTS

Thanks to Frank Hopkinson at Pavilion Books; Karl Mondon, for the terrific photographs;
Peter Bhatia, for the use of the *Cincinnati Enquirer* photos; the photographers, often
anonymous, of the "then" photos—Enquirer photographers Paul Briol, Jim Callaway,
Ran Cochran, Dan Dry, Bob Free, Herb Heise, Allan Kain, Gary Landers, Lawrence J.
Neumann, Walter B. Oelze, Harry Pence, Dean Rutz, Fred Straub, Dick Swaim, Mark Treitel,
and Carl Wellinger; and N.A. Berthol, Jack E. Boucher, Adolphus Forbriger, Carl Mydans,
Rombach & Groene, and B. Anthony Stewart; Luann Gibbs; friends and family, for their support;
and the architects and people who built this great city.

CINCINNATI
THEN AND NOW®

JEFF SUESS

PHOTOGRAPHED BY
KARL MONDON

PAVILION

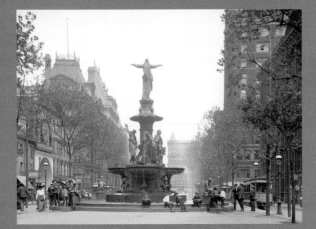
Fountain Square, 1906 p. 8

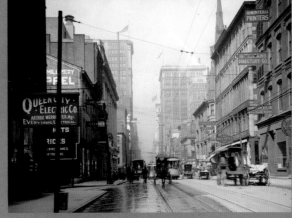
East Fourth Street, 1905 p. 22

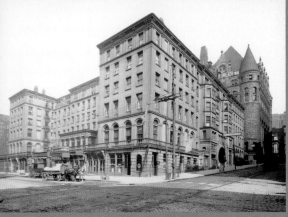
Burnet House, 1905 p. 28

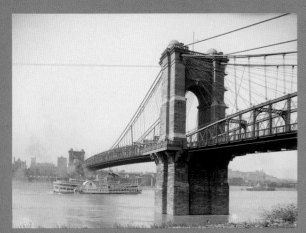
Roebling Suspension Bridge, 1907 p. 30

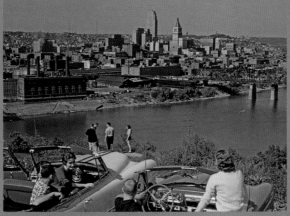
Cincinnati Skyline, 1955 p. 32

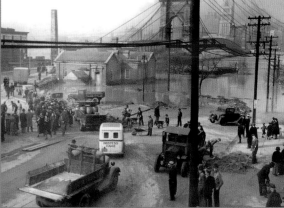
1937 Flood p. 38

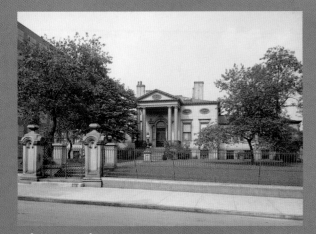
Taft Museum of Art, c. 1906 p. 44

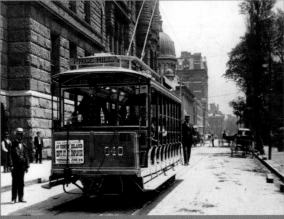
Cincinnati Streetcars p. 54

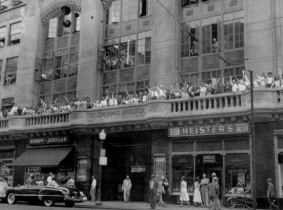
Cincinnati Enquirer Building, 1952 p. 72

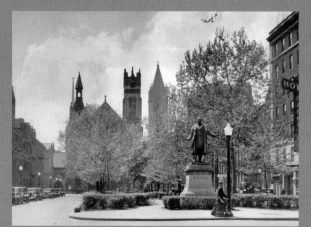

Garfield Place, 1939 p. 78

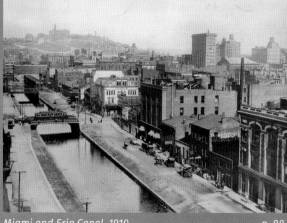

Miami and Erie Canal, 1910 p. 88

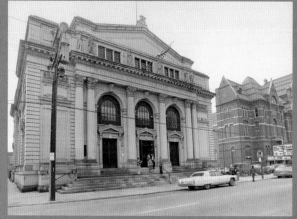

Memorial Hall, 1981 p. 96

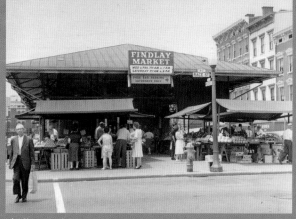

Findlay Market, 1963 p. 100

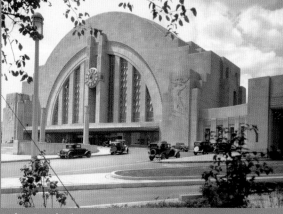

Union Terminal, 1933 p. 104

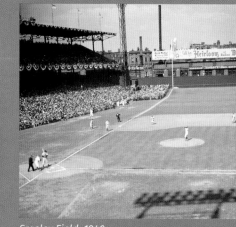

Crosley Field, 1940 p. 106

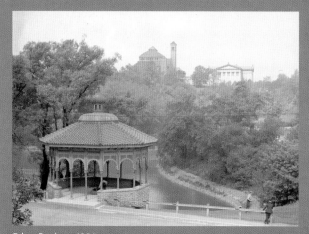

Eden Park, c. 1904 p. 112

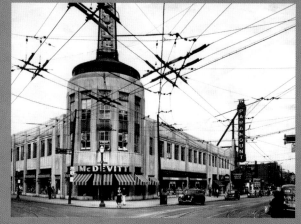

Peebles' Corner, 1940 p. 118

Cincinnati Observatory, c. 1925 p. 140

CINCINNATI

THEN AND NOW INTRODUCTION

Cincinnati was first called the Queen City in 1819. Henry Wadsworth Longfellow cemented the nickname in the closing lines of his 1854 poem, "Catawba Wine," an ode to Nicholas Longworth's vineyards along the Ohio River:

And this Song of the Vine,
This greeting of mine,
The winds and the birds shall deliver,
To the Queen of the West,
In her garlands dressed,
On the banks of the Beautiful River.

The name is fitting for a city that rose above its setting, seeking to emulate the high culture of Europe even as it stood proud as the first all-American city founded after the Revolutionary War.

Cincinnati blossomed from the second of three settlements planted in the Ohio River wilderness. Before 1788, only a few white men had set foot upon the Shawnee Indian territory north of the river. John Cleves Symmes, a New Jersey delegate in the Continental Congress, had purchased 330,000 acres in the Northwest Territory, and resold parcels to prospective settlers. Benjamin Stites led the first group to settle Columbia in November 1788. Symmes led the third group himself in 1789, believing North Bend to be the ideal location.

Partners Matthias Denman, Colonel Robert Patterson, and John Filson selected a flat basin on the river surrounded by hills on three sides. Filson came up with the name Losantiville by cobbling together syllables to mean "the city opposite the mouth of the Licking River" that flowed into Kentucky. Filson disappeared one day while scouting the Miami woods, presumed killed by Native Americans, and Israel Ludlow took his place as partner and surveyor. On December 28, 1788, flatboats carrying eleven families and twenty-four men pulled to shore at an inlet marked by a sycamore tree (what would become Sycamore Street). The settlers broke down the boats and used the wood to build the first houses.

Losantiville was chosen as the site of Fort Washington, a territorial fort with a garrison to provide protection

for the settlers from the threat of Indian raids. General Arthur St. Clair, governor of the Northwest Territory, arrived at the fort in January 1790, and changed Losantiville to Cincinnati, named for the Society of the Cincinnati, a military fraternity for Revolutionary War officers. The society was inspired by Lucius Quinctius Cincinnatus, a Roman leader in the fifth century BC who gave up his power to return to his fields, which had a parallel in George Washington.

The first steamboat traveled the Ohio River in 1811. Within a few years, thanks to the Miami and Erie Canal connecting Lake Erie to the river, Cincinnati was a bustling trading port and a leader in shipbuilding. But it was the prodigious meatpacking operations that earned Cincinnati the unwelcome sobriquet Porkopolis. Drivers herded filthy pigs through the city streets on the way to slaughterhouses. Fetid smoke and soot polluted the air. No part went to waste. Procter & Gamble and Emery fortunes were made turning lard into candles and soap.

Cincinnati was, in every way, the definition of a boomtown. The population doubled every ten years. By 1850, Cincinnati was the sixth-largest city in the United States. German immigrants in the 1840s found a new home in the area north of the canal—what they called "over the Rhine"—and passed on their love of beer and bratwurst, as well as their hard-working ethic.

A northern city, Cincinnati had many southern interests, and business connections down to New Orleans. Ohio may have been a free state, but slavery was legal just across the river in Kentucky, and many northerners opposed ending slavery. Abolitionists including Levi Coffin and John Rankin operated the Underground Railroad, a network of safe "stations" that helped fugitive slaves escape to freedom. The Ohio River took on the status of "the River Jordan" on the path to "the Promised Land." Harriet Beecher Stowe used her experiences from living in Cincinnati to write *Uncle Tom's Cabin*, which was credited with helping to change hearts and minds about the evils of slavery.

After the Civil War, the city was busting at the seams, and racial tensions, poverty, and crime reached a boiling point. The 1884 Courthouse Riot was one of the deadliest riots in U.S. history. People were desperate to climb out of the basin. The inclined plane railways introduced in the 1870s finally made that possible and gave residents some breathing room as the city spread to the hilltops.

Despite this turmoil, the post-bellum decades were the golden age for Cincinnati's culture and influence. Five U.S. presidents were born in the area or spent significant time in the Queen City. Many of the institutions that define Cincinnati today were emerging. The Cincinnati Red Stockings became the first professional baseball team in 1869. Samuel Hannaford, Cincinnati's premier architect, showed he could work in any style in designing many buildings that have become treasures. A reputation as a world-class music city was borne from the May Festival, the Cincinnati Opera, and the Cincinnati Symphony Orchestra.

Then, railroads stretched the country further west. The drive for opportunities that drew settlers down the Ohio River on flatboats sent them in wagon trains to fertile new grounds. Vast plains ideal for raising livestock were closer to meatpacking facilities in Chicago. The original West became the Midwest, and America outgrew the Queen City.

As Cincinnati moves forward, it also glances back. Development of downtown and Over-the-Rhine is restoration, not only of historic buildings but the city's character. The new streetcar is part of a commitment to the urban core. The Banks and stadiums bring folks back to where it all started, congregating by the river. The National Underground Railroad Freedom Center opened in 2004, steps away from "the River Jordan." Aging icons that not long ago would have been cleared away are meticulously restored at great expense. ArtWorks murals turn old brick faces into portraits of the city's history. Then and now are intertwined.

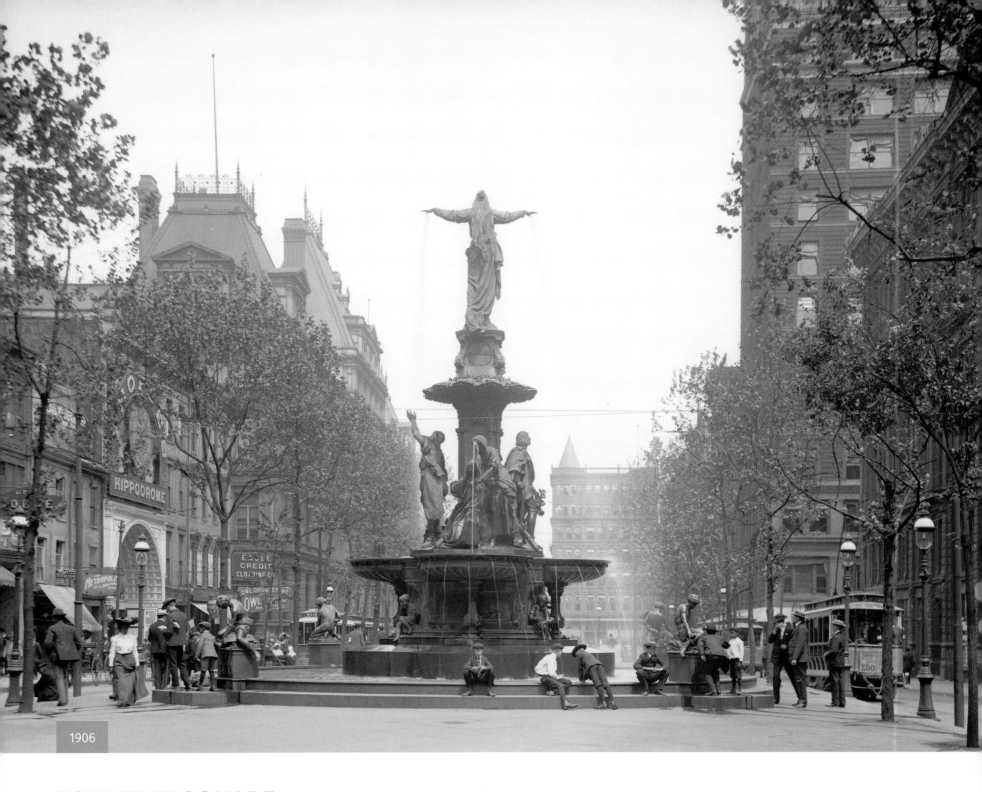

1906

FOUNTAIN SQUARE

The heart of Cincinnati

8

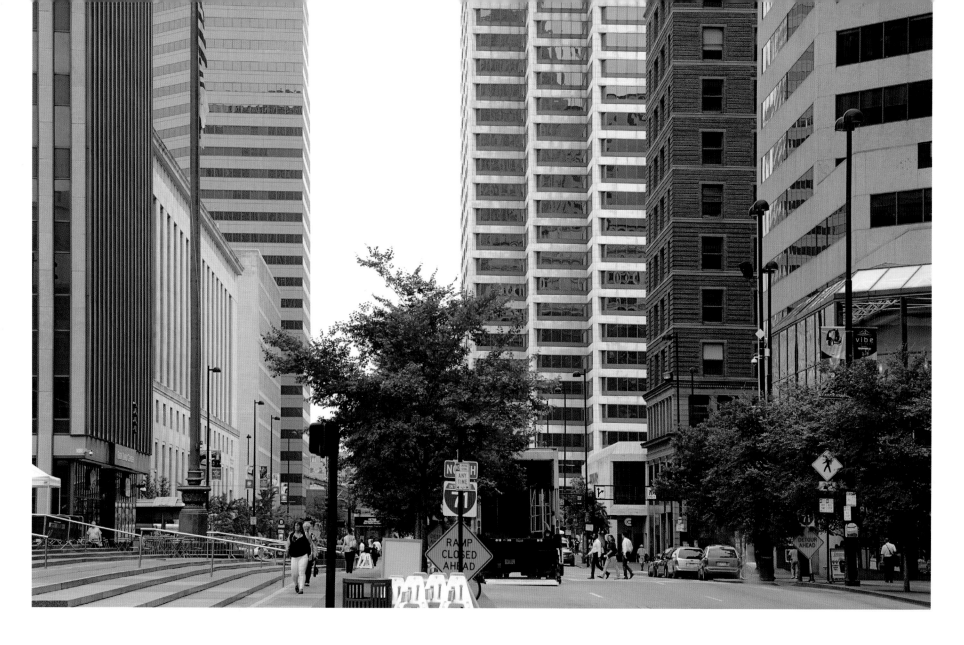

LEFT: Fountain Square is the heart of Cincinnati. It is where the city gathers to celebrate Reds championships and the ends of wars. Before the square was completed in 1871, Fifth and Vine Street was a place to avoid. Henry Probasco's gift of a fountain was an opportunity to get rid of the foul Fifth Street Market, but the land had been specified for a public market. The courts decided a fountain could count as a marketplace, and the butchers' stalls were torn down in three hours. Just in case, flowers were sold from an iron flower stand once a year to meet the condition of a marketplace. In this 1906 photo, the fountain is in its original configuration facing east. Also, from left: Marcus Loew's People's Hippodrome, perhaps the first theater in the city to show moving pictures; the U.S. Post Office at Government Square; the Pickering Building in the center; and the Traction Building, the only structure pictured, aside from the fountain, that remains.

ABOVE: There were no automobiles when Fountain Square was constructed, but as cars took over downtown streets, an island in the middle of Fifth Street became an impediment to traffic. The 1964 city plan called for a new Fountain Square off the street that would be more of a public gathering place. The city demolished the old Mabley & Carew building at the northeast corner of Fifth and Vine, and built the plaza on that spot. The fountain was moved and turned around to face west. The new Fountain Square was dedicated in 1969 and triggered more development all around it. But even the second incarnation of the square was outdated within a few decades. Urban planners called for a plaza that was more of a destination than a "drive-by square," and Fountain Square underwent another remodel in 2006. The middle of Fifth Street has been the site of many Oktoberfest and Taste of Cincinnati festivals over the years.

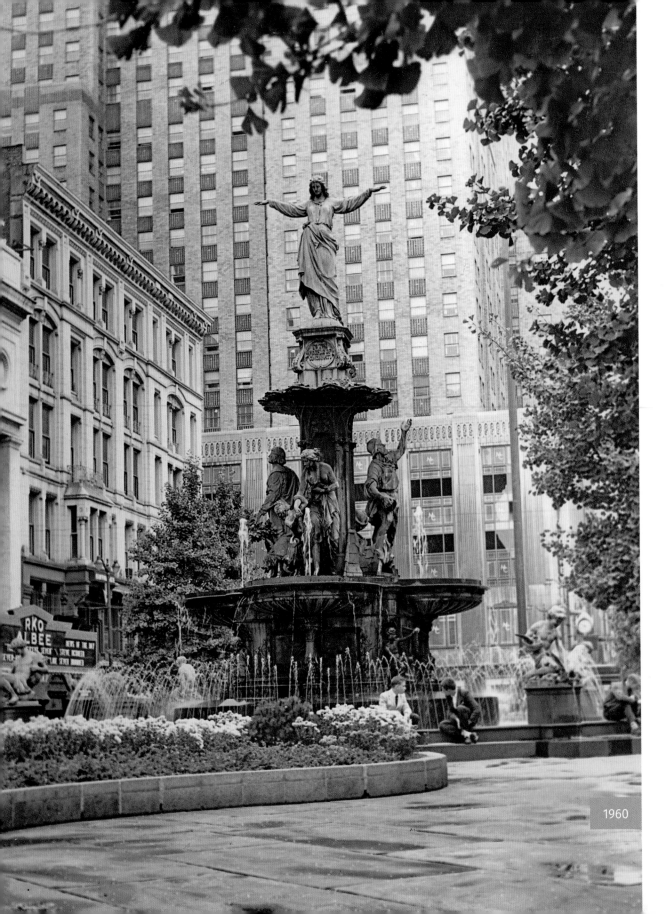

1960

TYLER DAVIDSON FOUNTAIN

"To the People of Cincinnati"

LEFT: The Tyler Davidson Fountain, still in its original position in 1960, is backed by Carew Tower. Henry Probasco and Tyler Davidson had wished to present a gift to the city in gratitude for the success of their hardware business, but the Civil War disrupted their plans. After Davidson passed away in 1865, the monument doubled as a tribute to him. Probasco found a design by sculptor August von Kreling in Munich and commissioned the bronze fountain for Cincinnati. The central figure, known as the *Genius of Water*, is a woman with outstretched arms showering blessings of water on figures below. A man reaches for water to quell a fire. A mother and child head to a bath. A farmer prays to the heavens for rain. A daughter gives her father a drink. Four drinking fountains (no longer operable) circle the basin, each with a figure of a frolicking boy. The fountain was dedicated on October 6, 1871. The pediment lists the year in Roman numerals along with Probasco's message: To the People of Cincinnati.

RIGHT: The Tyler Davidson Fountain originally faced east in the center of the Fountain Square esplanade. For the complete remodeling of the square, in 1971 the fountain was relocated to the new square and turned facing west to greet oncoming traffic. Over time the bronze coating took on a green patina, which is how viewers saw the fountain in the opening credits of the TV show *WKRP in Cincinnati*. The fountain underwent major restoration after a study in 1998 found it was crumbling. The *Genius of Water* was displayed at the Cincinnati Art Museum for a time, giving a unique close-up view. Restored with a new brown coating, the fountain was rededicated in 2000, only to be shelved again five years later when the city overhauled Fountain Square, a project overseen by the newly formed Cincinnati Center City Development Corporation (3CDC). The Tyler Davidson Fountain was moved once again, this time to face south.

BELOW: Dramatic lighting gives the fountain a splash of color.

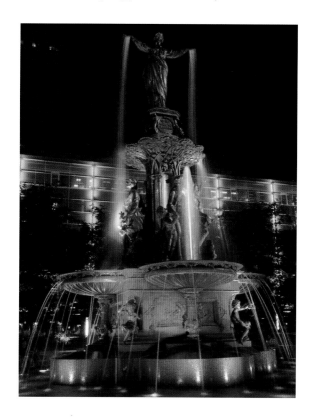

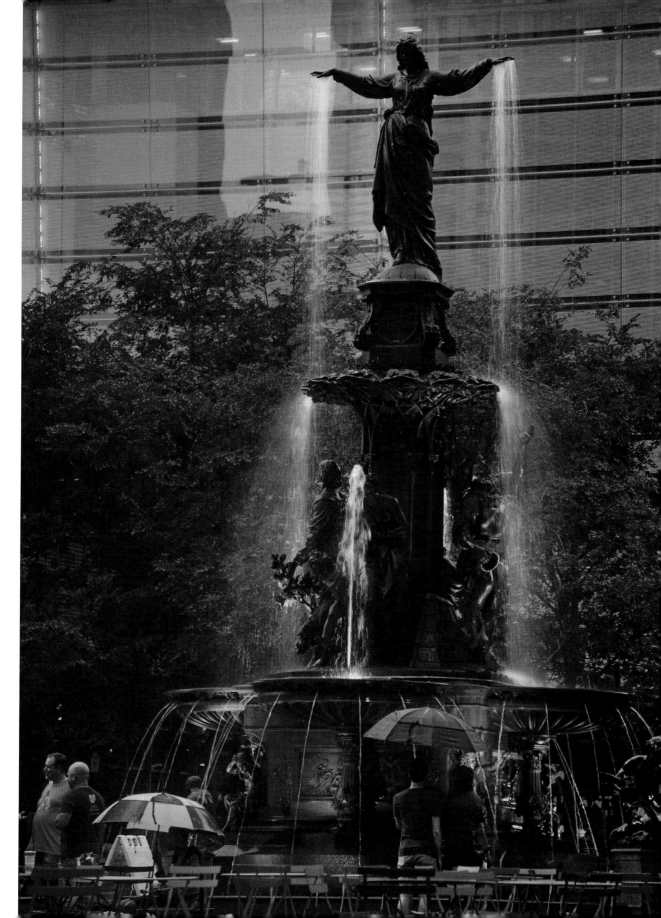

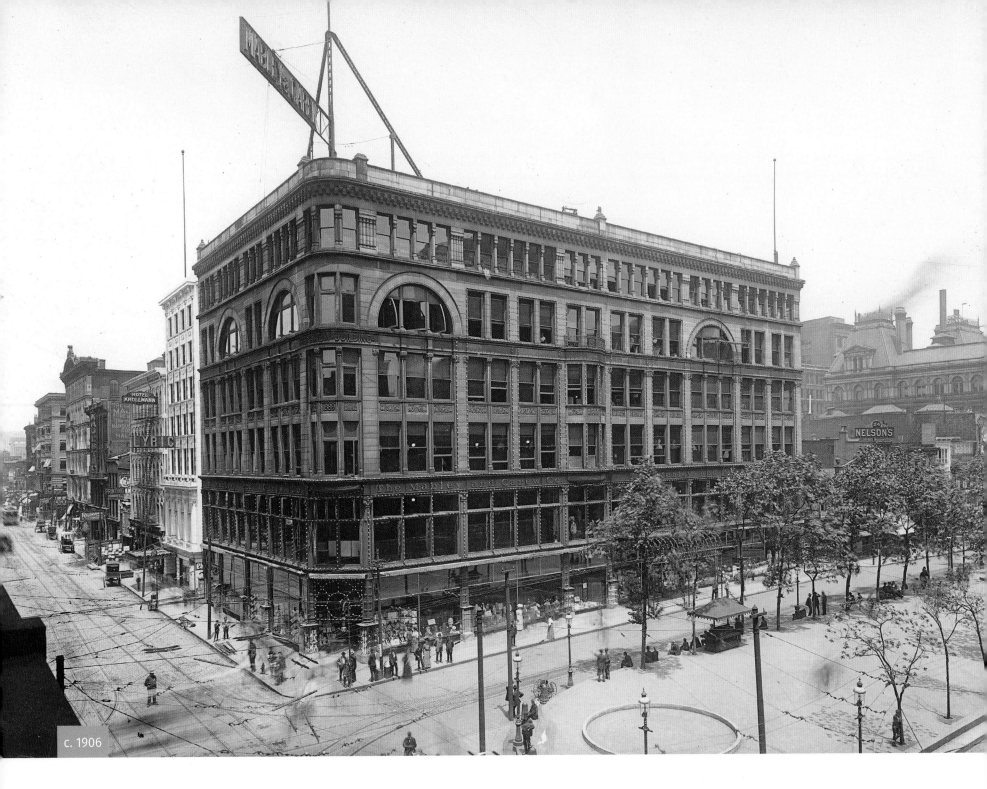

c. 1906

MABLEY & CAREW

The department store helped build up Fifth and Vine

12

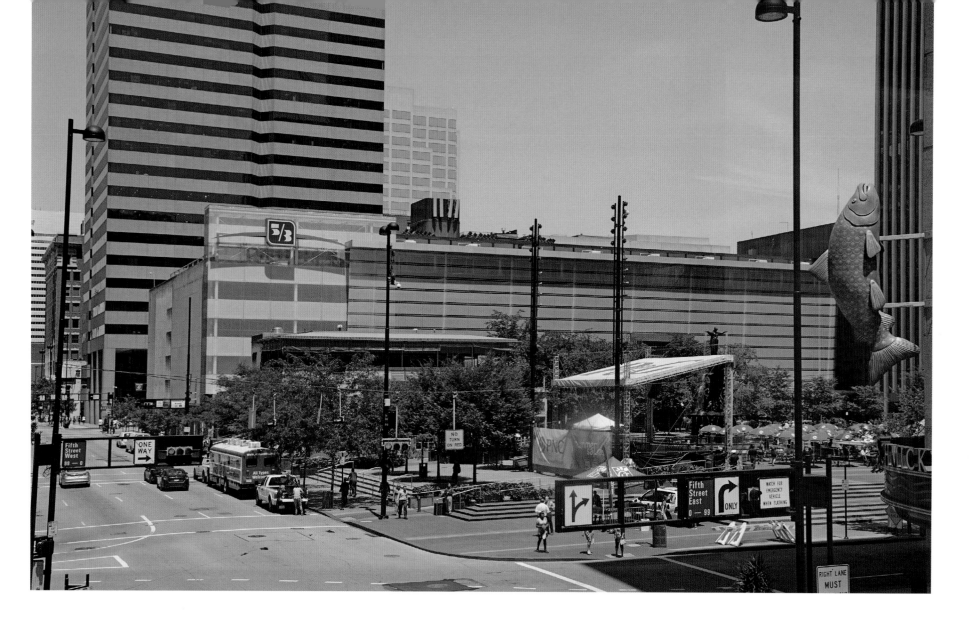

LEFT: The Mabley & Carew Department Store had much to do with making downtown Cincinnati respectable in the late 1800s. The company history tells us that clothiers C. R. Mabley and J. T. Carew, having missed their train in Cincinnati, wandered about town and stumbled on a vacant site that would be perfect for a new store. Mabley & Carew opened in 1877 and expanded to the northeast corner of Fifth and Vine streets. Cincinnati architect James W. McLaughlin designed the large Romanesque-style store building in 1889. The building edges and arched window insets were lined with 10,000 incandescent bulbs that lit up at night. At Christmastime, the store put on a pantomime show for the crowd on Fountain Square. J. T. Carew himself cleaned up the "nasty corner" opposite the store by financing the handsome Carew Building. Also of note in this photo are the Lyric Theater, which opened in 1906, and the Majestic Café, formerly the Vine Street Dime Museum, where not-yet-famous cartoonist Winsor McCay drew lavish posters advertising the dime museum's collection of curiosities.

ABOVE: Mabley & Carew relocated twice at the same intersection. First, to Carew Tower on the southwest corner in 1930, then to the old Rollman's department store on the northwest corner in 1962. The company was sold to Elder-Beerman in 1978, and the store closed down in 1985. The old Mabley & Carew building fared no better. Since it was built on different lots, it was sold and chopped up piecemeal until the once elegant building became known as "Old Eyesore." It was demolished in 1965. Validating Mabley & Carew's judgment that this was a perfect spot, the remodeled Fountain Square has occupied this corner since 1969. Since the second makeover in 2006, there has been nearly constant activity on the square so that the concert stage tent and the winter ice-skating rink often overshadow the Tyler Davidson Fountain.

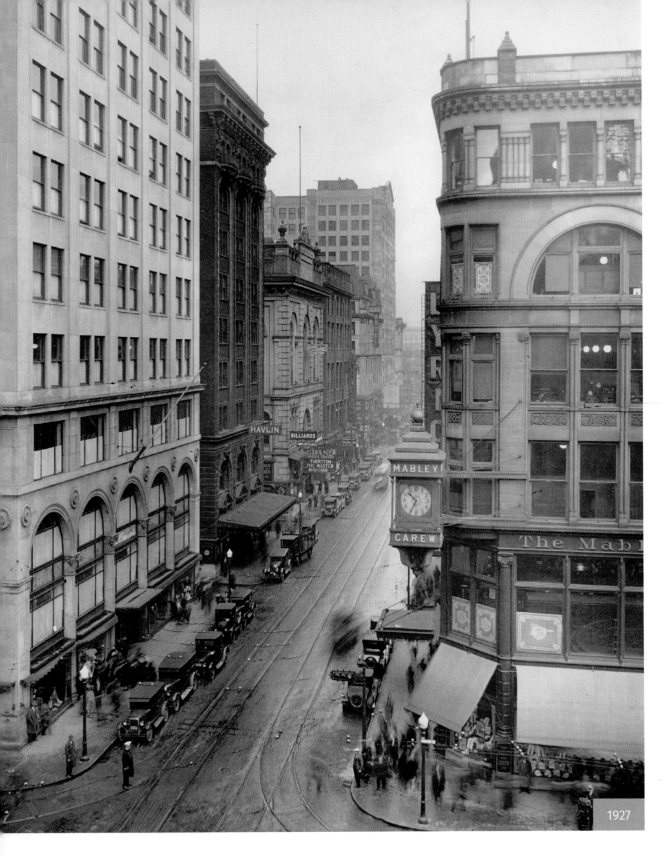

1927

VINE STREET
The backbone of the city dividing the east side from the west

LEFT: Vine Street is the city's axis, the traditional dividing line between east and west. The center of town was originally meant to be Main Street, but the city gravitated towards Vine, in no small part because of Fountain Square. In 1895, when the city renumbered all the streets, Vine Street was used as the center. This view from 1927 has changed so much it is hardly recognizable. From the left, starting at the northwest corner of Fifth and Vine: Rollman's department store, built in 1923, and the Havlin Hotel were later combined, and then converted into a modern Mabley & Carew store in 1962. The Grand Opera House, built in 1860, was rebuilt in 1902 after a fire. Greenwood Hall was the former home of the Ohio Mechanics Institute. The Palace Hotel and the Enquirer Building, under construction in the photo, are the only buildings pictured that are still around. On the right is the original Mabley & Carew store. Note, also, the two-way traffic on Vine Street.

RIGHT: While Vine Street remains the center from which the city radiates, it has undergone significant change as Cincinnati has evolved. The original Mabley & Carew was demolished for Fountain Square. The former Rollman's building was torn down in 1991 to make way for a planned skyscraper as part of a proposed Fountain Square West development that never materialized. The three-story building that took its place includes Macy's and Tiffany's stores, and holds up the Fifth Third Bank LED video board for the square. Corporate headquarters for Macy's (formerly Federated Department Stores) and Kroger are also along Vine Street, as is the Main Library. Vine Street extends into Over-the-Rhine where it is the center of the neighborhood redevelopment, chock full of trendy restaurants and rehabbed historic Italianate architecture.

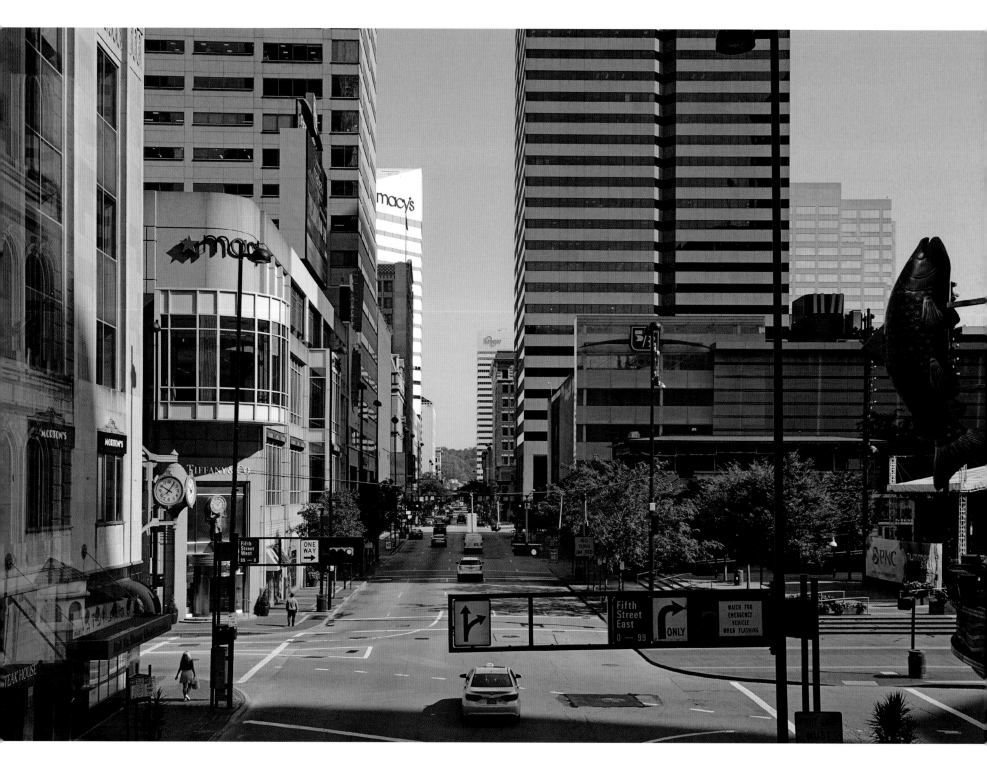

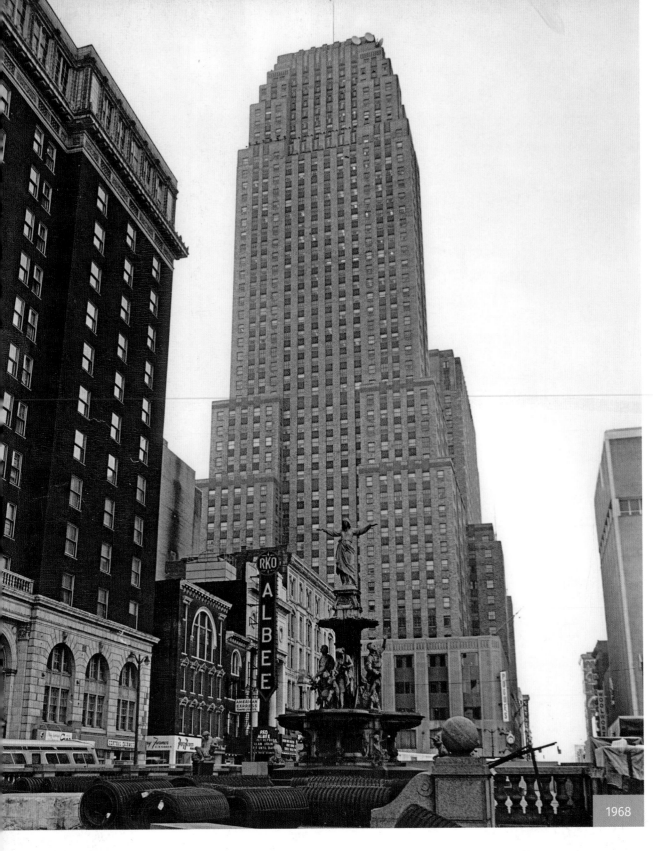

1968

CAREW TOWER

Defining the city skyline as the tallest building for 71 years

LEFT: In 1968, Carew Tower stood as a beacon above the heart of the city, a stalwart backdrop to Fountain Square. Neighbors include the majestic RKO Albee Theater and the latest incarnation of the Gibson Hotel. This was worlds apart from what J. T. Carew saw a century earlier when he looked across Fifth and Vine streets from Mabley & Carew. Dismayed by the low quality shops and saloons on what was deemed the "nasty corner," Carew vowed to erect a handsome building there, and in 1891, he did. The Carew Building with a clock tower in the corner was a James W. McLaughlin design. The Emery family, who made their fortune in lard oil, purchased the property and just before the 1929 stock market crash announced a new $33 million multi-use skyscraper with a hotel and both retail and office space. The forty-eight-story Carew Tower, designed by Walter W. Ahlschlager, opened in 1930 as a beautiful example of early Art Deco and immediately changed the skyline.

BELOW: The "nasty corner" at Fifth and Vine streets was a carryover of the tough area before Fountain Square and Mabley & Carew made it respectable.

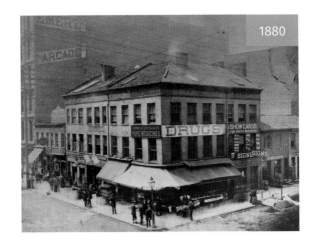

1880

16

RIGHT: Virtually every other structure around Carew Tower has changed. The Westin Hotel occupies the block of Fifth Street where the Albee and Gibson had been. Pogue's, Woolworth's, and Mabley & Carew are all gone. Even the fountain has moved. Only Carew Tower stands tall. At 574 feet, Carew Tower was the tallest building in Cincinnati from 1930 until 2011. By mutual consent, no other structure was allowed to be taller, so Carew Tower always dominated the skyline and the observation deck offered an unrivaled view. In 2011, the Great American Tower took the title by 91 feet. Carew Tower is a National Historic Landmark. The Hilton Netherland Plaza Hotel occupies the western portion of the complex. The hotel appears much as it did in the 1930s, with Art Deco décor and the celebrated Orchids at Palm Court restaurant. Doris Kappelhoff, better known as Doris Day, made her professional debut singing in the Netherland's Pavilion Nightclub at age seventeen in 1939.

BELOW: The clock above the former "nasty corner" has kept time while the retail residence has changed from Mabley & Carew to Pogue's to Morton's and Boi Na Braza steakhouses.

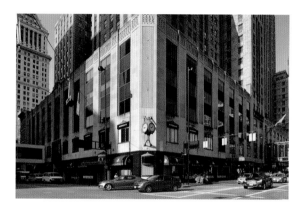

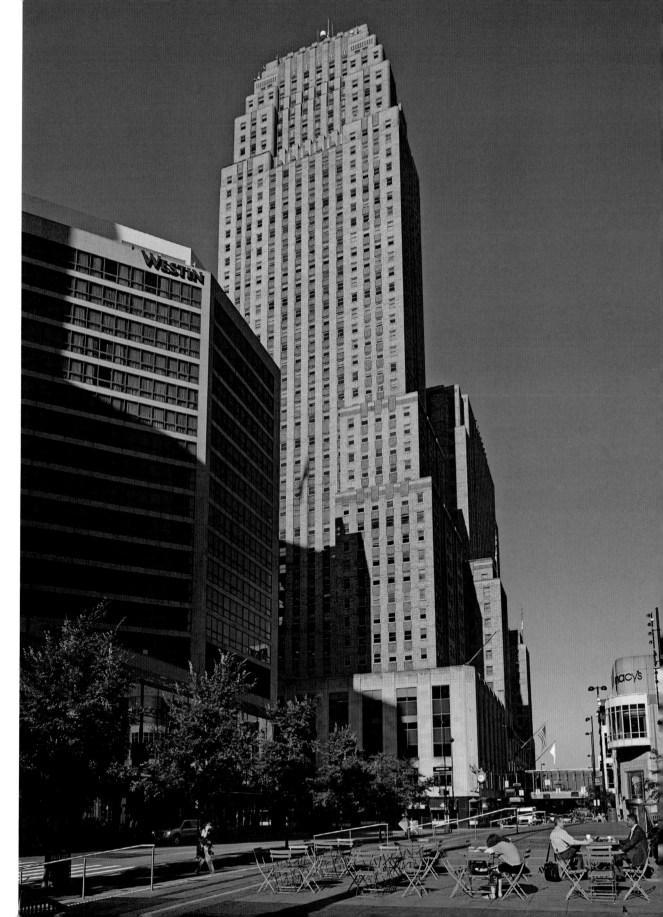

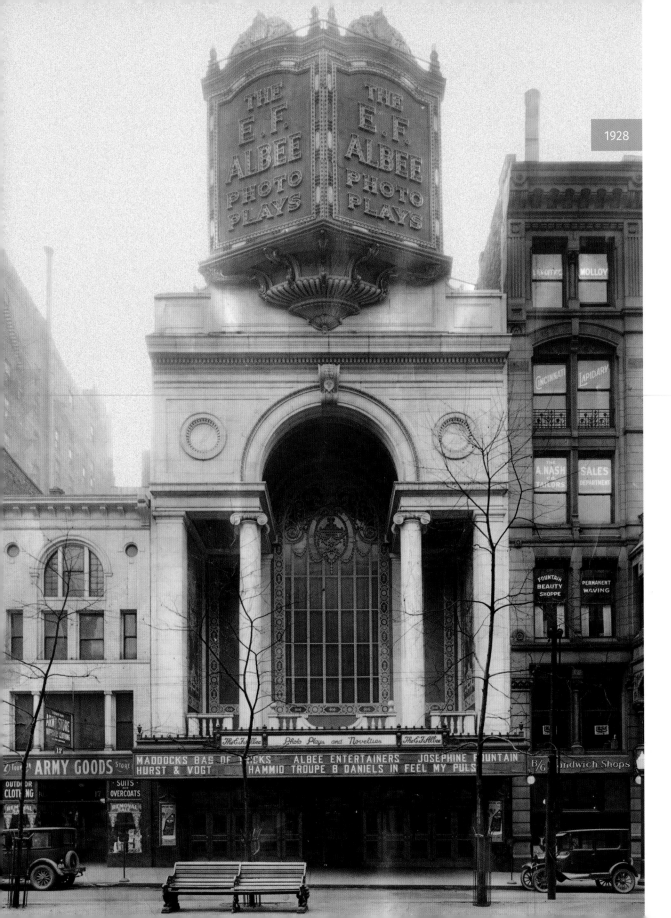

1928

ALBEE THEATER
The most elegant of the city's movie palaces

LEFT: The palatial Albee theater opened on Christmas Eve, 1927, with the silent picture *Get Your Man*, starring Clara Bow, the "It" Girl. Moviegoers dressed to the nines passed under the massive Neoclassical archway and into the lobby where they found marble staircases with gilded fixtures, and railings and walls bedecked in intricate Rococo ornamentation. The cavernous five-story auditorium seated 4,000 with no pillars to obstruct views, so there was not a bad seat in the house. The Albee opened shortly after *The Jazz Singer* ushered in the talkies, so the Wurlitzer organ saw little use. Going to the theater to watch a film or a vaudeville act was a memorable event, and the house was often better than the show. The RKO Albee was the crème de la crème of Cincinnati movie palaces, but as audiences dried up in the age of television, like most downtown theaters, the Albee lost its luster. The crimson curtain closed in 1974.

RIGHT: As theater after theater in downtown Cincinnati was torn down, there was hope that the greatest of them would be spared, but a campaign to "Save the Albee" fell short. The location opposite Fountain Square was prime real estate for redevelopment, and most of the city block, including the Gibson Hotel, was demolished in the 1970s to put up the Westin Hotel and U.S. Bank Tower. There was discussion of incorporating the Albee into the skyscraper's design, but the money wasn't there. The Albee's archway façade was preserved piece by piece, and in 1986, it was affixed to the Fifth Street end of the convention center. The Mighty Wurlitzer organ was installed in the Emery Theatre but was little used, then found a home in the Music Hall ballroom. The $38 million deluxe Westin Hotel opened in 1981, with Neil Armstrong as the first guest. Inside the hotel's four-story-tall glass atrium guests find a display honoring the history of the Albee.

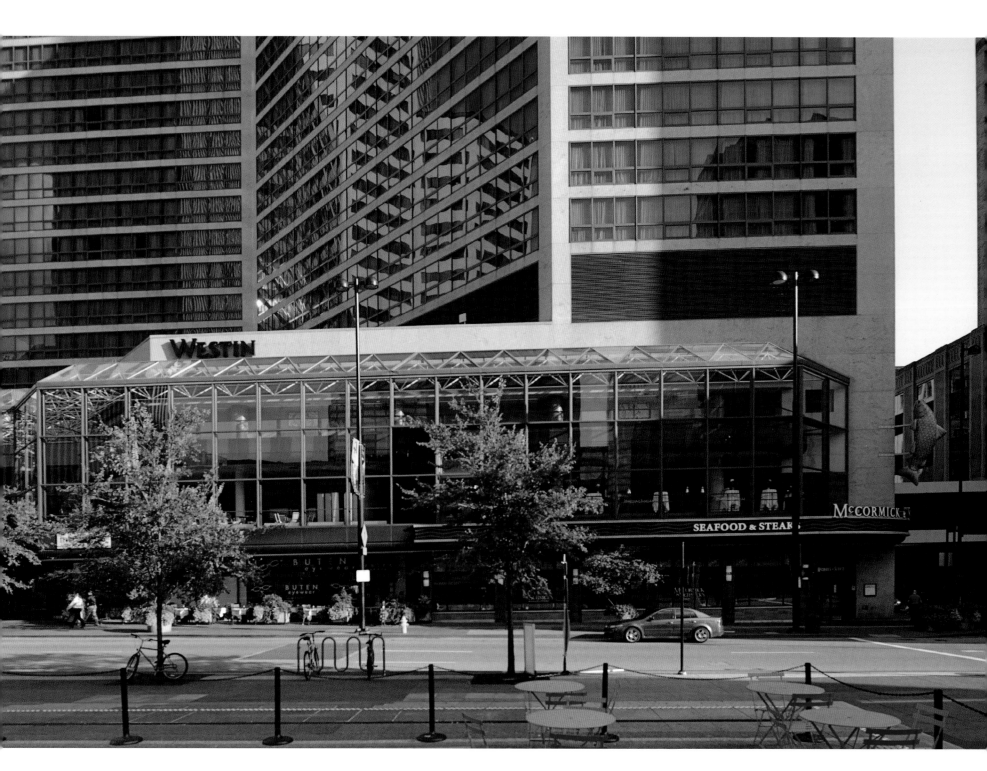

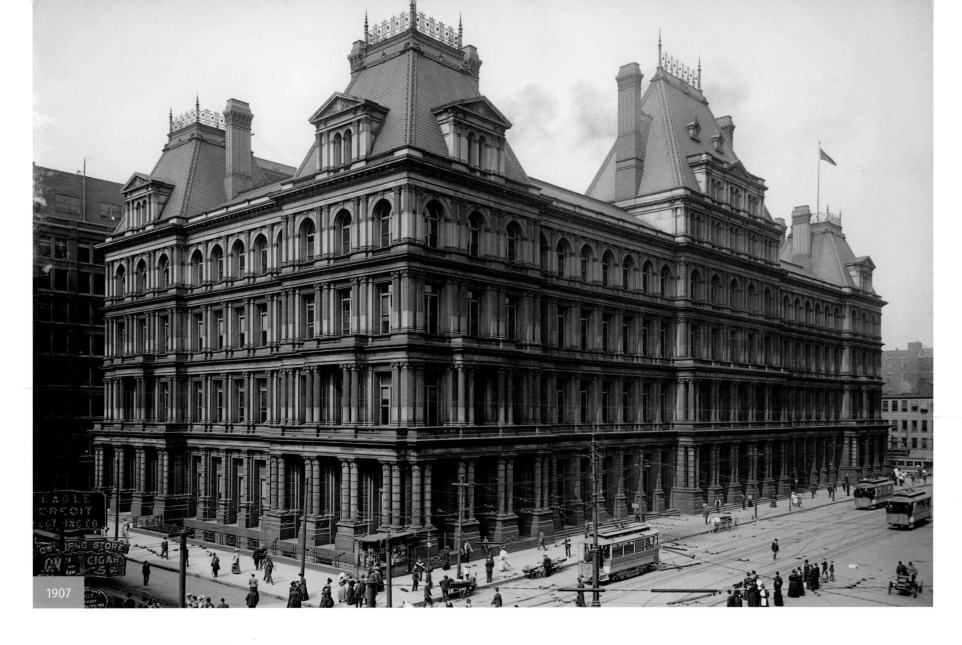

1907

GOVERNMENT SQUARE

The post office may have gone, but the court remains

ABOVE: The United States Post Office and Custom House, as it appeared in 1907, was an imposing building occupying an entire block at Fifth and Walnut streets. The city's first federal building took eleven years to complete and opened in 1885 as a replacement for the old post office at Fourth and Vine. Designed by Alfred B. Mullett, the supervising architect for the Treasury Department, the handsome French Renaissance structure was a four-story hollow square surrounded by offices for the post office, Internal Revenue, courts, government office and custom house—a catch-all for government activity. The block became known as Government Square in 1891. It was a fitting appellation for the site, having been visited by presidents James Monroe, Andrew Jackson and John Quincy Adams. In 1859, Abraham Lincoln gave a speech from the nearby balcony of the silver manufacturing shop of E. & D. Kinsey, in which he referenced his comment that "a house divided against itself cannot stand."

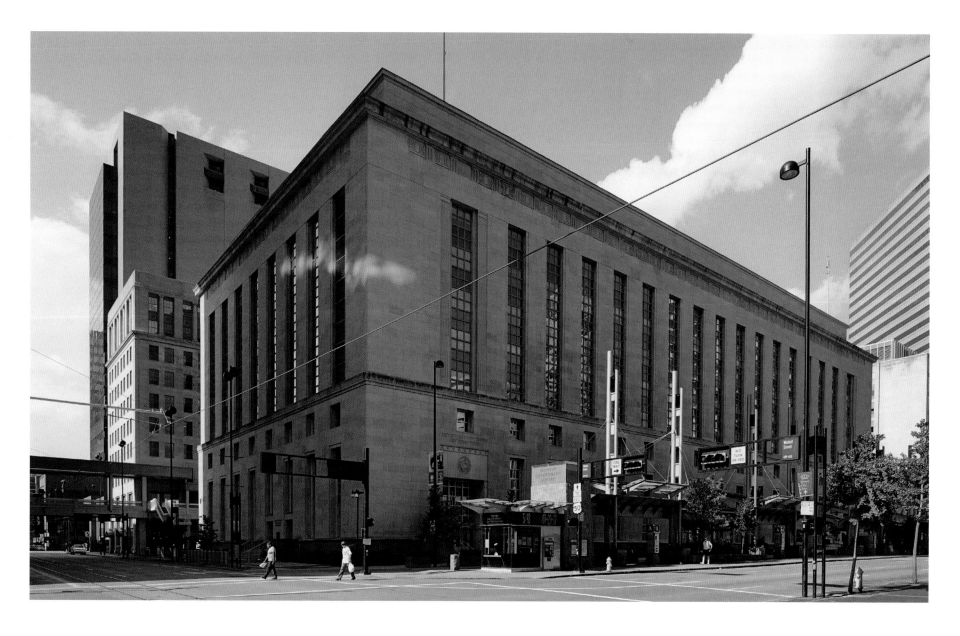

ABOVE: Although striking in appearance, the post office and custom house became insufficient for the government's needs, and it was razed in 1936. The new United States Post Office and Courthouse opened in 1939. Although the concrete Art Moderne structure is not as large as its predecessor, it actually has more working area. Metro buses have used

Government Square as their bus-stop hub since 1977. John F. Kennedy campaigned at Government Square in 1960, and spoke there again in 1962 just days before the Cuban Missile Crisis. With his Boston accent, he pronounced the city as "Cincinnotty." The Dalton Street location is now the main post office, but the courthouse still functions as a U.S. Court of

Appeals. In 1994, the building was officially named the Potter Stewart United States Courthouse. Stewart was a Cincinnati City Council member and a Supreme Court justice who famously wrote that hard-core pornography was difficult to define, but that "I know it when I see it." The courthouse is often mistaken for the John Weld Peck Federal Building one block east.

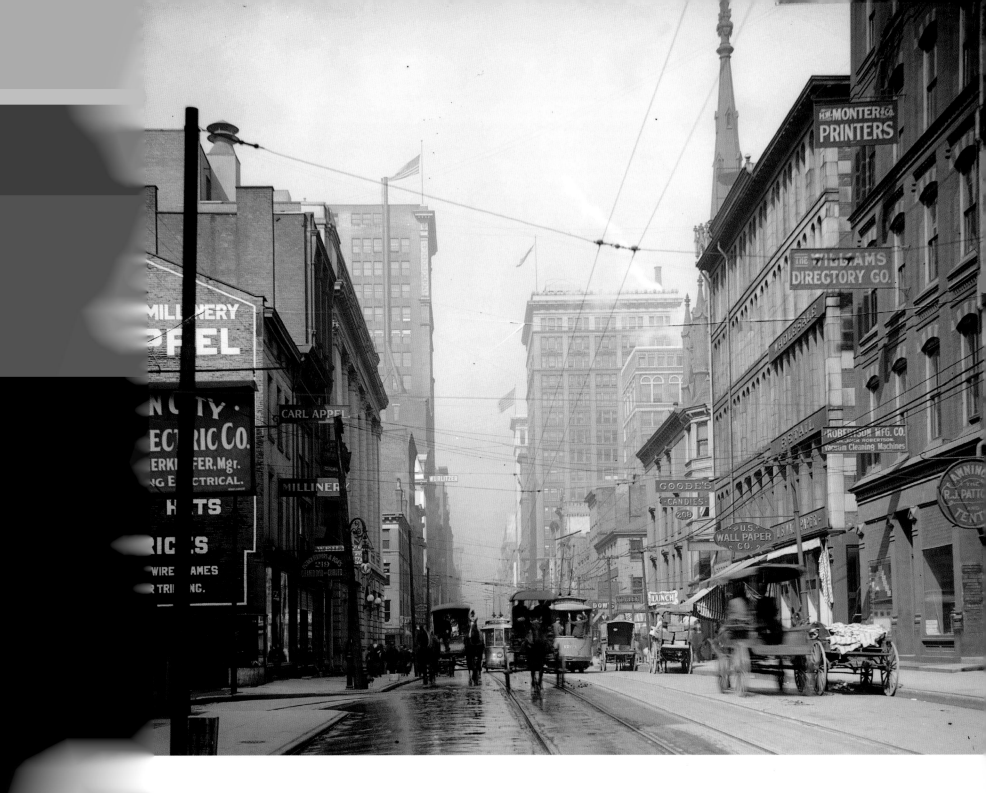

MILLINERY
APPEL

NUTY ·
ECTRIC CO.
ERKIMER, Mgr.
NG ELECTRICAL.

CARL APPEL

MILLINERY

HATS

RICES

WIRE FRAMES
R TRIMMING.

219

WURLITZER

GOODE'S
CANDIES
208

DOW'S

LUNCH

H.W. MONTER & Co.
PRINTERS

THE WILLIAMS
DIRECTORY CO.

ROBERTSON MFG. CO.
Vacuum Cleaning Machines

U.S.
WALL PAPER
CO.

THE
R.J. PATT
TENT

URTH STREET

yterian Church was planning to build its own skyscraper in the financial district...

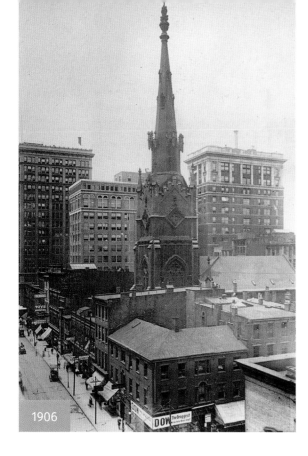

1906

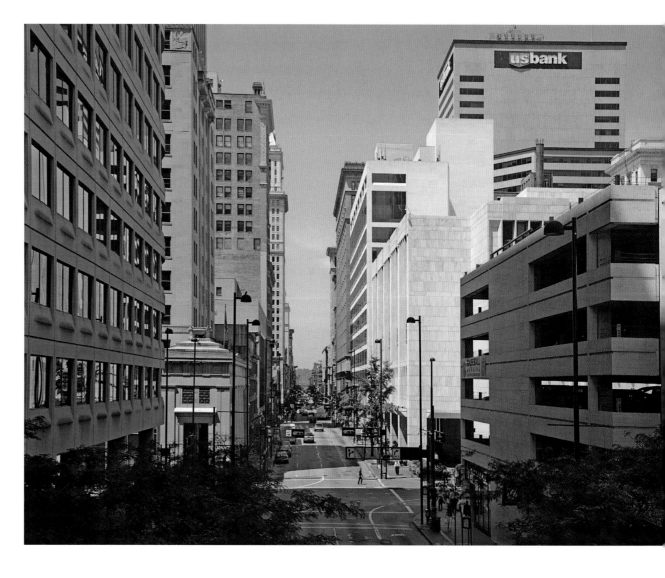

LEFT: Once lined with mansions and the grandiose Pike's Opera House, Fourth Street became home to banks and retail space as the city's financial artery shifted north from Third Street in the mid-1800s. The tall spire of the First Presbyterian Church stands out among the shops and banks on the east side of Fourth Street, looking west in this 1905 photo. The oldest congregation in the city dates to 1790, when the city's first church had unplastered walls and no ceiling. This Neo-Gothic church was built west of Main Street in 1851. The two tallest buildings in the photo were designed by Chicago architect Daniel Burnham: The Union Trust Building on the north side, constructed at Walnut in 1901, was the tallest building in the city until Burnham's Clopay Building across the street was completed in 1904.

-ABOVE: The 285-foot Neo-Gothic spire of the First Presbyterian Church rose above all other buildings, topped with a golden hand pointing to heaven.

ABOVE: Skyscrapers along Fourth Street now obstruct the view. The south side of the street finds the Cincinnati Gas & Electric Building (now Duke Energy Building), a Neoclassical tower. Every Christmas, starting in 1936, generations of Cincinnatians crowded into the CG&E lobby to view the elaborate holiday model train display until the trains were relocated to Union Terminal in 2010. Both of Burnham's buildings are still around: Clopay became the Fourth & Walnut Center; Union Trust became the Bartlett Building, then the Renaissance Cincinnati Downtown Hotel, with its restaurant, D. Burnham's, named for the architect. The concrete Federal Reserve Bank building stands on the spot of the First Presbyterian Church. If only the church's plans hadn't fallen through, the scene would be very different today. In 1929, the church announced that it was building a 470-foot skyscraper, Art Deco with a Gothic cathedral-like spire, to be called Temple Tower. Alas, there was no money, and First Presbyterian merged with Church of the Covenant.

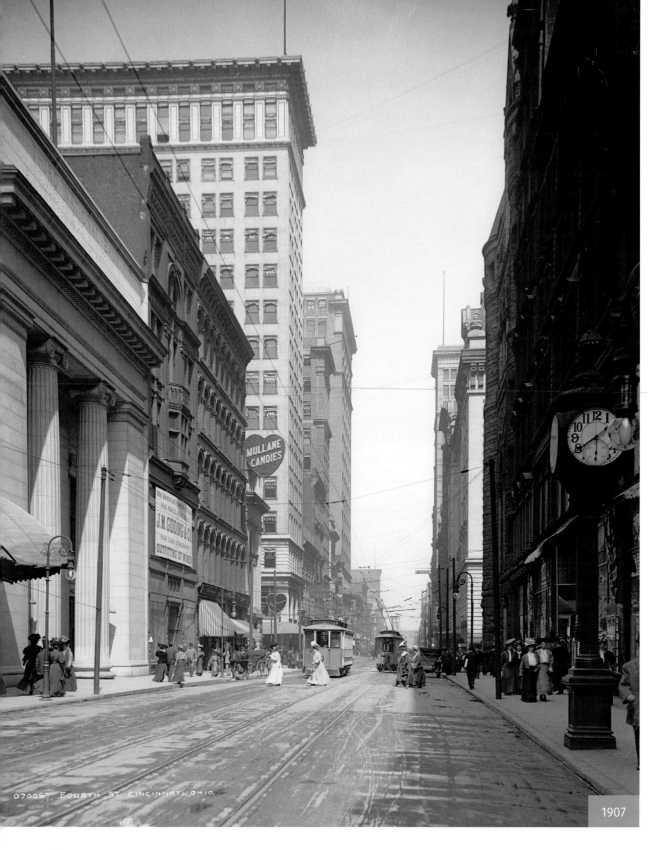

070067 FOURTH ST CINCINNATI, OHIO.

1907

WEST FOURTH STREET
The former home of fashion is now a historic district

LEFT: In 1907, West Fourth Street between Race and Vine was the city's most fashionable block. Ionic columns set the Third National Bank apart from all else. Next door, J. M. Gidding Co., a ladies' clothier, was a new addition that year. Shortly after this photo was taken, a decorative Rookwood terra-cotta trim featuring colorful fruits and garlands was added to Gidding's. Mullane's Candies in the Suire Pharmacy Building was a gilded confectionary with an artsy stained-glass window of cherubs partaking of sodas and sweets. The tallest building in the center is the Ingalls Building, built in 1903 as the world's first reinforced concrete skyscraper. Designed by Cincinnati architectural firm Elzner & Anderson, it was named for its main investor, railroad president Melville E. Ingalls. Across the street, the Sinton Hotel was completed in 1907 to replace Pike's Opera House that had burned down. The castle-like Chamber of Commerce Building is just visible. McAlpin's department store had moved into the old Shillito's store in 1880. The clock out front served as a rendezvous for shoppers and young couples.

RIGHT: The West Fourth Street Historic District was added to the National Register of Historic Places in 1976. Although some of the buildings remain, the businesses have changed drastically. In 1908, the Third National Bank merged with the Fifth National Bank, resulting in that Cincinnati staple, Fifth Third Bank. Gidding's merged with its next-door competitor Jenny's in 1962, and Gidding-Jenny closed in 1992. The Rookwood trim, obscured by a tree in this photo, was restored in 2003. The buildings housed a T. J. Maxx department store until 2014. The Suire building, built by William Walter and James Key Wilson, was the headquarters of Herschede's Jewelers as well as the first home of the American Classical Music Hall of Fame, which is now located in Memorial Hall. The Sinton Hotel was torn down in 1964. PNC Tower occupies the Chamber of Commerce's corner spot. McAlpin's closed the downtown store in 1996, and was absorbed by Dillard's. A decade later the historic building was refurbished as luxury condominiums known as the McAlpin.

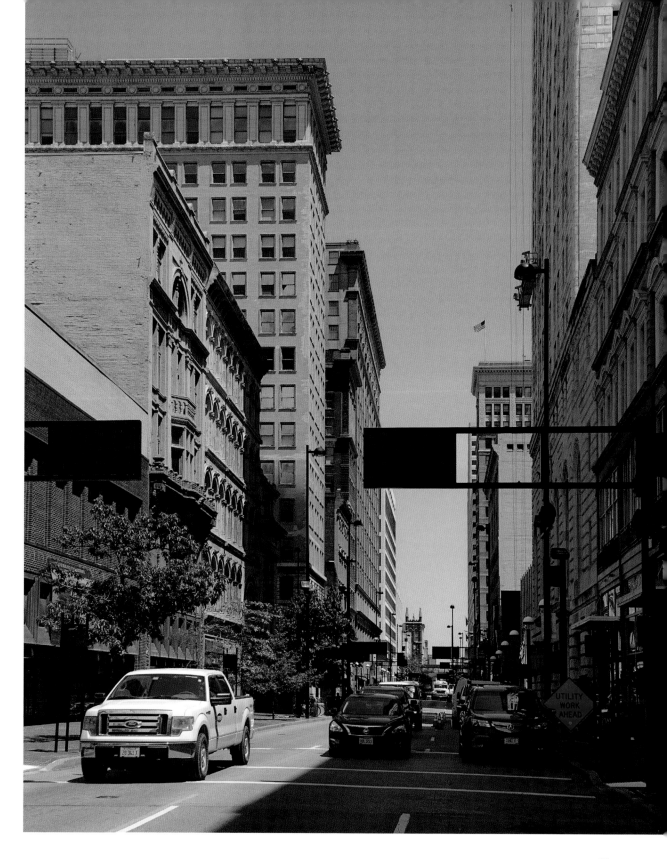

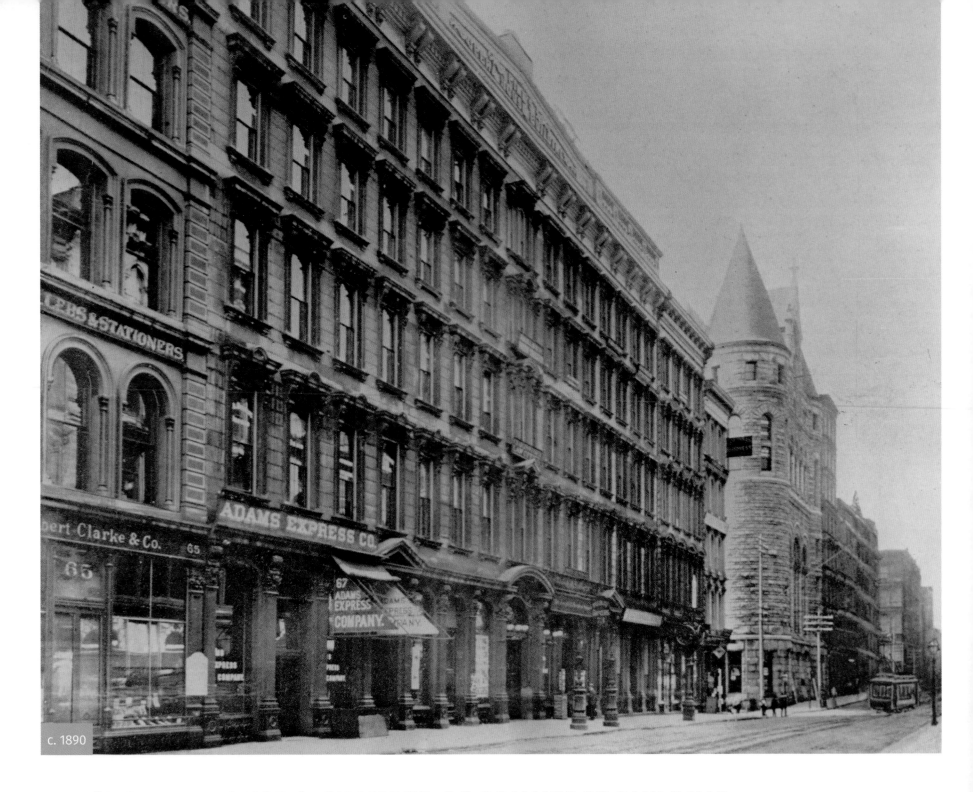

c. 1890

PIKE'S OPERA HOUSE & CHAMBER OF COMMERCE BUILDING

The final work from one of America's greatest architects

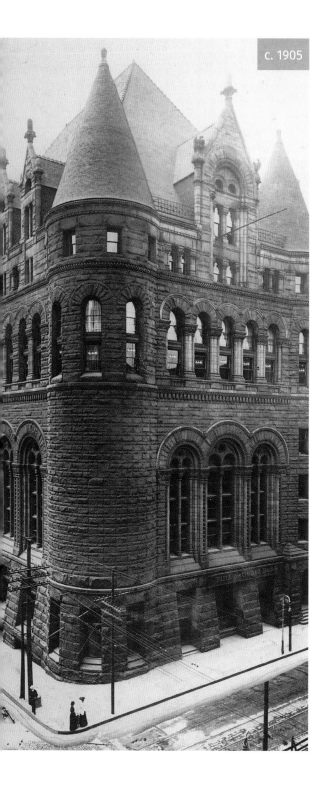

c. 1905

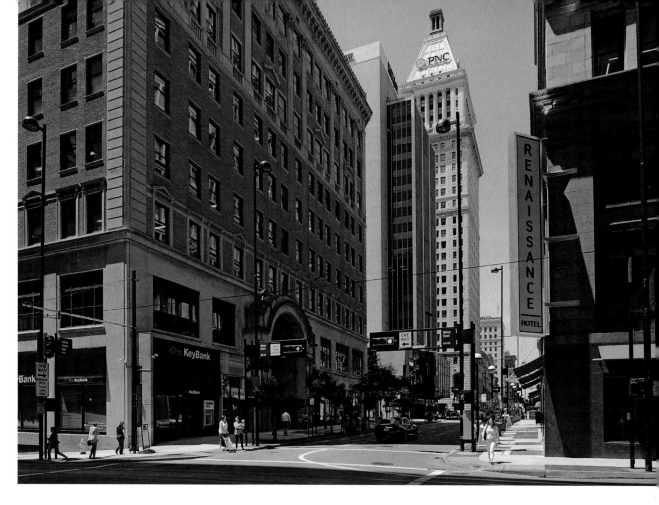

OPPOSITE: This row of buildings on Fourth Street near Vine, pictured about 1890, would soon share a tragic fate. Pike's Opera House in the center was the second incarnation of the celebrated theater. The original opera house built by Samuel Pike in 1859 was one of the premier stages in the nation, drawing the world's best talent. A gas leak led to an explosion and fire on March 22, 1866, that consumed most of the block. Pike rebuilt on the same spot with a similar design. Pike's Opera House was remembered for its elegant interior and its cruel fate. The Chamber of Commerce Building (left) appears like a castle across Vine Street. It was the final design by the prestigious American architect H. H. Richardson, completed posthumously in 1889. The Romanesque style of the building, featuring arched windows, rough-hewn stone and turrets, is named for Richardson, and was emulated by many contemporary architects.

ABOVE: On February 26, 1903, Pike's Opera House was again consumed by a fire, but would not rise again. The elegant Hotel Sinton was built on the spot in 1907, but was demolished in 1964 to build Provident Tower. The end of the Chamber of Commerce Building was truly tragic. On January 10, 1911, a kitchen fire spread through the building and weakened the truss supporting the upper floors, which collapsed, killing six people. The stones were salvaged, intended for an observatory in Cleves. Instead, they lay in a field for decades. In the 1970s, University of Cincinnati architectural students used the stones in a sculpture in Burnet Woods as a monument to Richardson. The stone eagles from the building flank the Melan Arch Bridge in Eden Park. The distinctive Union Central Building rose up on the Chamber site in 1913 as the fifth tallest building in the world at the time, defining the Cincinnati skyline. The classical columns and pyramidal peak were designed by Cass Gilbert to echo the Mausoleum at Halicarnassus, one of the Seven Wonders of the World.

BURNET HOUSE

Cincinnati's storied hotel hosted a meeting that would shape the end of the Civil War

BELOW: Built at the northwest corner of Third and Vine streets in 1850, the Burnet House was one of the first luxury hotels in America, boasting 340 rooms and running water at a time when most inns were little more than a few rooms over a tavern. Hotel architect Isaiah Rogers, who had also built the Tremont House in Boston and New York's Astor House, became so enamored of Cincinnati that he stayed

and later designed the rebuilt Pike's Opera House and Hamilton County Courthouse. With its domed roof and impressive stairway entrance, the Burnet House looked more like a government building than a hotel. Every notable visitor to the Queen City, from opera star Jenny Lind to Oscar Wilde and the future King Edward VII, stayed at the Burnet House. Abraham Lincoln was a guest twice and gave a speech from the balcony. In

1864, Generals Ulysses S. Grant and William Tecumseh Sherman met in the second-floor parlor, set up maps, and planned the ending of the Civil War. Architect James W. McLaughlin supervised a renovation in 1885 that removed the dome and relocated the entrance from Third Street to Vine Street, as pictured in 1905. The castle-like Chamber of Commerce peeks out behind the Burnet House.

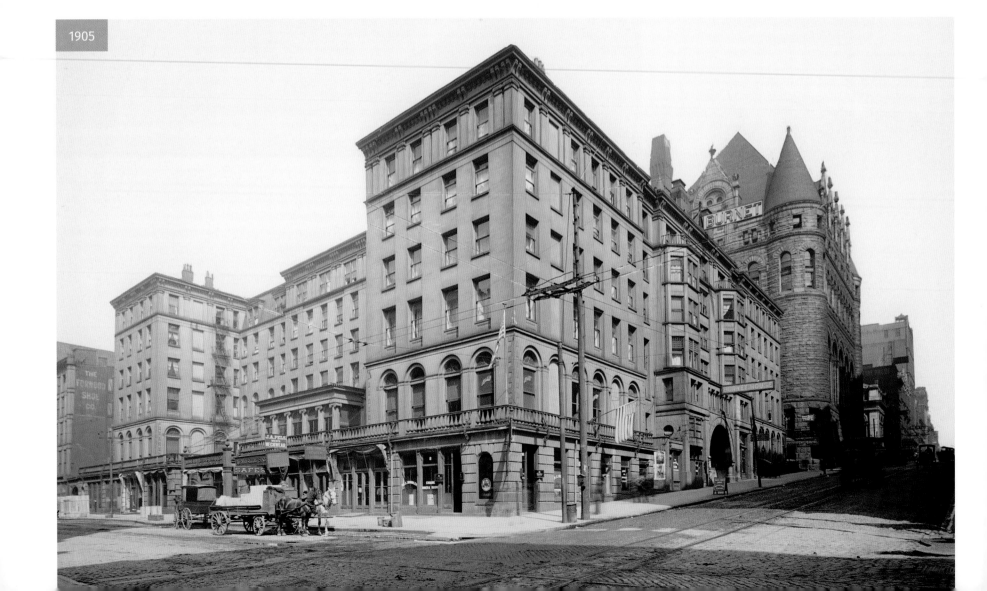

1905

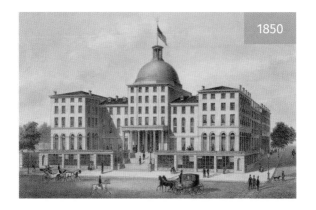

1850

BELOW: As the city center moved further away from the river, the Burnet House's Third Street location was no longer in the thick of activity. A modern hotel in the mid-1800s was antiquated by the turn of the century. The Burnet House closed in 1926 with a ceremony honoring the hotel's history, and historic artifacts were auctioned off before it was torn down. Union Central Life Insurance built an annex to their tower on the old Chamber of Commerce site behind the Burnet House. Perhaps in homage, the annex (now part of PNC Tower) has the same H-shape and general features of the Burnet House. A historic marker identifies the location of the most historic of Cincinnati sites from the city's golden age. The former PNC annex at 309 Vine Street is being converted into the luxurious City Club Apartments, returning the site to a semblance of its former role as the Burnet House.

LEFT: A lithograph from 1850 shows the Burnet House with the original dome.

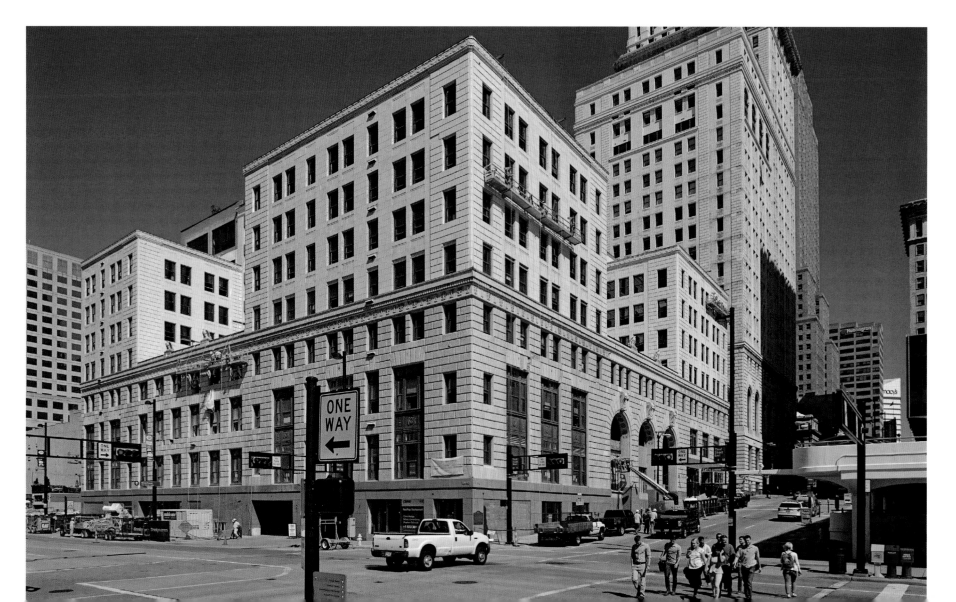

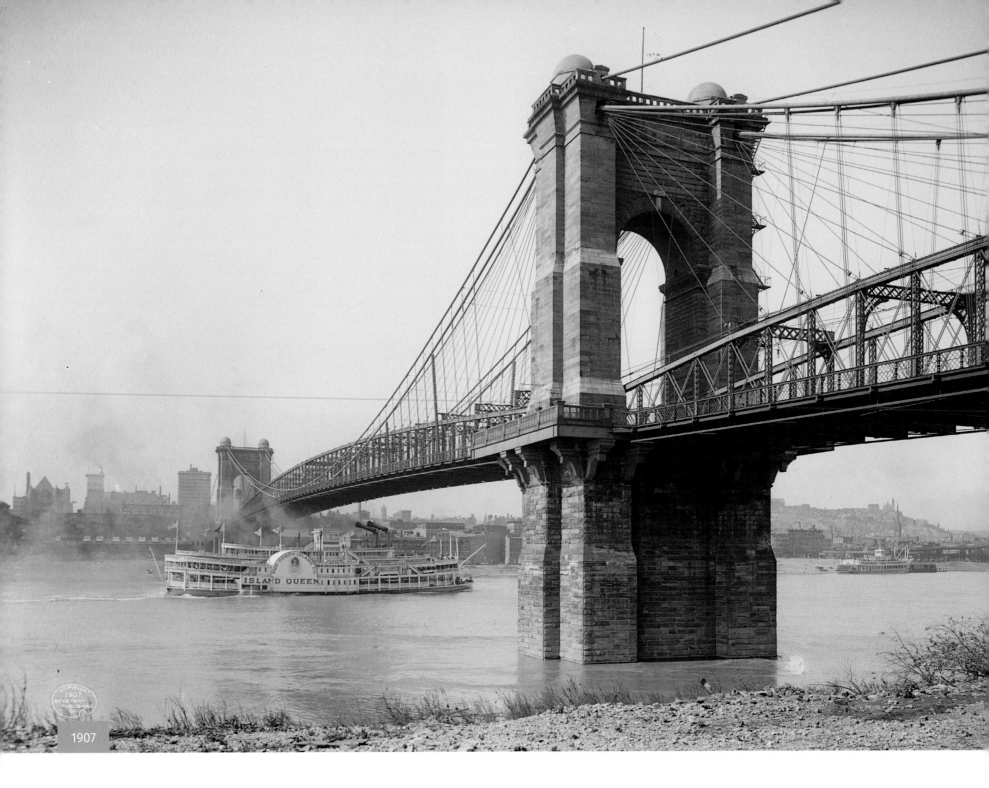

1907

ROEBLING SUSPENSION BRIDGE

The first bridge to cross the Ohio River was a prototype for the Brooklyn Bridge

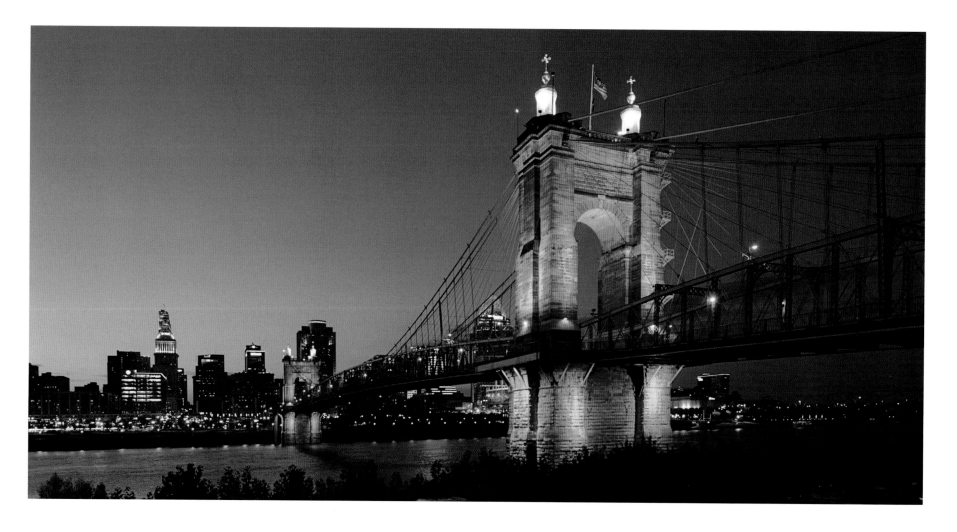

LEFT: The legacy of the John A. Roebling Suspension Bridge extends beyond Cincinnati. It was the first bridge to cross the Ohio River and the longest suspension bridge in the world at the time. German bridge builder John A. Roebling (born Johann Röbling) was a bridge pioneer and this was the forerunner for his most famous work, the Brooklyn Bridge. Work on the Covington and Cincinnati Suspension Bridge began in 1856, but was halted by the Civil War. In September 1862, Confederate forces moved to invade Cincinnati. The city's citizens fashioned a pontoon bridge out of coal barges to cross into Kentucky, where they built battlements that dissuaded the rebels. The incident demonstrated the need for Roebling's bridge. Cincinnati's suspension bridge officially opened on January 1, 1867. The *Island Queen* passes underneath the Suspension Bridge in 1907, ferrying patrons to and from Coney Island. The steamboat, launched in 1896, was fated to burn while docked at the Public Landing in 1922. A second *Island Queen* continued the service until it, too, was destroyed in a fire in 1947.

ABOVE: River traffic has changed dramatically since Cincinnati was a steamboat town. Barges still ply the river, but the only floating palaces found are nostalgic—a dinner cruise on a screw-powered riverboat or the Tall Stacks festival. The Roebling Bridge has become one of Cincinnati's most recognizable icons, and was named a National Historic Landmark. Technically the Ohio River is owned by the state of Kentucky, so the Roebling Bridge is painted Kentucky blue. The gold spheres and crosses atop the pylon towers have been restored so the bridge glistens in every photograph of the city skyline. Joseph Strauss, a graduate of the University of Cincinnati, grew up admiring Roebling's suspension bridge and was inspired to build something monumental himself. He succeeded, designing the most famous suspension bridge in the world, the Golden Gate Bridge in San Francisco.

CINCINNATI SKYLINE
The Kentucky hills offer spectacular views of the city skyline

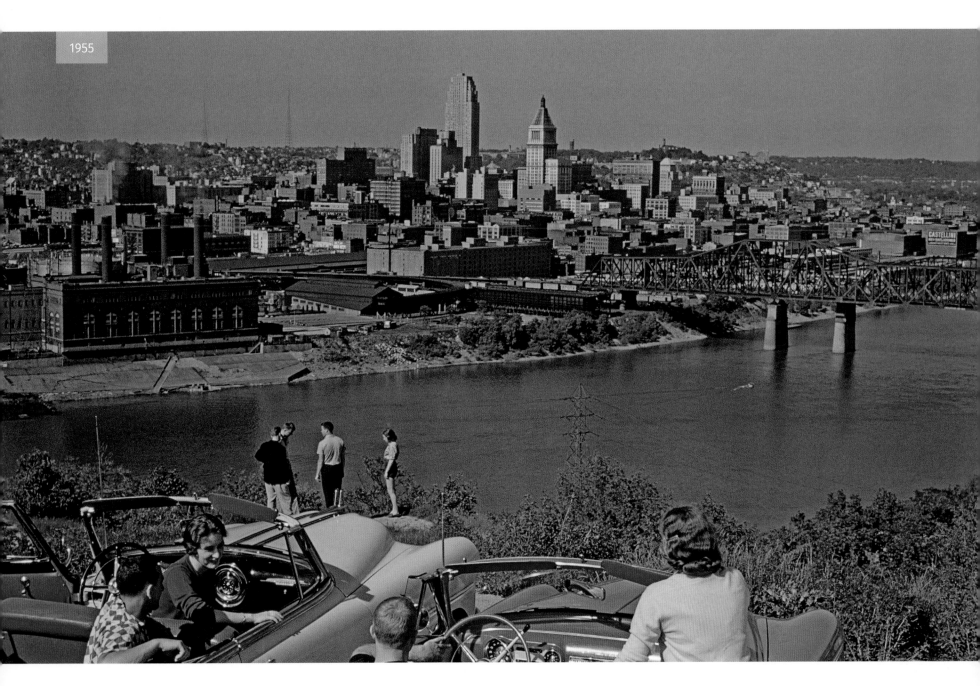

1955

LEFT: In this color photo from 1955, teenagers parked at the bluffs of Devou Park in Covington, Kentucky, get a spectacular view of the Cincinnati skyline. This is similar to the view of Cincinnati that appeared in the introduction to the soap opera *The Edge of Night* produced by Procter & Gamble. Carew Tower and Central Trust Tower dominate the skyline as the tallest buildings in the city. Picking out the familiar structures is like a game. The Terrace Plaza Hotel with the saucer-shaped Gourmet Room perched on the ledge. The green-capped Cincinnati Gas & Electric Building. Holy Cross-Immaculata Church on the cliff of Mount Adams. The riverfront was undeveloped then except for warehouses, factories, and rail yards. The bridge crossing the Ohio River is the double-track Chesapeake and Ohio Railroad Bridge. The original C&O Railroad Bridge, completed in 1889, was inadequate for the added load, so a second bridge was built alongside it in 1929, with the original used for automobile traffic.

BELOW: Today's skyline is more varied, especially since Great American Tower was completed in 2011. This view shows how the "crown" edges out Carew Tower as the highest point in Cincinnati. The older, shorter buildings are now hidden amongst corporate skyscrapers. The view from Devou Park shows the changes along the riverfront as well, starting with the bridge. The older section of the C&O Bridge was demolished in 1970, and the Clay Wade Bailey Bridge, in light blue, was added in 1974. The Banks riverfront project has finally been realized, bookended by Paul Brown Stadium (2000), home of the Cincinnati Bengals, on the west end, and the Reds' home, Great American Ball Park (2003), on the east end. Among the notable additions to the banks are: General Electric's Global Operations Center (2016); the National Underground Railroad Freedom Center (2004), a museum educating on the fight to end slavery; and Smale Riverfront Park (2015), with interactive sculptures and Carol Ann's Carousel, featuring hand-carved horses and animals that reflect Cincinnati history.

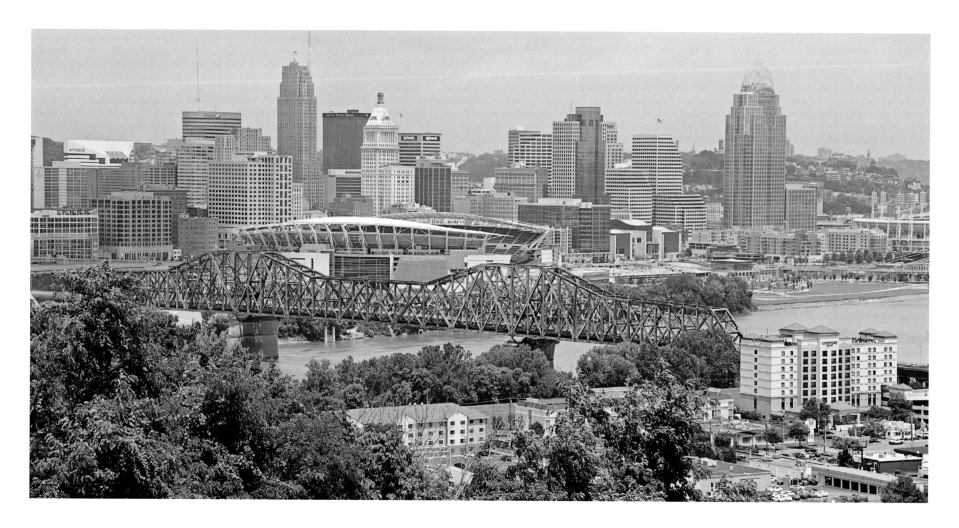

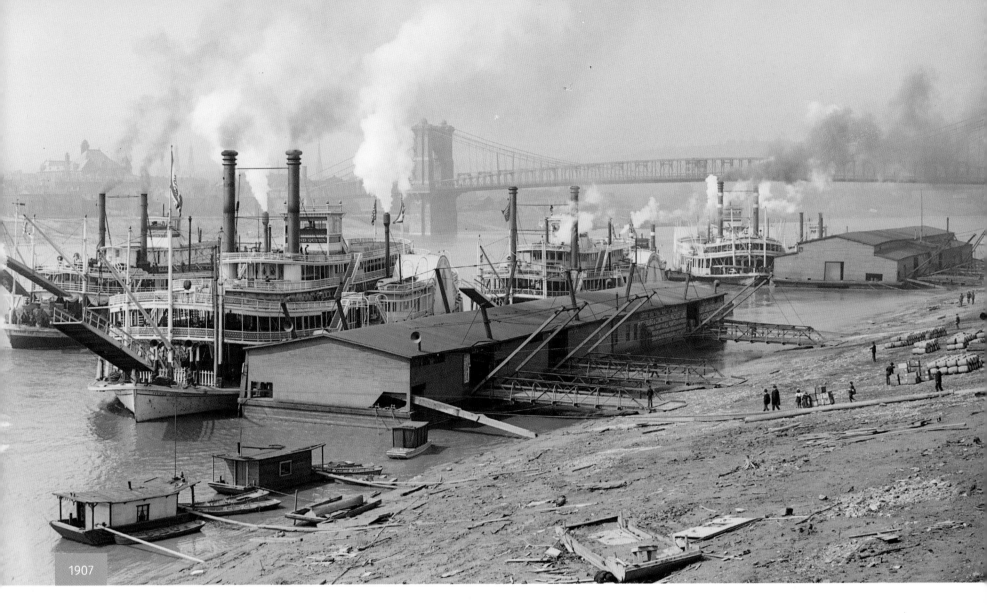

1907

PUBLIC LANDING

For a century this was the most important spot in the city

ABOVE: Since the city was founded, the Public Landing was meant for everyone to use. When Israel Ludlow laid out the first plat of Cincinnati (then called Losantiville) in 1789, he set aside the spot where the settlers had pulled ashore as a "common," or public landing. But the plat wasn't recorded until 1802. That same day, Joel Williams, another original settler, filed his own plan, which broke the Public Landing into lots, with the best spots for him. After a lengthy legal battle, the

courts sided with Ludlow's plan for a Public Landing south of Front Street, from Main Street to Broadway. As Cincinnati became a bustling river port city, thousands of steamboats a year docked at the Landing, a bare area that slanted to the river. Passengers descended gangplanks to get on board while stevedores unloaded cargo and wagons lugged goods into town. "For nearly a hundred years the life of the city pivoted about this two-block area," says *The WPA Guide to Cincinnati*.

1956

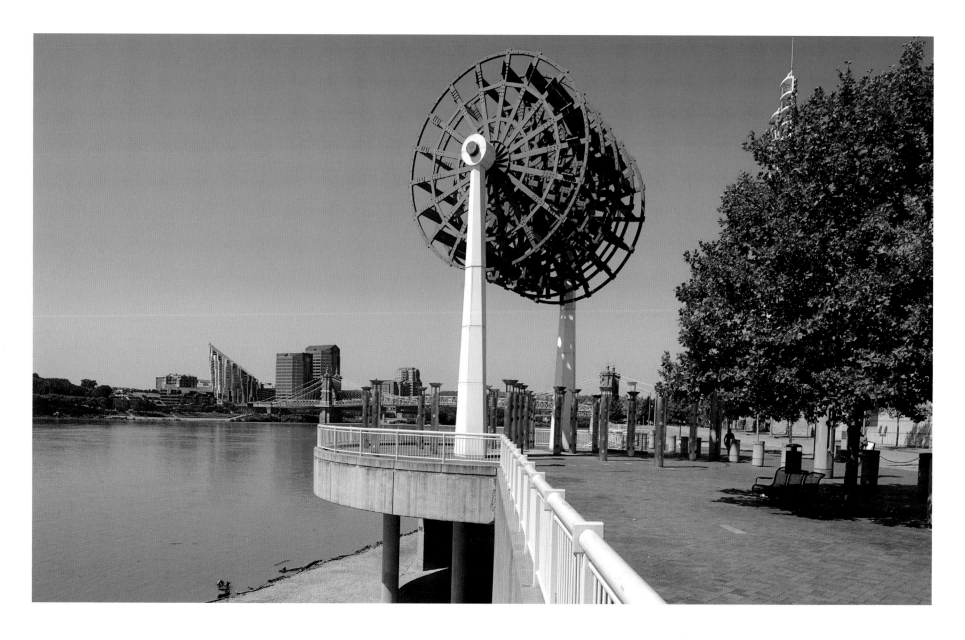

ABOVE: In 1967, the Public Landing was appropriated to build Riverfront Stadium as part of an effort to revitalize the riverfront. The city cited a 1911 Ohio Supreme Court ruling that allowed for the Public Landing to be taken for other public uses if the use is of superior importance. Evidently, baseball was more important than the landing. To compensate, the city created a "new Public Landing" one block east, from Broadway to the Central Bridge (replaced by the Taylor-Southgate Bridge). Local attorneys sued when the city began limiting parking on the Public Landing. They quoted the 1803 case over Ludlow's original plan, which defined the Public Landing as "a public common for the use of the citizens," and argued that the city was obligated to replace the landing with something of equal value with the same lack of restrictions. The courts disagreed. The paddle wheel outside Great American Ball Park is a tribute to the original Public Landing underneath.

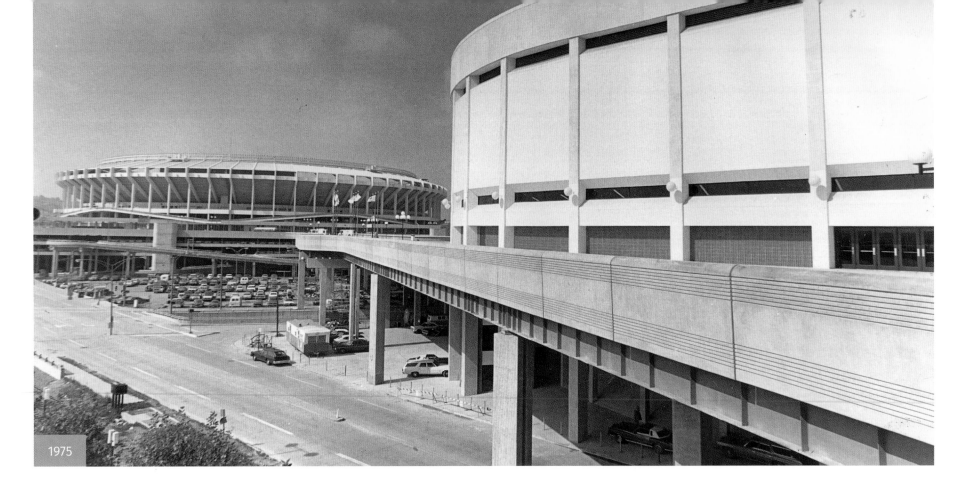

1975

RIVERFRONT STADIUM & RIVERFRONT COLISEUM

Fans didn't warm to their "cookie cutter" stadium

ABOVE: A sports arena located on the riverfront had been part of the city's 1948 master plan. Riverfront Stadium, pictured on the left, was completed in time to host the MLB All-Star Game in July 1970. Following the trend at the time, the concrete bowl had a field that converted for both baseball and football. Riverfront replaced the aging Crosley Field as home of the Reds. The Big Red Machine won back-to-back World Series championships in 1975-76. The 1990 Reds went wire to wire and clinched the title at home. The Cincinnati Bengals played the famous 1982 "Freezer Bowl" at Riverfront, which sent them to their first Super Bowl. A stone's throw away is Riverfront Coliseum, an indoor arena completed in 1975. The Coliseum hosted sports, shows, and concerts, notably Elvis Presley's next-to-last concert in 1977. Tragedy struck on December 3, 1979, at a concert for the British rock group the Who. The Coliseum's festival seating was first-come, first-served, and fans rushed the still-closed doors. In the crush of bodies people popped out of their shoes and eleven people were killed.

RIGHT: An aerial view of the riverfront in 1983.

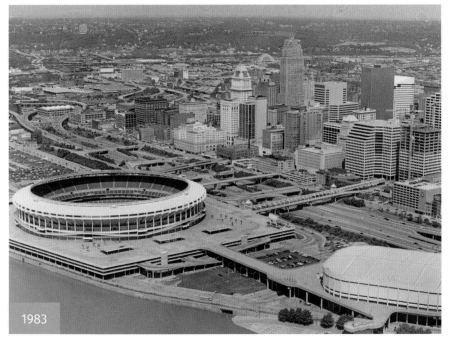

1983

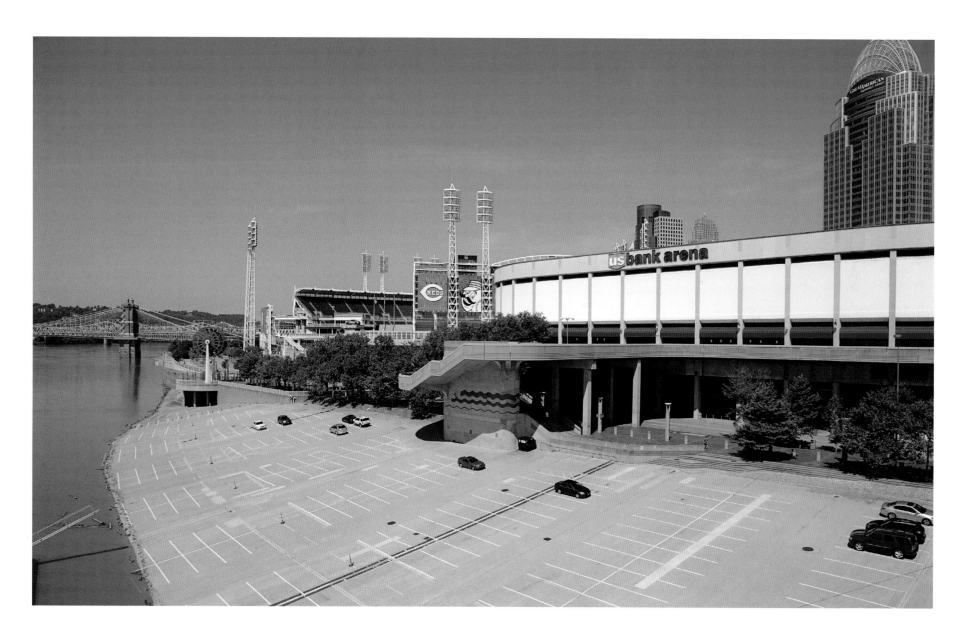

ABOVE: Despite the memories made on the field, no one seemed sorry when Riverfront Stadium, then known as Cinergy Field, was replaced after the 2002 baseball season. The Astroturf and uninspired bowl never connected with players or fans the way Crosley had. In the 1990s, fancy new ballparks were being built all over the country. The Bengals threatened to move out of town until taxpayers voted to pay for the new Paul Brown Stadium. After much debate, the Reds' new ballpark was built just outside Cinergy Field's outfield wall rather than in Broadway Commons, where the casino was later built. Great American Ball Park opened in 2003 and enjoys a riverboat theme because it's so close to the Public Landing, where steamboats used to dock. The banked landing is used for parking. Riverfront Coliseum went through several name changes; it has been U.S. Bank Arena since 2002. The arena hosts concerts and Cincinnati Cyclones hockey. The sorely outdated facility was blamed for the city missing out on hosting the 2016 Republican National Convention.

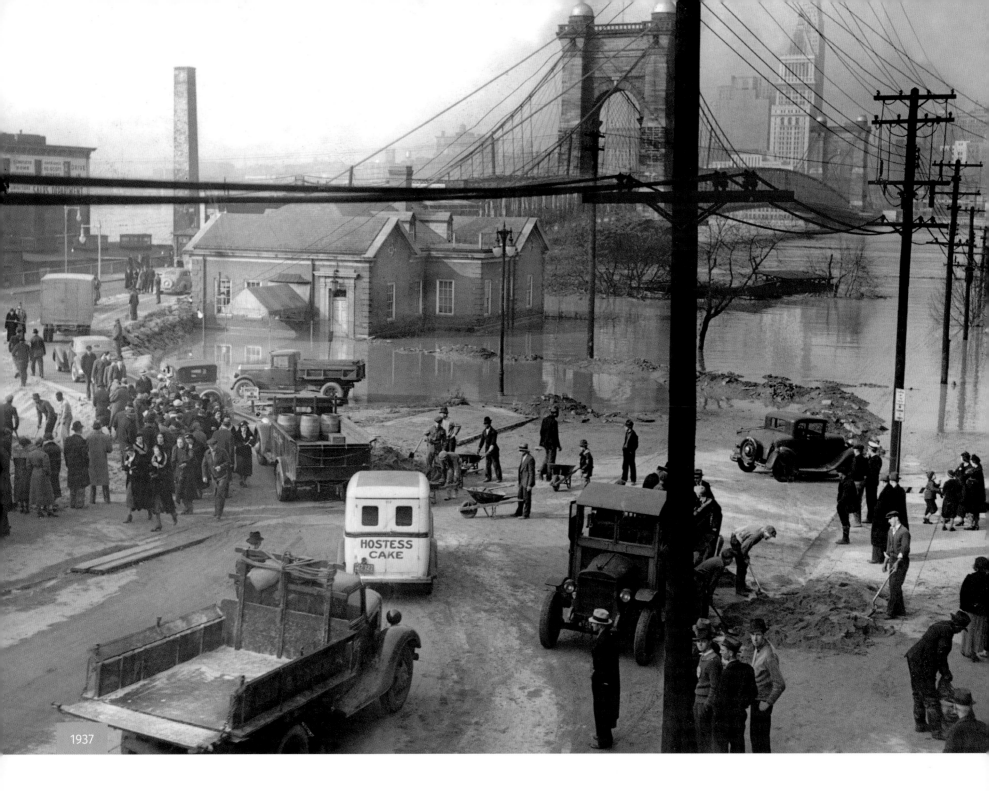

1937

1937 FLOOD
The Ohio River crested at 79.9 feet in the region's worst flood

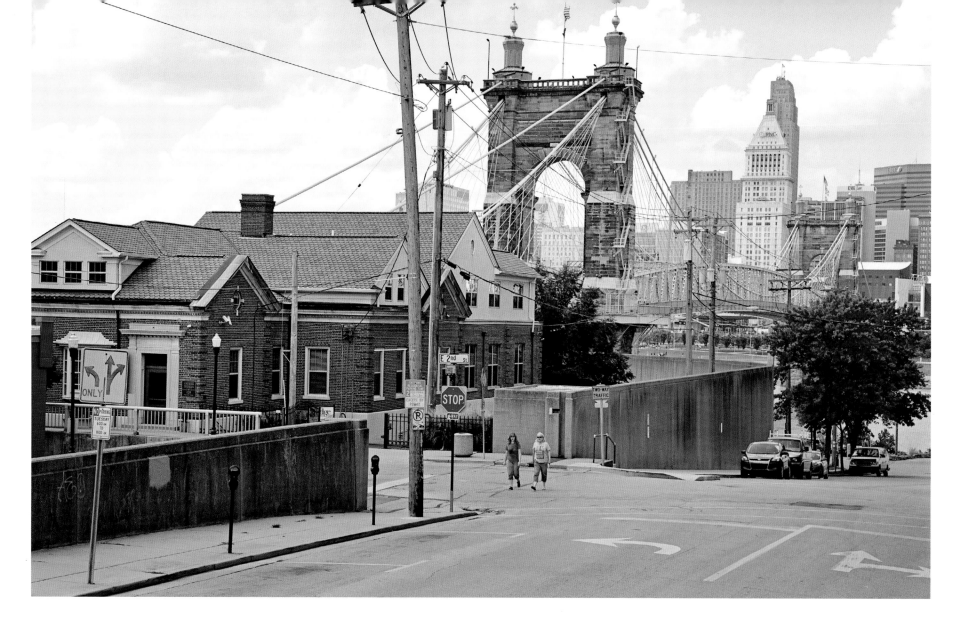

LEFT: Cincinnati is no stranger to flooding, but by any measure the 1937 flood was cataclysmic. Ten days of record rainfall in January left the swollen Ohio River out of control. Towns all along the river's path were devastated, resulting in $7.8 billion in damage and claiming 385 lives, including six locals. Every day the river rose higher, breaching the 52-foot flood stage on January 24. Sandbags couldn't hold back the water. On January 26, a day remembered as Black Sunday, floodwaters knocked over fuel storage tanks in Camp Washington, spilling a million gallons of petrol into the Mill Creek. A spark ignited an inferno along Spring Grove Avenue. Flames shot 150 feet high. Warehouses of flammables exploded, spewing black, toxic smoke in the air. The raging fire cut off telephones, natural gas, and electricity, and the drinking water went dry. Two days later, the Ohio River reached its highest peak ever: 79.9 feet. Lower downtown streets were under twenty feet of water. The water finally began to recede on January 29, and the recovery began.

ABOVE: The 1937 flood left its mark on Cincinnati. People remember. They share personal stories and photos of flooded streets. An aerial photo shows Crosley Field groundskeeper Matty Schwab checking out the flooded ballpark in a rowboat, while Reds pitcher Lee Grissom waves to the camera. Many lessons were learned as well. Floodwalls and levees have been added along both sides of the Ohio River to contain the water. Riverfront structures are built over parking garages that can be flooded. Every precaution has been made to ensure that such a disaster could not happen again, but nature thwarts all expectations. In March 1997, another major flood struck. Flash floods engulfed riverside towns in Ohio and Kentucky. The muddy-brown Ohio River reached 64.7 feet, spilling over Pete Rose Way. This wasn't as bad as 1937, but it was bad enough: $400 million in damages and twenty-four lives lost in Ohio and Kentucky. But the debris is cleaned up, and life goes on.

WESTERN & SOUTHERN LIFE INSURANCE BUILDING

The company has played a major part in the city's development

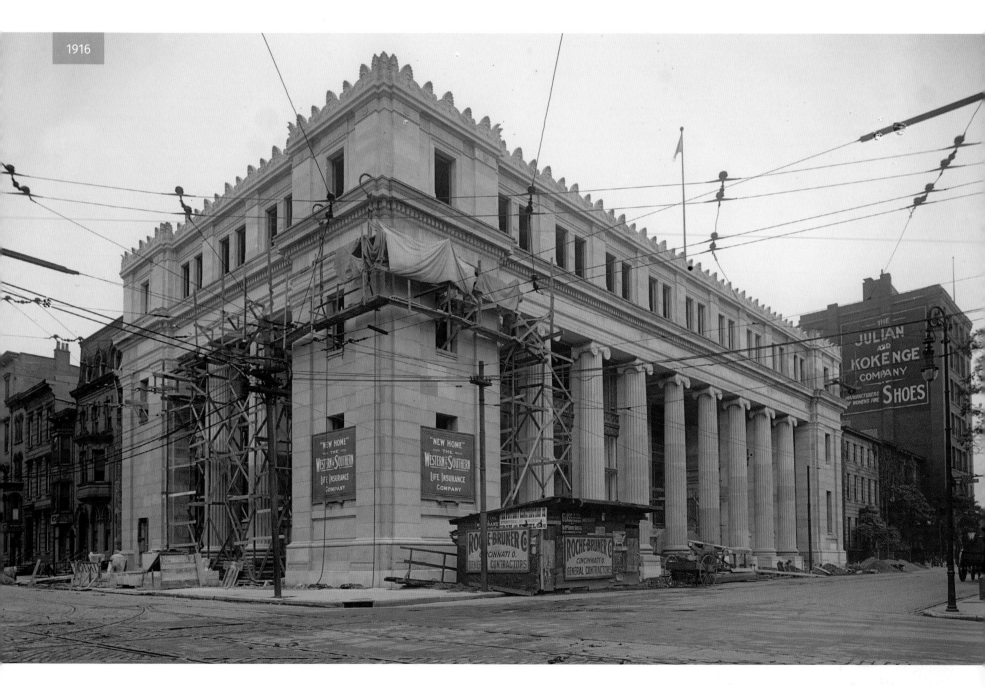

1916

LEFT: The "new home" of the Western & Southern Life Insurance Company was under construction at the northeast corner of Fourth and Broadway streets in 1916. The insurance company had been headquartered at that spot since 1901 when it occupied a three-story mansion, the former home of Edmund Dexter, a wealthy purveyor of whiskey. The home was torn down for the Beaux-Arts structure designed by Harry Hake and Charles H. Kuck. Although the building is only four stories tall, the massive Ionic columns evoke strength, exactly the impressive image needed for the Fourth Street financial district. William J. Williams formed Western & Southern in 1888, so named for its geographic location in western and southern Ohio. The company has diversified into investments, mutual funds, real estate holdings, and other forms of insurance, now all under the umbrella of Western & Southern Financial Group.

BELOW: The Western & Southern Building looks relatively unchanged in the last century. The sailing ship sculpture that seems to be launching between the columns is the building's one bit of whimsy in the otherwise buttoned-up financial district. Western & Southern has been closely involved in the city's development and direction. The late CEO William J. Williams, nephew of the founder, was a co-owner of the Cincinnati Reds in the early 1980s, and a founding partner of the Cincinnati Bengals. The company sponsors the WEBN Riverfest fireworks, and they built the Great American Tower at Queen City Square. Over the last several decades, Western & Southern has been molding the historic Lytle Park district by funding major renovations of the park and digging out the I-71 Lytle Tunnel, but also using its clout to alter historic boundaries for development and relocating the Anna Louise Inn shelter house for women.

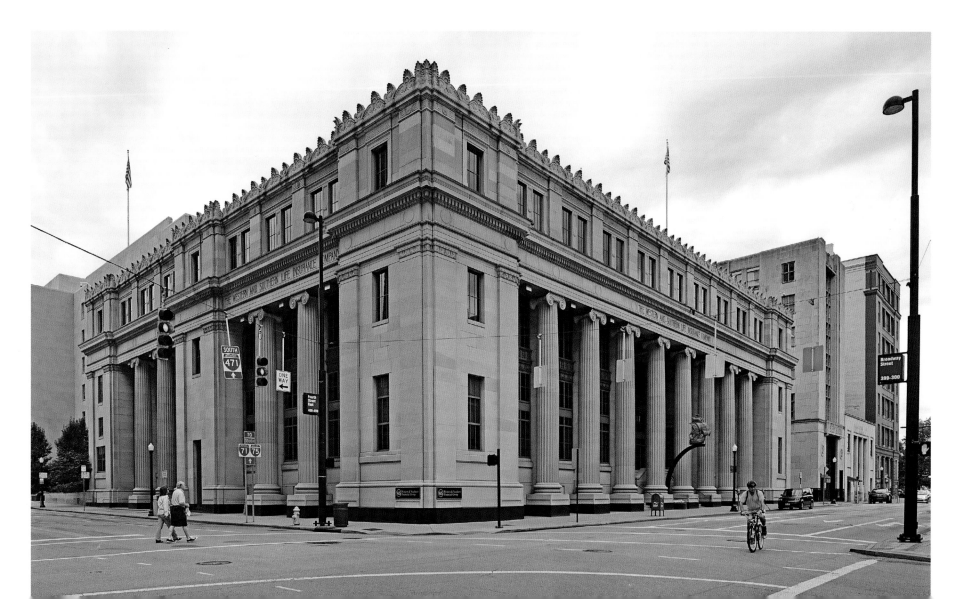

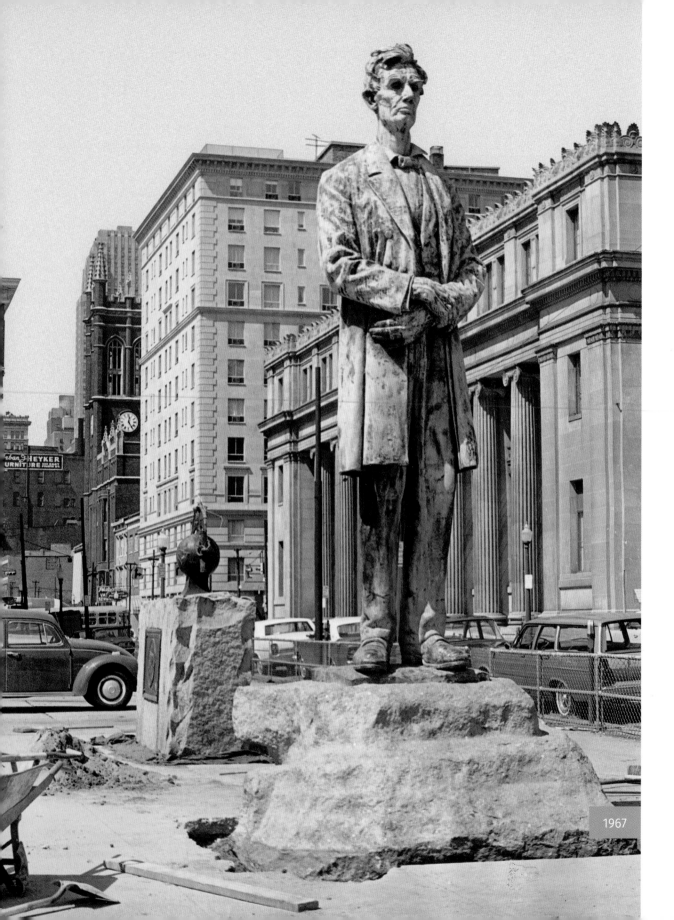

1967

LYTLE PARK

Lincoln's son described his father's statue as "grotesque"

LEFT: Lytle Park is a quiet refuge along East Fourth Street named for the Civil War hero and poet General William Haines Lytle. His grandfather purchased the land in 1806 and built one of the first brick homes in the Northwest Territory. General Lytle was killed in battle in 1863. City Councilman Mike Mullen, one of Boss Cox's cronies, used his influence to turn the land into a public park in 1907, then, despite vociferous protests, pushed to have the 100-year-old Lytle mansion torn down as well. The eleven-foot-tall statue of Abraham Lincoln, a gift from Charles and Anna Taft in 1917, was also controversial. Artist George Grey Barnard depicted Lincoln as a tall, gangly fellow, beardless, with oversized hands and feet. Critics around the country complained that it looked like a caricature. Robert Todd Lincoln, the president's son, called the statue "a monstrous figure, which is grotesque as a likeness of President Lincoln and defamatory as en effigy." Cincinnatians, though, have embraced the statue, which was carefully set aside during renovations to Lytle Park in 1967.

RIGHT: The Lytle Park Historic District has deep connections to the city's earliest days. Fort Washington was built here in 1789 to protect the first settlers against Native Americans. Excavators working on a parking garage in 1952 uncovered the remnants of the fort's gunpowder magazine. A plaque outside the old Guilford School on Fourth Street marks the site of the territorial fort. Some of the city's earliest prominent citizens lived in stately homes in the area that now surrounds the park. Western & Southern Financial Group has invested heavily in Lytle Park. They financed the construction of Lytle Tunnel in the 1960s, which meant tunneling through a section of the park. In 2017, Western & Southern agreed to donate money for another remodel that would move the Lincoln statue across to Fourth Street and add a decorative fountain and walkways.

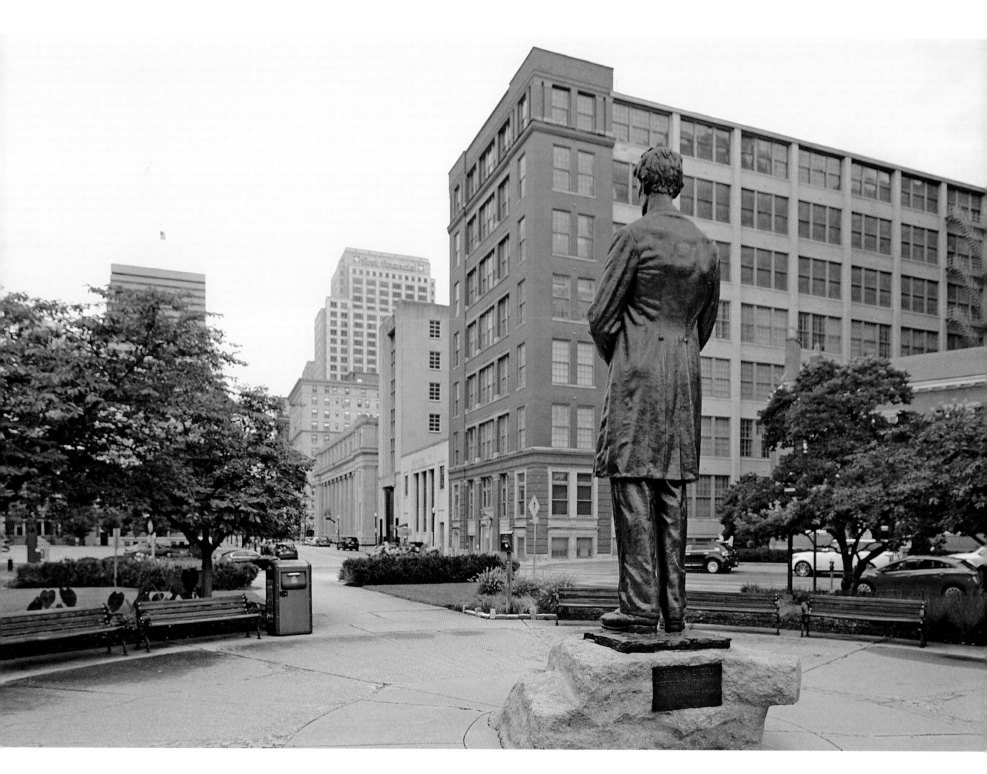

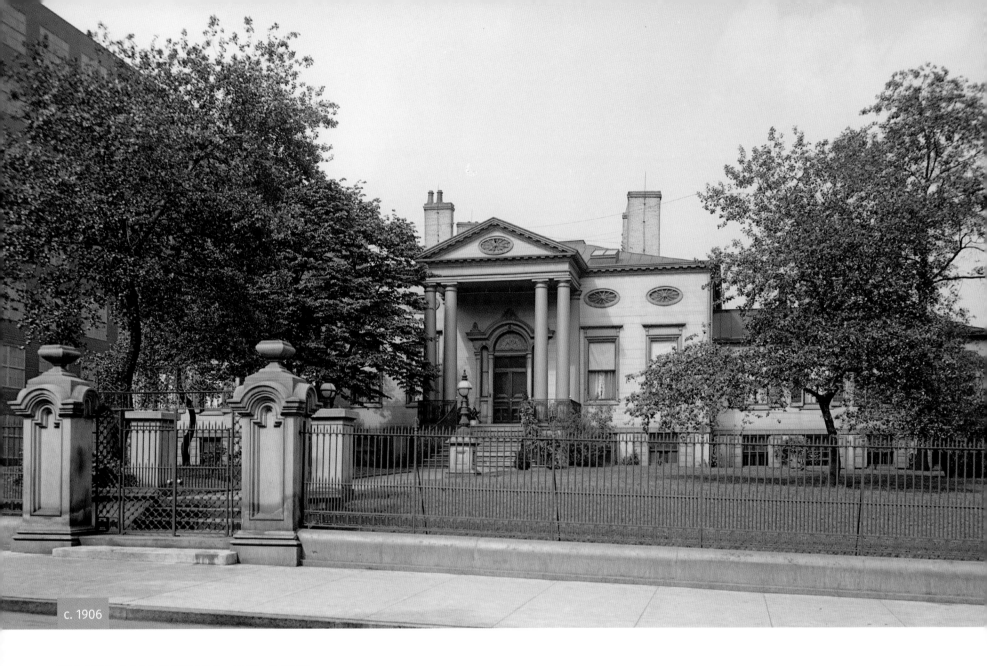

c. 1906

TAFT MUSEUM OF ART
This historic home plays host to a fine-art collection

ABOVE: Although the house bears their name, the Tafts were the last in a line of prominent Cincinnatians to live in the house. It was built on Pike Street in 1820 for local merchant Martin Baum, and today is the last of the stately homes from the city's early residents. The Federalist home has a central hall resting on a half-story basement. Almost as soon as it was completed Baum attempted to sell due to an economic downturn. Nicholas Longworth purchased the home in 1829, and added the wings and other upgrades over thirty years. Among the additions were the gorgeous landscape murals in the entrance painted by African-American artist Robert S. Duncanson around 1850. Wealthy industrialist David Sinton bought the home in 1871. His daughter Anna Sinton married Charles Phelps Taft in the Music Room, and the couple lived in the house with Sinton. In 1908, Taft's half-brother, William Howard Taft, accepted the nomination for president under the house's portico, and spent Election Day there awaiting the results sent by telegraph directly to the veranda.

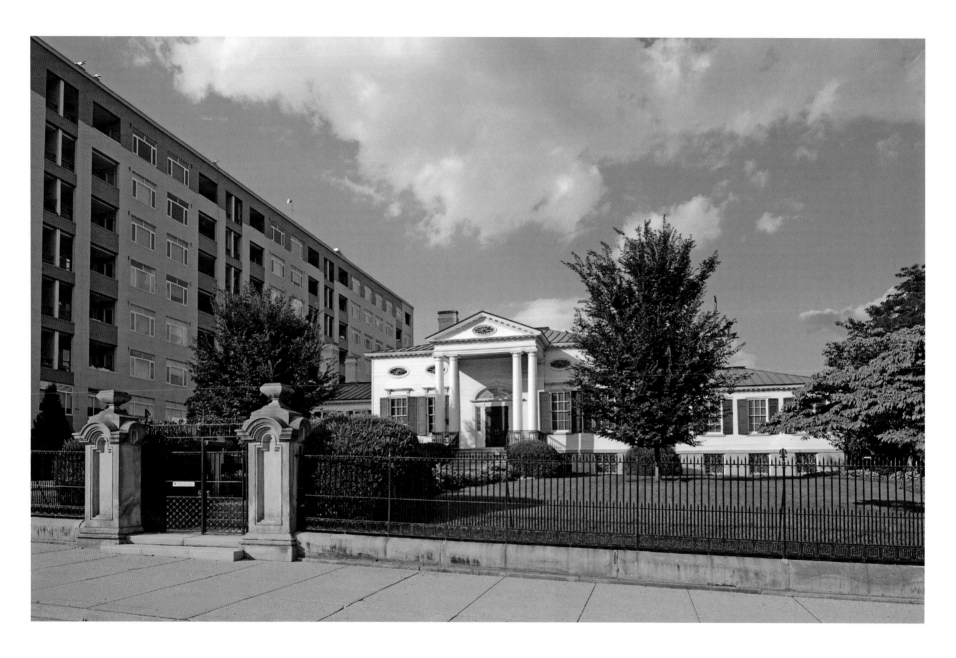

ABOVE: Charles and Anna Taft used the "architecturally eclectic" house as a showcase for their large fine-art collection. They also wished to preserve the residential feel of the area, so in 1927, the Tafts bequeathed the house and the 690 works of art to the people of Cincinnati. The house was remodeled and opened in 1932 as the Taft Museum of Art. The museum is part art museum, part historic home, beautifully restored to its nineteenth-century grandeur as a National Historic Landmark. The Duncanson murals are a rare treat to be found in their original setting. By having the art collection hanging on the walls, it feels as though patrons are visiting the Tafts' home and admiring their personal collection. The collection includes works by Rembrandt, Thomas Gainsborough, James Abbott McNeill Whistler, and John Singer Sargent, as well as top local artists Frank Duveneck and Henry Farny.

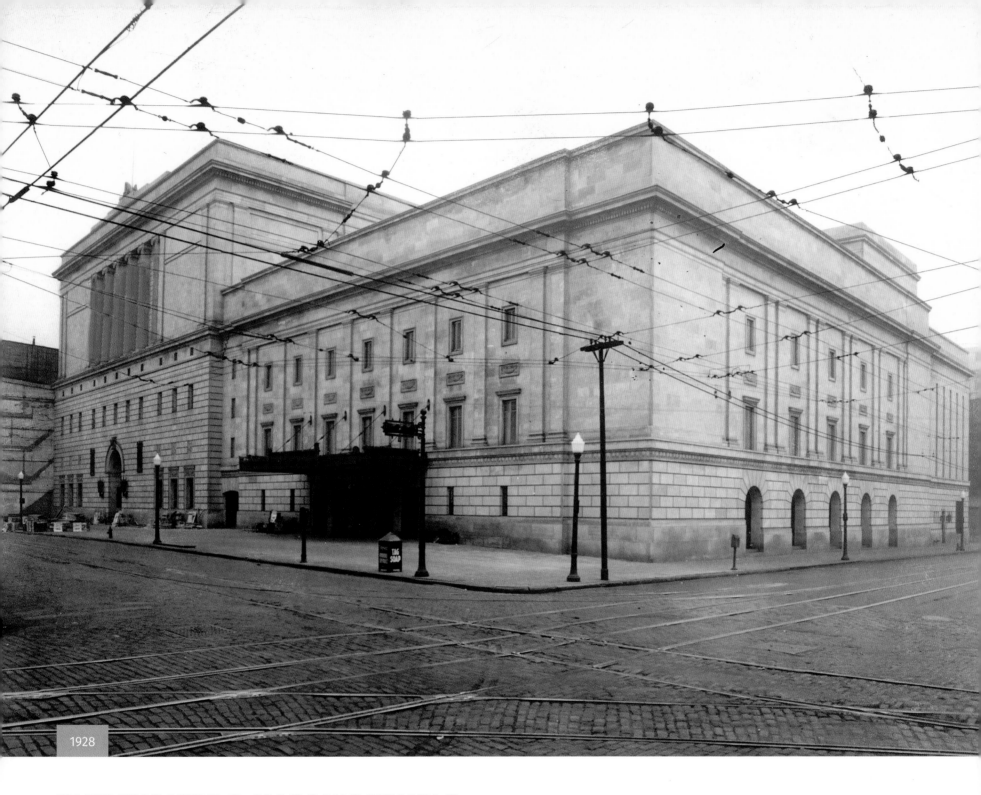

1928

TAFT THEATRE & MASONIC TEMPLE
The versatile auditorium was built as part of the Masonic center

46

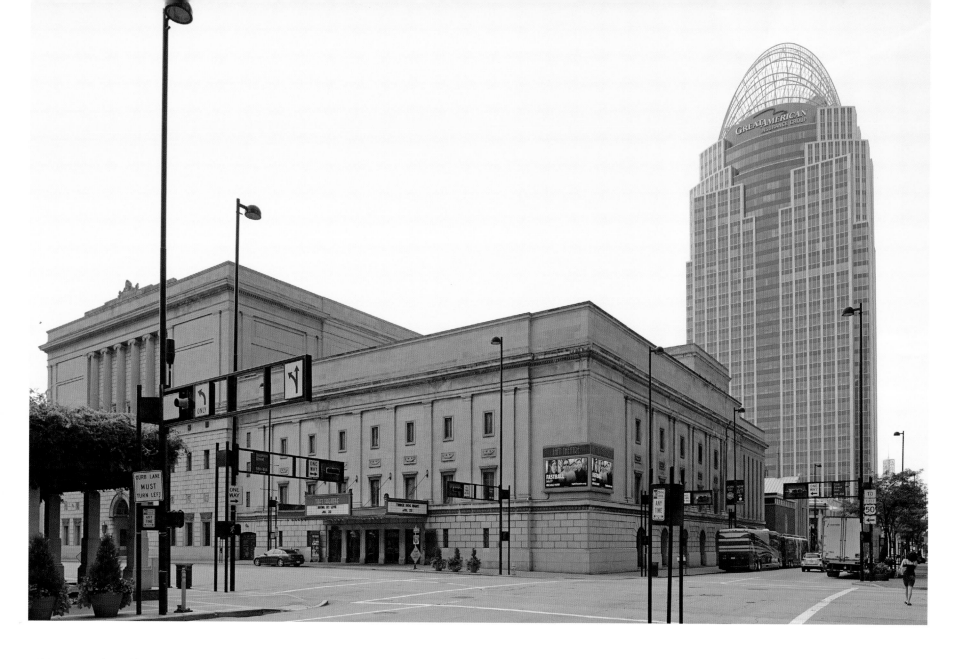

LEFT: Few people realize that the Taft Theatre is actually part of the Masonic Temple on East Fifth Street between Sycamore and Broadway. In 1916, Cincinnati's eighteen Masonic groups organized to construct a new temple as a replacement for the Gothic-style temple built by James W. McLaughlin and John R. Hamilton at Third and Walnut in 1859. The new Beaux-Arts limestone structure was designed by Harry Hake and Charles H. Kuck, and built by the Scottish Rite Freemasonry. The building is in three parts—a Masonic Temple in the middle, the Scottish Rite Cathedral in the east wing, and the Taft Theatre in the west wing, on the corner of Sycamore. The Masonic Temple and Taft Theatre opened in 1928. A planned Syrian Shrine Mosque was never built. The 2,500-seat Taft Theatre was named for Charles Phelps Taft, who had served as the general honorary chairman of the building committee.

ABOVE: The Taft Theatre, the last of the splendid downtown theater palaces, was remodeled in 2011, so it was the perfect temporary home for the Cincinnati Symphony Orchestra during the renovation of Music Hall in 2016 and 2017. The Taft presents concerts and is also the performance venue for the Children's Theatre of Cincinnati. It was the home for the Broadway touring series before the Aronoff Center opened in 1995. Both the Cincinnati Masonic Temple and Taft Theatre are still owned by the Scottish Rite of Freemasonry. Towering over them—in fact, towering over all other Cincinnati buildings—is the Great American Tower at Queen City Square, which opened in 2011 on East Fourth Street. According to the tower's architect, Gyo Obata, the distinctive "crown" (actually a diadem) that makes the building the tallest in the city, topping 665 feet, was inspired by Princess Diana's tiara.

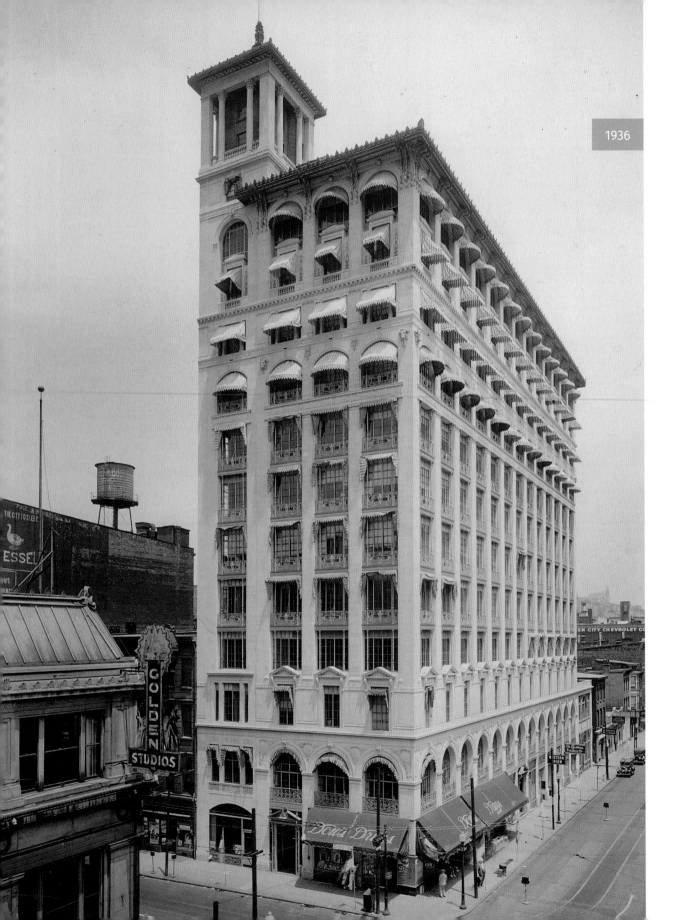

1936

GWYNNE BUILDING
The Vanderbilt fortune helped build the former P&G headquarters

LEFT: This elegant Beaux-Arts building at Sixth and Main streets is the Gwynne Building, completed in 1914. Although too fine a detail to see in this 1936 photo, the decorative grillwork alternates the initials G and V for Alice Gwynne Vanderbilt, a Cincinnati native married to New York socialite Cornelius Vanderbilt II. The Vanderbilts had sent Alice's cousin Ernest Flagg to study at the École des Beaux-Arts in Paris, and he became a prominent New York architect. His Singer Building in Manhattan has the dubious distinction of being the tallest building ever demolished. In 1914, Alice Vanderbilt commissioned Flagg to design a building in her hometown. It's named for her father, Judge Abraham Gwynne. The storefront is Dow's Drugs, one of a chain of drugstores in Cincinnati run by Cora M. Dow, a rare female pharmacist and entrepreneur for the times. Dow owned eleven drugstores, but she had always wanted to be an opera singer, so upon her death in 1915 she willed her fortune to the Cincinnati Symphony Orchestra.

RIGHT: The Gwynne Building stands on the same corner where candle maker William Procter and soap maker James Gamble had built their first business partnership in 1837. As a tribute to their company origins, Procter & Gamble leased and eventually purchased the Gwynne Building, which they used as their corporate headquarters from 1914 until 1956 when they moved to the Central Building one block east. Since that time, the Gwynne Building has been used as offices. In 1992, the Richter & Phillips Company purchased the building where they had occupied the street-level storefront since the 1970s. The family-owned diamond and jewelry shop started in downtown Cincinnati in 1896, and has been owned by the Fehr family since 1930. Richter & Phillips sold the building and moved across the street in 2015. Although the historic Gwynne Building may not get the attention of the other Ernest Flagg designs, or even much notice within Cincinnati, it is one of the city's handsomest buildings.

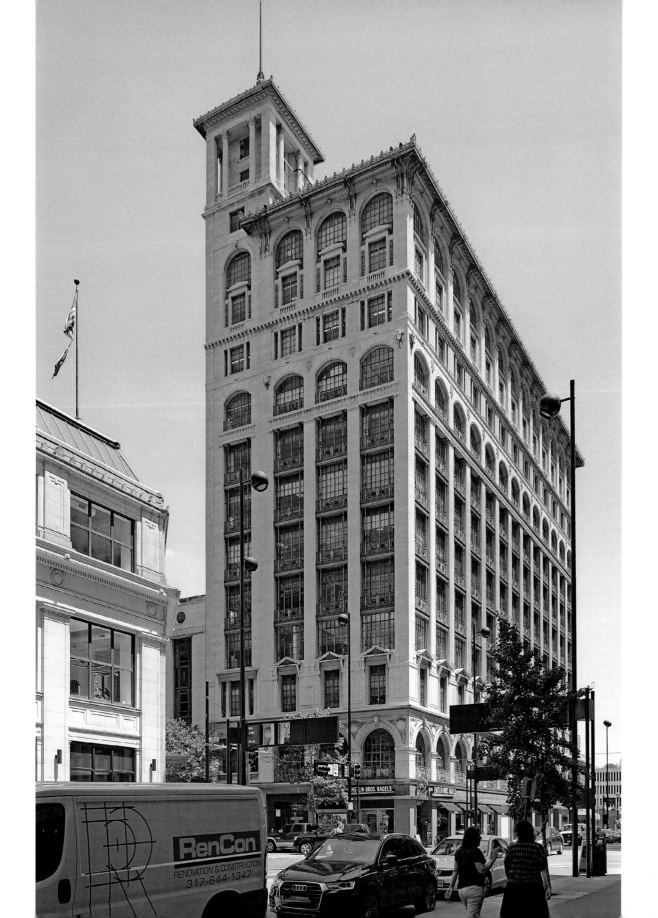

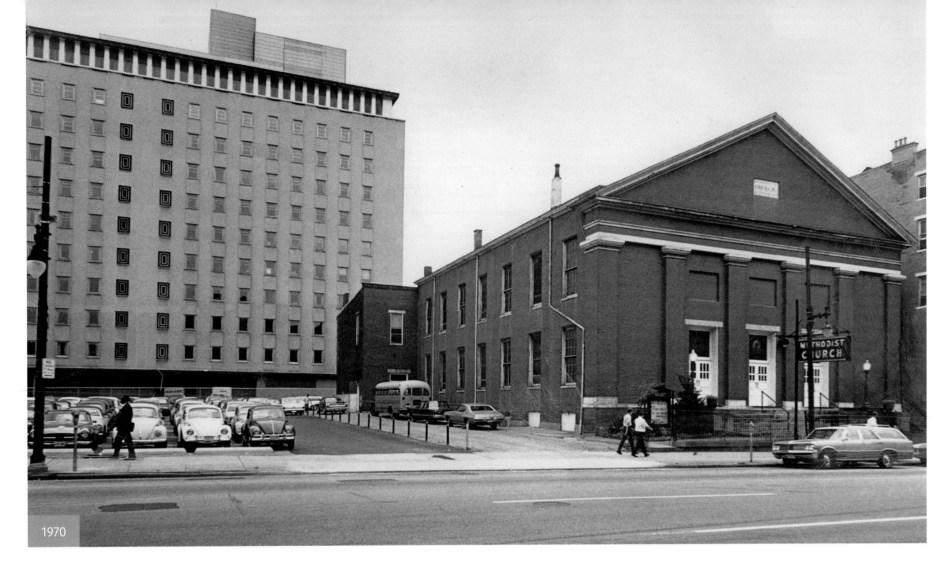

WESLEY CHAPEL / PROCTER & GAMBLE

Cincinnati's oldest church was torn down for P&G headquarters expansion

ABOVE: In 1970, Procter & Gamble's Central Building headquarters loomed over the little red-brick Methodist church, a portend of the fate of the historic Wesley Chapel. The church was built in 1831 on Fifth Street between Broadway and Sycamore to replace Old Stone Church, the city's first Methodist house of worship. The Gregorian-style church was modeled after John Wesley's original Methodist chapel in London, and seated 1,200, making it the largest meeting place in the West. In 1843, former President John Quincy Adams spoke at Wesley Chapel after laying the cornerstone for the new observatory on Mount Ida (now Mount Adams).

Although large for its day, 140 years later Wesley Chapel was tiny compared to downtown skyscrapers. P&G bought up several city blocks of buildings, including Wesley Chapel, to expand their corporate headquarters. The company offered to relocate the church building, but the small congregation opted to move to an odd round concrete building in Over-the-Rhine. Wesley Chapel was torn down in the middle of the night in 1972.

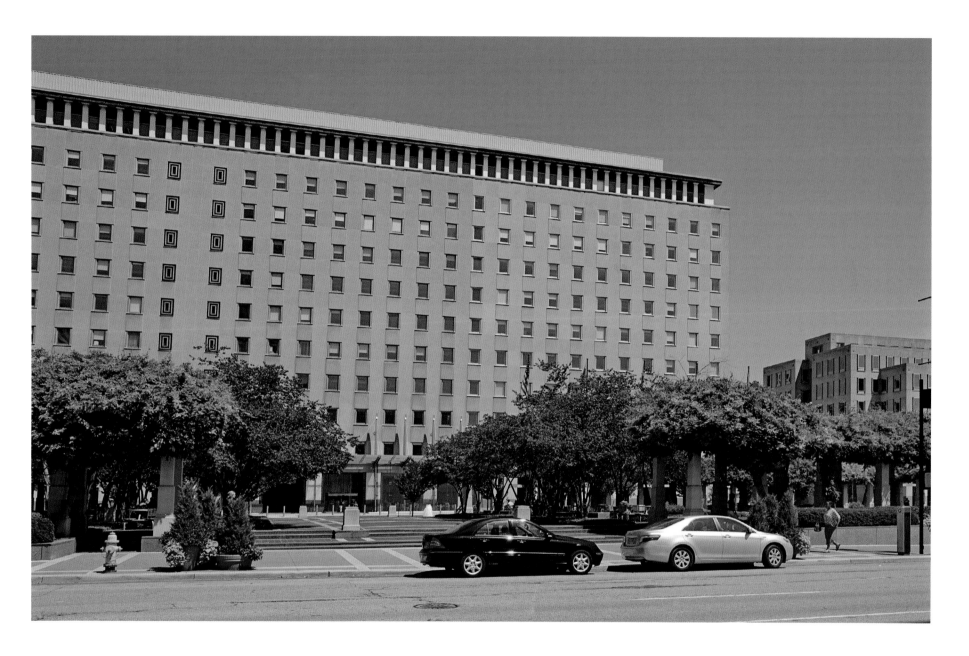

ABOVE: Procter & Gamble, the leading producer of Ivory Soap, Pampers diapers, and Tide laundry detergent, moved their headquarters from the Gwynne Building to the eleven-story modernist Central Building, now known as One Procter & Gamble Plaza, in 1956. It is not surprising that a company so dedicated to branding would find a more suitable statement with their expansion. The Postmodern P&G towers, completed in 1985, were designed by Kohn Pedersen Fox, a firm from New York. The twin seventeen-story towers are distinctive while also being harmonious with the rest of the city's skyline. What makes the P&G headquarters more inviting is the inclusion of a garden park. The pleasant green spaces are nice spots for downtown workers to eat their lunch, or walk down the shaded walkways entwined in wisteria. The park extends along Fifth Street to the site of the old Wesley Chapel.

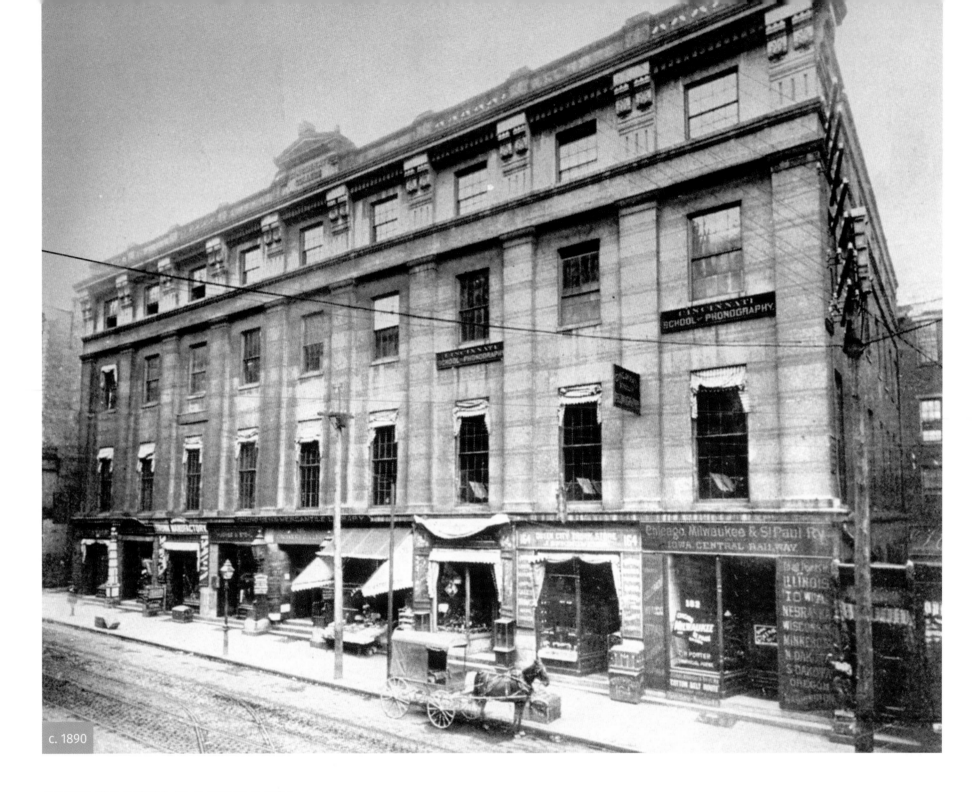

c. 1890

MERCANTILE LIBRARY

The city's oldest library has an extraordinarily long lease

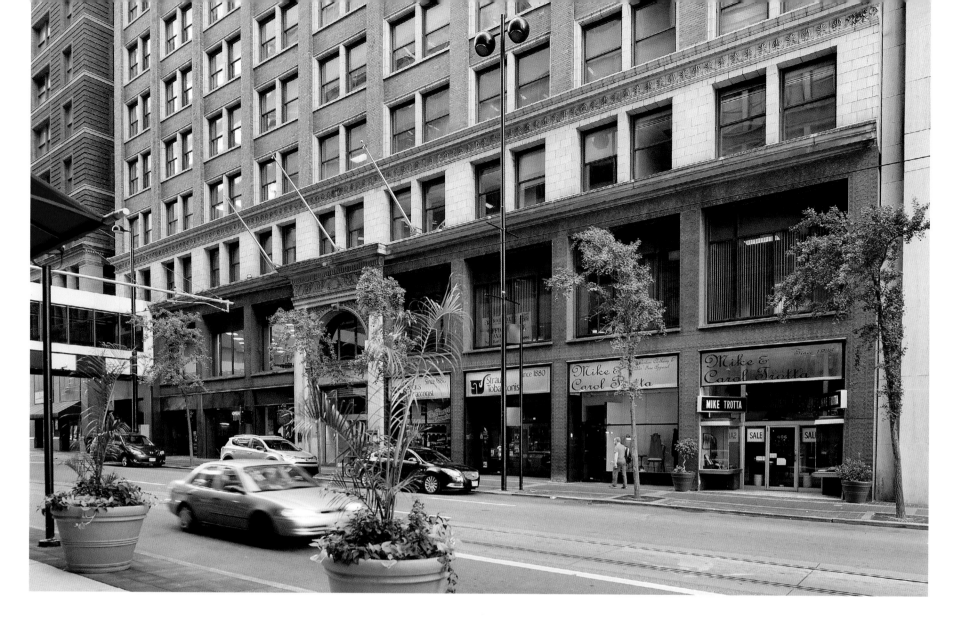

LEFT: In 1835, forty-five local merchants and clerks, including future President William Henry Harrison, founded the Young Men's Mercantile Library Association to establish a subscription library. In 1840, the Mercantile Library moved into the second floor of the Cincinnati College building on Walnut Street, above Fourth, a site that has remained the library's home ever since. The Cincinnati College was chartered in 1819 and would merge with the University of Cincinnati in 1918. The Mercantile Library's collection was fortunate to survive two disastrous fires that twice wrecked the college building, in 1845 and 1869. After the first fire, the Mercantile Library paid Cincinnati College $10,000 in advance rent in order to assist in rebuilding, so the college granted them a 10,000-year lease, renewable forever. The lease was drafted by Alphonso Taft, the father of President William Howard Taft. Also in the Cincinnati College building circa 1890 was the Cincinnati School of Phonography, which taught Pitman shorthand, developed by Sir Isaac Pitman and brought to Cincinnati by his brother, artist Benn Pitman.

ABOVE: In 1902, the Cincinnati College offered the property to the library to construct their own building. The Mercantile Library Building at 414 Walnut Street was completed in 1908. The library occupies the eleventh floor with meeting space on the twelfth. The interior of the library is a bibliophile's dream—shelves of old books, some dating to the earliest days of the library. Large windows allow plenty of natural light. Perched on shelves are busts of presidents, statesmen, and even a young and beardless Charles Dickens, appearing as he did when the author visited Cincinnati on his American tour of 1842. The Mercantile Library is the oldest library in the city, and one of the last subscription libraries in the country. Over its history, the Mercantile has hosted speeches from such distinguished authors as Herman Melville, Harriet Beecher Stowe, and William Thackeray. Today, the library's collection holds nearly 80,000 volumes, including ebooks and graphic novels.

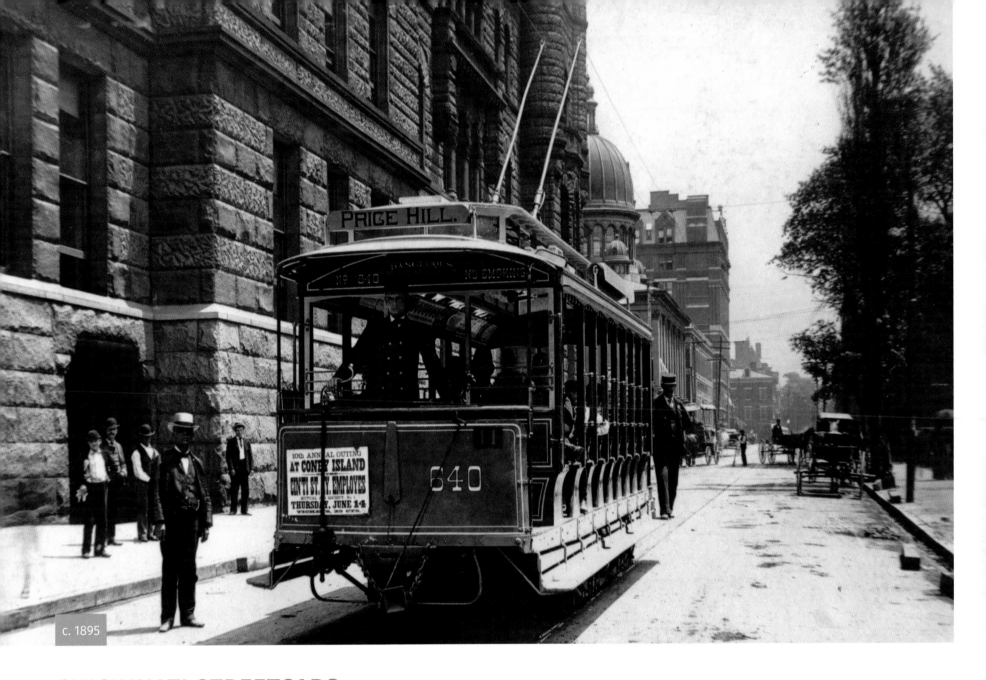

c. 1895

CINCINNATI STREETCARS
Public transportation spurred development then and now

ABOVE: Cincinnati's streetcars rolled into the car barn for what was thought to be the last time on April 29, 1951. Track-bound streetcars had been phased out for quieter, more maneuverable buses. Cincinnati's hills were problematic for public transportation. Horse-drawn omnibuses had been the first solution in 1850, but the steep hills were too tiring for the horses to climb with a load of passengers. Steam "dummy" cars, like the line in Mount Lookout, were often volatile and spooked horses.

Starting in 1872, the inclines finally solved the hill problem, and it wasn't long before they were incorporated into streetcar routes. The first electric streetcar line ran down Colerain Avenue in 1889. Soon a spider web of streetcar lines over two hundred miles long spread across the city and neighborhoods, carrying folks from home to work to ballgames and everywhere in between. A streetcar bound for Price Hill is pictured outside City Hall about 1895. By 1950, Americans craved the freedom of their cars.

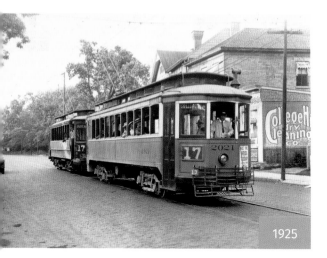

1925

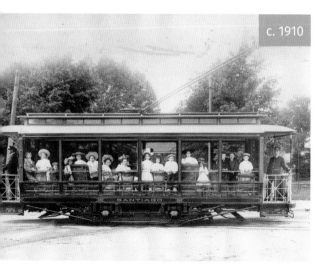

c. 1910

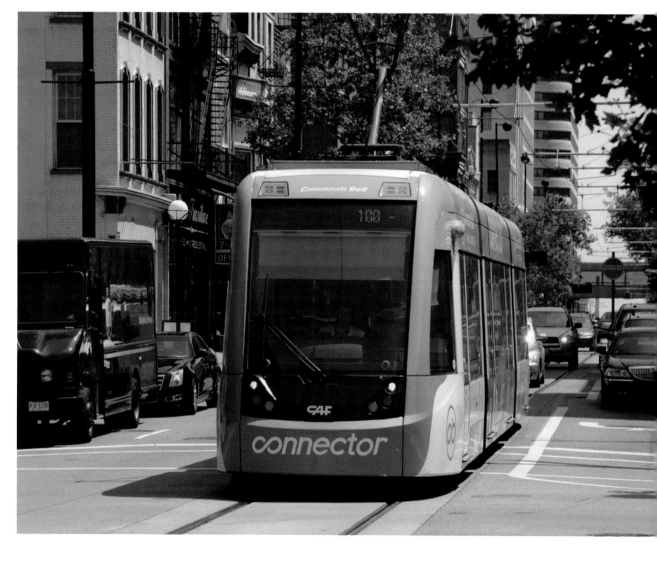

TOP: An electric streetcar on the College Hill route in 1925.

ABOVE: The "Santiago" open-air parlor car takes children to the Cincinnati Zoological Gardens about 1910.

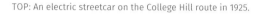

ABOVE: Times change. Cincinnati's urban core has attracted new interest from people wanting to live in a walkable city. Reliable rapid transit has been touted as the way to spur development along the fixed track route. Despite years of political squabbling and two referendums, construction of a new streetcar line finally began in 2012. The original plan to connect downtown all the way up to the University of Cincinnati was scaled back. Phase one runs a 3.6-mile route from the Banks near the stadiums to Findlay Market in Over-the-Rhine, running past Fountain Square, the public library, the Aronoff, and Music Hall along the way. The Cincinnati Bell Connector, named for the telephone company sponsor, is operated by SORTA, which runs the Metro buses. The sleek streetcar looks more like a commuter train than a touristy Victorian trolley or bus. The inaugural ride was on September 9, 2016. The cost is one dollar for two hours, or two dollars for the day.

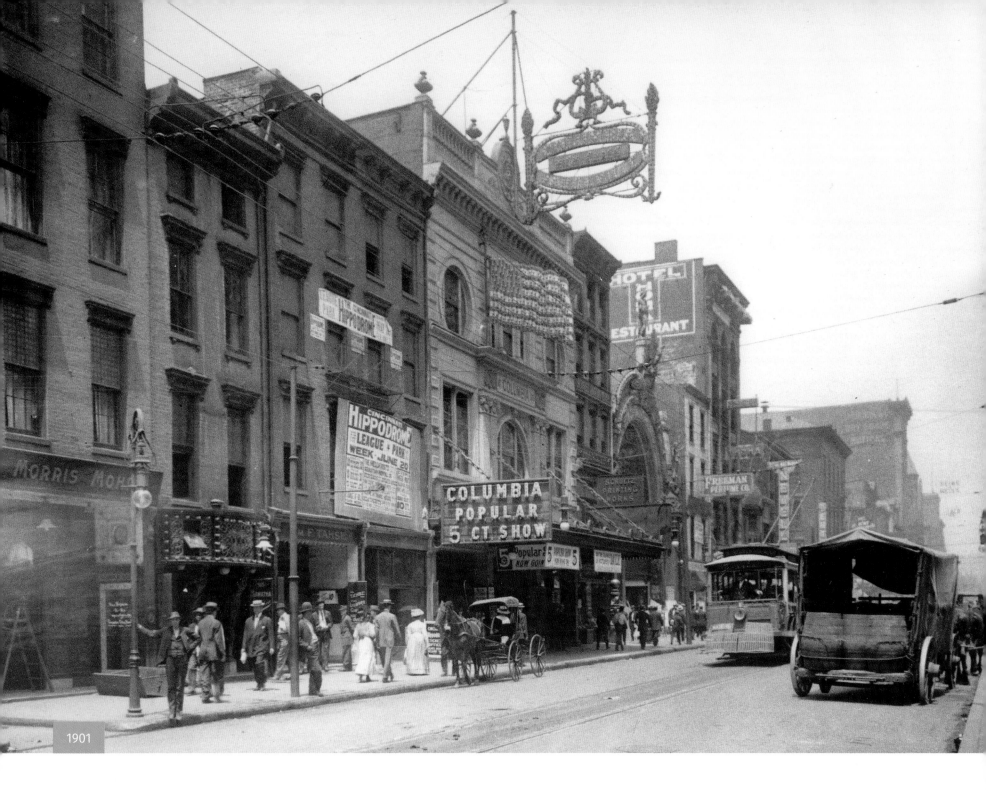

1901

COLUMBIA THEATRE

From a popular vaudeville venue to a Fountain Square garage

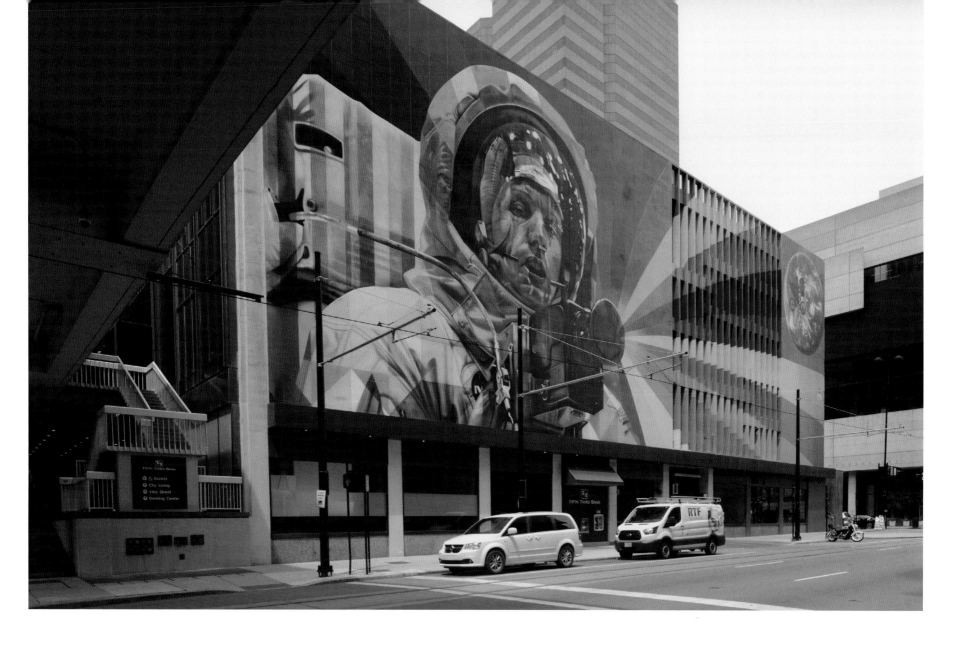

LEFT: There were a number of theaters along the two city blocks between Vine and Walnut streets, from Fountain Square to Seventh. The Columbia Theatre, pictured about 1901, was not the original stage at that location on the east side of Walnut, just north of Sixth. The Fountain Square Theater opened on that spot in 1892. Designed by James W. McLaughlin, the theater had a peculiar orientation with the opening facing Lodge Alley rather than Walnut, making it difficult to attract patrons. In 1899, Max C. Anderson turned the entrance around and rechristened it the Columbia Theatre. A decorative Columbia sign and an American flag were strung up with electric lights. Anderson ordered another reconstruction in 1909 by acclaimed theater designer J. M. Wood. The new theater was classical and elegant with a marble stairway and beautiful mahogany doors. The next year the theater was sold to Benjamin Franklin Keith, the "K" in RKO, and the name was changed to B. F. Keith's Theatre.

ABOVE: In 1921, the Keith's Theatre was encased within the lobby of a handsome twelve-story office building designed by Rapp & Rapp of Chicago, the premier theater architects of the day. Bowing to trends, it switched from vaudeville to "photoplays," as indicated by the blazing marquee sign. As was the case for all the downtown movie houses, suburban theaters and drive-ins cut into business. In 1959, Keith's was refitted with a Todd-AO screen, a curved screen similar to Cinerama that showed 70mm films in wide angle to make the audience feel like they were in the movie. It was too little, too late. The Keith Theatre Building was torn down in 1966 to make way for the remodeled Fountain Square. A colorful Neil Armstrong mural adorns a wall on Walnut Street near the spot. The first man on the moon, a native of Wapokoneta, Ohio, taught aerospace engineering at the University of Cincinnati in the 1970s after leaving NASA. He spent the last forty years of his life in Lebanon and Indian Hill.

CONTEMPORARY ARTS CENTER

The arts center building bolsters the city's arts reputation

1983

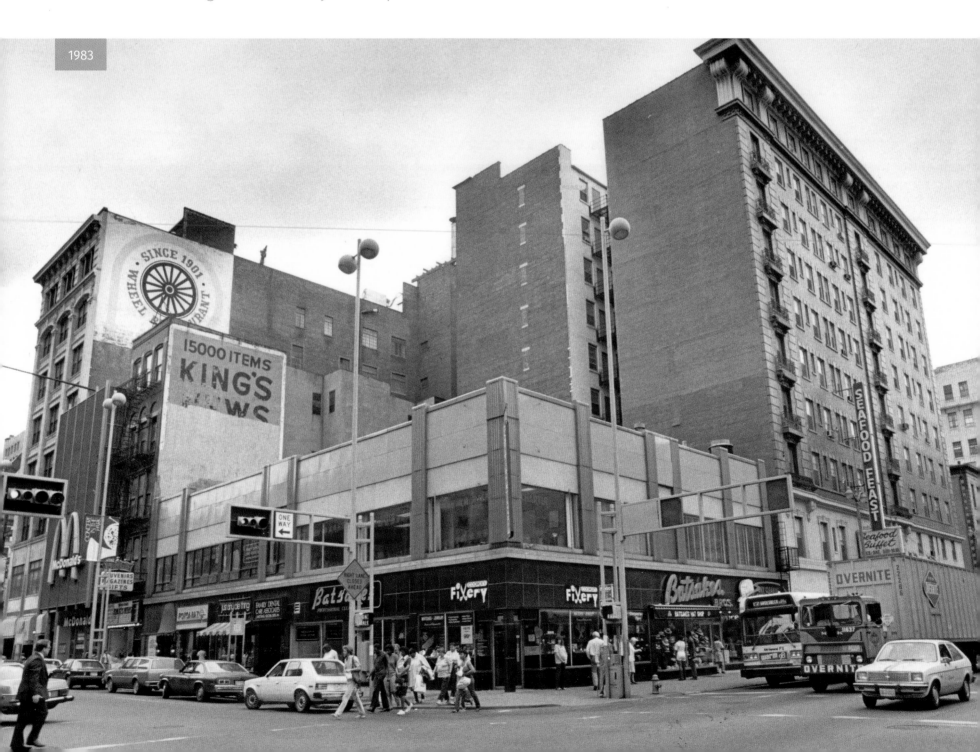

LEFT: In 1983, the corner of Sixth and Walnut streets hosted a variety of businesses: the Wheel Restaurant, a popular lunch spot that had been open since 1901; Batsakes Hat Shop, whose clients included Luciano Pavarotti; and the Seafood Feast buffet in the old Metropole Hotel. Back in 1919, the Reds hung out at the Metropole after playing the Chicago White Sox in the World Series. Right outside the hotel Reds outfielder Edd Roush got word that gamblers had paid several White Sox players to throw the series. In later years, the Metropole was used as Section 8 housing. Publisher Larry Flynt turned King's News into a Hustler store in 1997, a poke in the eye to Hamilton County for convicting Flynt on obscenity charges for selling *Hustler* magazine twenty years earlier. The conviction was overturned on appeal. Much of this was torn down in 2000 to make way for the Contemporary Arts Center (CAC).

BELOW: The CAC's Lois and Richard Rosenthal Center for Contemporary Art garnered international attention when it opened in 2003. Acclaimed Iraqi-British architect Zaha Hadid became the first woman to design a major art museum in America. The building itself is contemporary art. From outside it appears as blocks of concrete, black aluminum, and glass stacked unevenly like an enormous puzzle. The atrium has a black zigzagging staircase. The CAC was founded as the Modern Art Society in 1939. In 1990, Hamilton County prosecutors charged CAC director Dennis Barrie with obscenity for exhibiting Robert Mapplethorpe's controversial photo collection that included explicit gay images. Cincinnati had a reputation as a "cultural backwater," but a jury of everyday Cincinnatians found Barrie not guilty. Now, the CAC anchors an arts corner, with the Aronoff Center for the Arts and 21c Museum Hotel in the former Metropole.

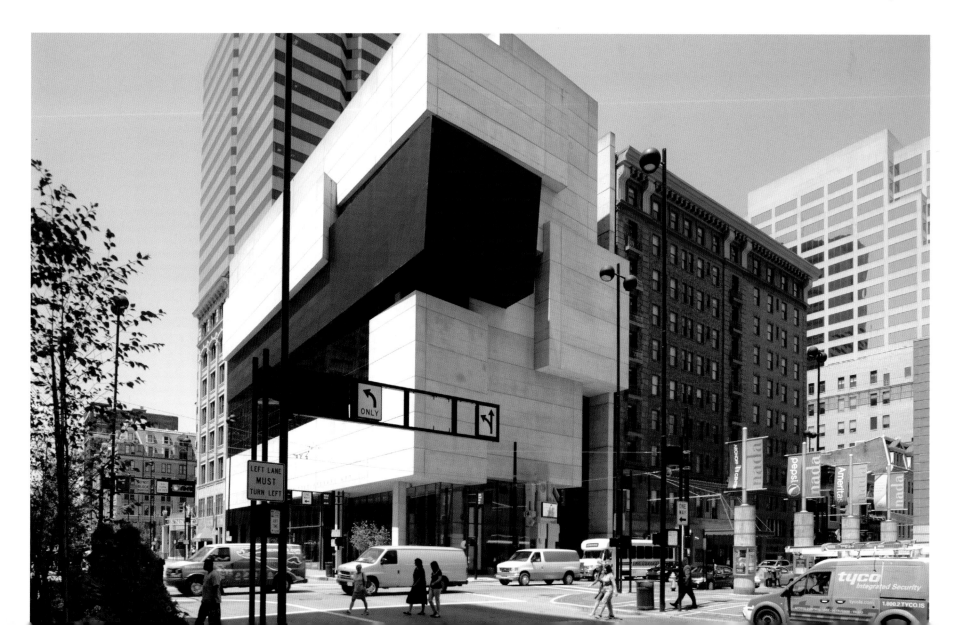

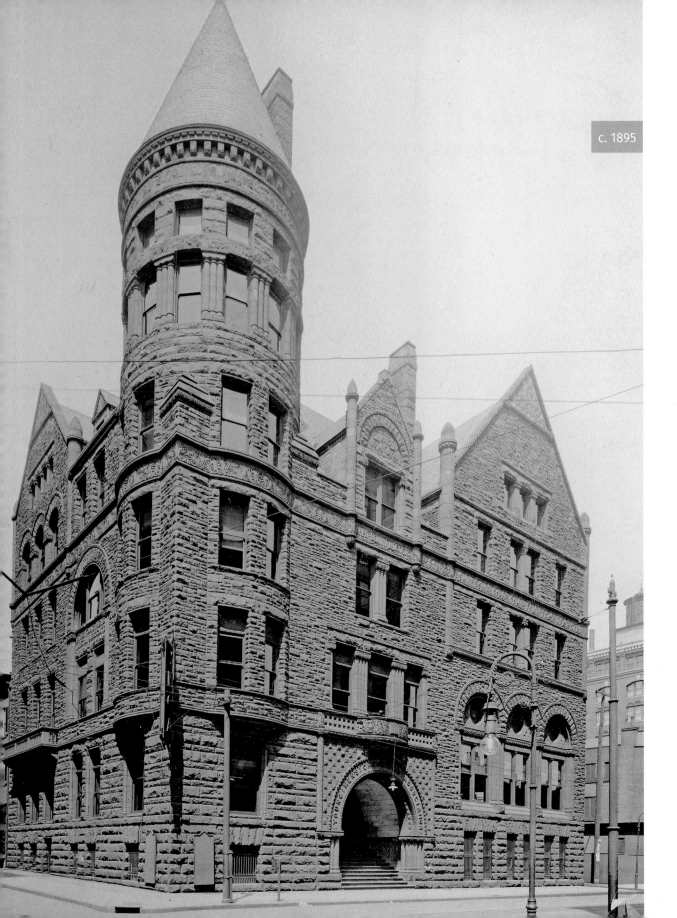

SHUBERT THEATER

The castle-like theater started life as a
branch of the YMCA

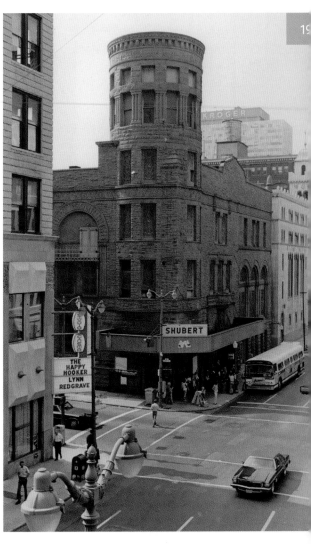

OPPOSITE: The building that became the Shubert Theater at the northwest corner of Seventh and Walnut streets was built in 1891 as the home for the local chapter of the Young Men's Christian Association (YMCA). The Romanesque design by James W. McLaughlin resembles a castle with the conical turret and thick, rough stone, almost an abbreviation of H. H. Richardson's Chamber of Commerce Building. The similarity became less noticeable after the Shubert Theatrical Company converted the YMCA building into a theater in 1920. The gabled roof and windows were chopped off. The cone was removed in 1946. Windows were bricked up with decorative covers, and the arched cave-like entrance was replaced with a conventional theater marquee and inset doors. Inside, the gym floor was cast at an angle for auditorium seating, an orchestra pit replaced locker rooms, and a stage was built over a swimming pool. At the same time, the George B. Cox Theatre was constructed next door on Seventh Street as a tribute to the late political boss.

RIGHT: The fates of the Shubert and Cox theaters were entwined. In 1954, the Cox closed. The Shubert briefly became Reverend Earl Ivie's Revival Temple in 1953, but it returned to the legitimate theater again in 1955, and the costumes were stored next door in the Cox. The interior was spruced up in 1964, along with a fancy ceiling ornament and a one-ton chandelier, but even that wasn't enough to save the Shubert from the same end as the other theater palaces downtown. The Shubert closed in 1975, and both theaters were demolished the next year. The URS Center office building, with a CVS Pharmacy storefront, stands at the spot of one of the city's most memorable theaters. It took another nineteen years for another theater to show up at Seventh and Walnut. The Aronoff Center for the Arts opened up kitty-corner from the Shubert site in 1995.

LEFT: In 1975, shortly before it was torn down, the Shubert Theater looked like a stripped-down castle.

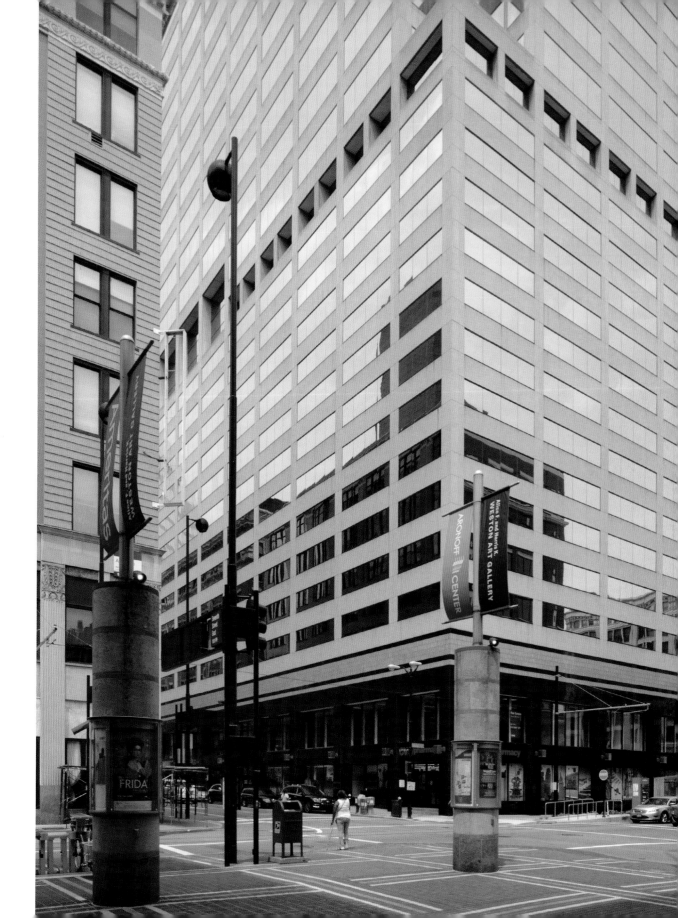

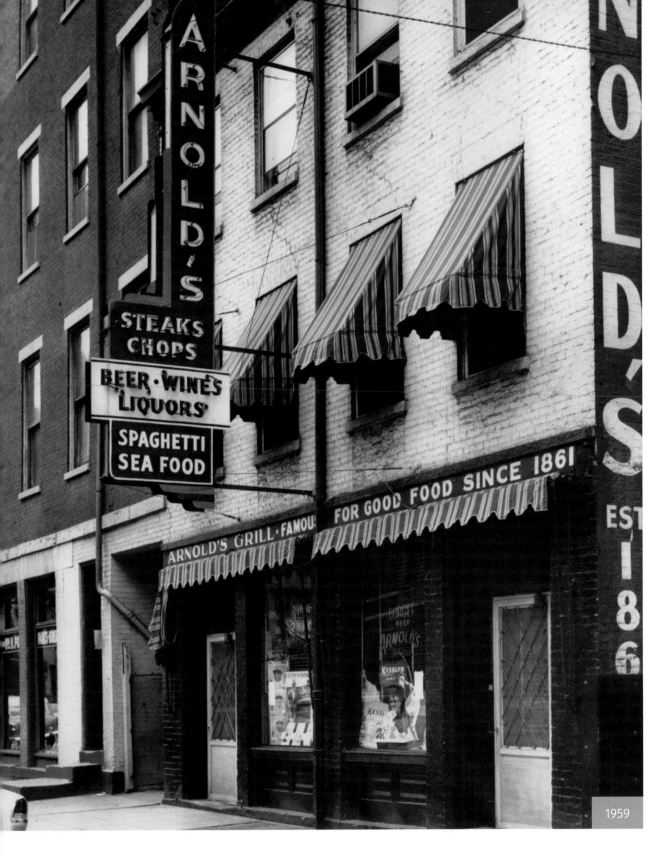

1959

ARNOLD'S BAR AND GRILL
The city's oldest restaurant and bar

LEFT: Arnold's Bar and Grill at 210 East Eighth Street embraces its history as the city's oldest restaurant and bar. The sign out front gives 1861 as the date Simon Arnold opened the saloon, but it first shows up in the city directory in 1878. Before that, Simon Arnold was listed as a cabinet and billiard-table maker on Court Street. Regardless, Arnold's has a long, rich history that is evident in every brick. The west side of the building was a livery and feed store that was later converted into a "Ladies' Entrance" waiting area for wives who were not allowed in the saloon. The Arnold family lived on the third floor while the second floor was for boarders. Hugo Arnold, who worked there as a barkeep as a boy, took over for his father in the 1890s, using the name Hugo Arnold's Cafe. When he passed away in 1926, his son Elmer reluctantly took over until he finally sold the family business in 1959, the year of this photo.

RIGHT: Although no longer in the Arnold family's hands, Arnold's retains its history. Greek brothers Jim and George Christakos took over Arnold's in 1959 and kept the name. The "authentic Greek spaghetti" they introduced is still on the menu. Local entrepreneur Jim Tarbell, who had converted a garage into the Ludlow Garage rock 'n' roll music venue in 1969, bought Arnold's in 1976 and reinvigorated the old bar. He knocked down a wall and created a courtyard for outdoor seating and live music. In 1998, Tarbell sold Arnold's to former manager Ronda Androski, who still owns the historic restaurant and pub. A claw-foot bathtub remains in the second-floor dining area as a souvenir of its domestic past, and bolsters the rumors that the tub was used to distill gin during Prohibition. The bathtub has become an emblem of Arnold's. The bar even has a motorized bathtub on wheels in the annual Bockfest parade that starts at Arnold's and travels through Over-the-Rhine celebrating the city's beer culture.

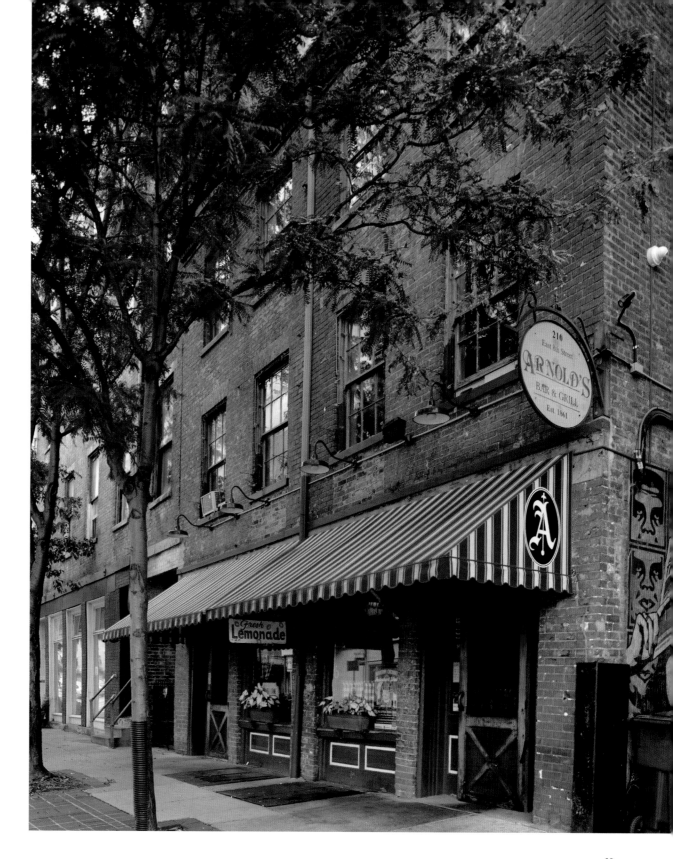

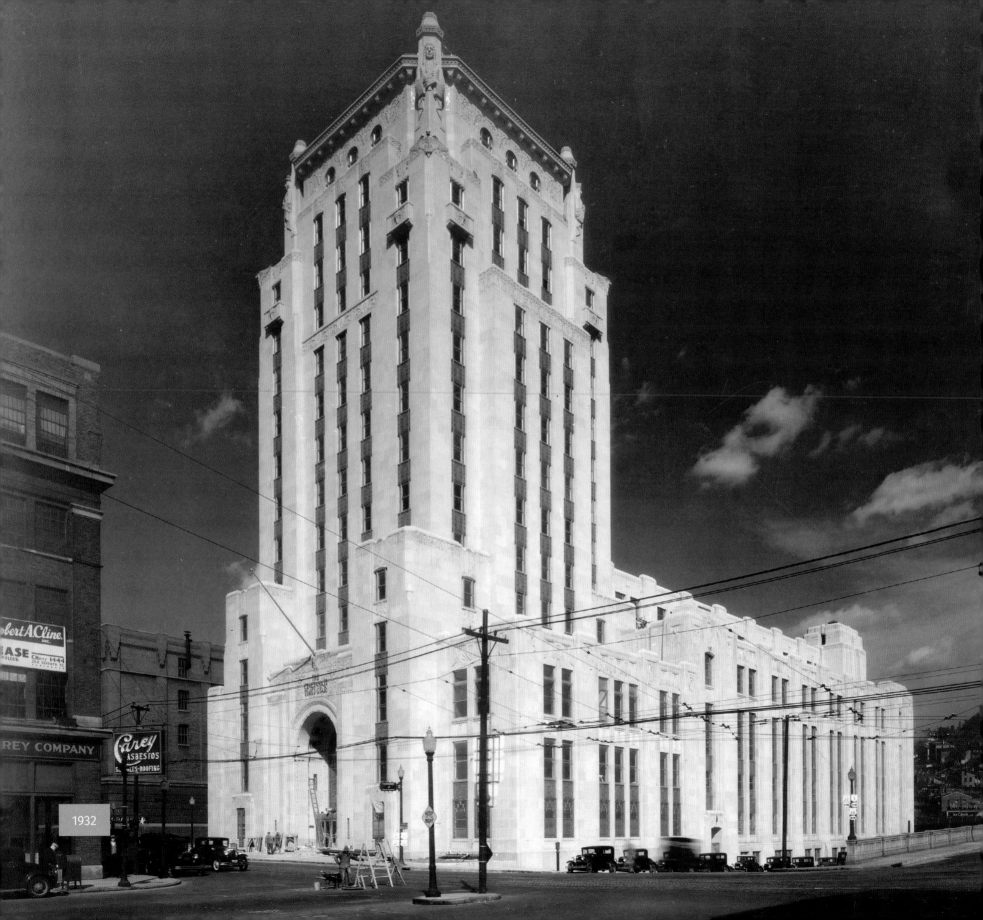

1932

TIMES-STAR BUILDING
An archetypal news building

LEFT: The Times-Star Building at 800 Broadway virtually shouts out that it was built for a newspaper. The *Cincinnati Times-Star* was formed in 1880 when Charles Phelps Taft merged the *Cincinnati Times* and the *Cincinnati Daily Star*. Taft served as editor until his death in 1929. His nephew Hulbert Taft took over and fulfilled the plan for a grand new office building, shown here shortly before its completion in 1933. Designed by H. Eldridge Hannaford, the sixteen-story concrete and limestone building is a beautiful example of Art Deco styling. The four figures at the corners symbolize qualities of 1930s journalism: truth, speed, patriotism, and progress. Bas-reliefs depict printers Benjamin Franklin and Johannes Gutenberg. An urn-shaped airplane beacon serves as a cap to the roof. Within the arched entrance is a gorgeous bronze grillwork above the door. The elevators are decorated with women of mythology. The building so evokes its era that one expects Superman to fly out of the top window.

RIGHT: As newspapers faced fierce competition from radio and television, readership declined across the industry. Hoping to bolster their share of the market, the *Times-Star* offered $7.5 million to purchase the *Cincinnati Enquirer* in 1952. However, the *Enquirer* staff rallied together to raise a counter-offer $100,000 higher and they purchased their own newspaper. Then, in 1958, the *Times-Star* employees received a telegram that E. W. Scripps, owner of the *Cincinnati Post*, had bought the *Times-Star* and was shutting it down. The entire staff was laid off. The *Post* moved into the Broadway building and the newspaper was published under the masthead of the *Cincinnati Post and Times-Star* until 1974 when the *Times-Star* name disappeared. The *Post* moved out of the building in 1984 to offices on Court Street, and published its last edition in 2007. Hamilton County purchased the historic Times-Star Building, and uses it as the Court of Domestic Relations.

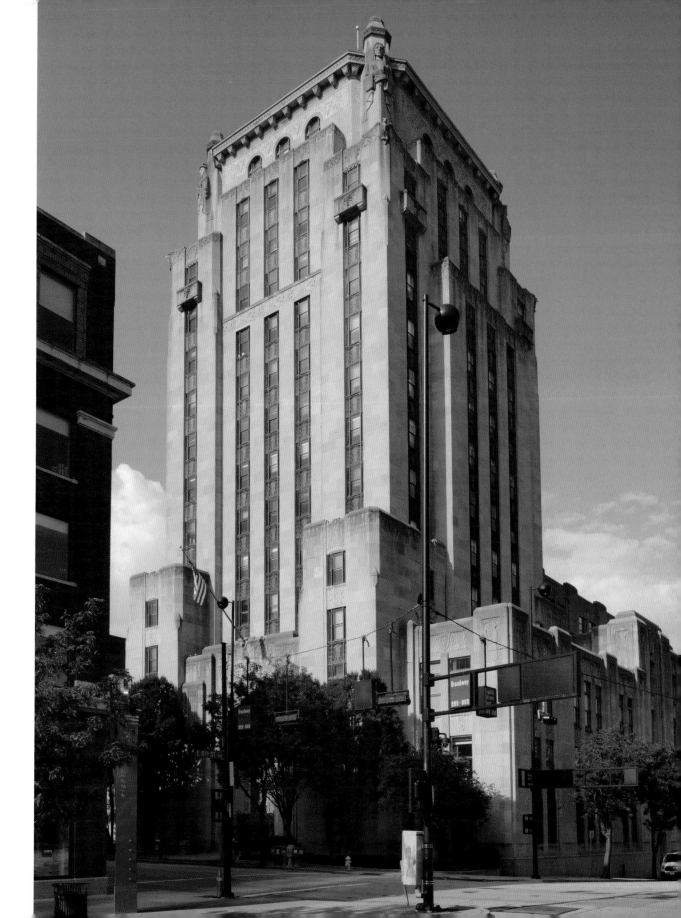

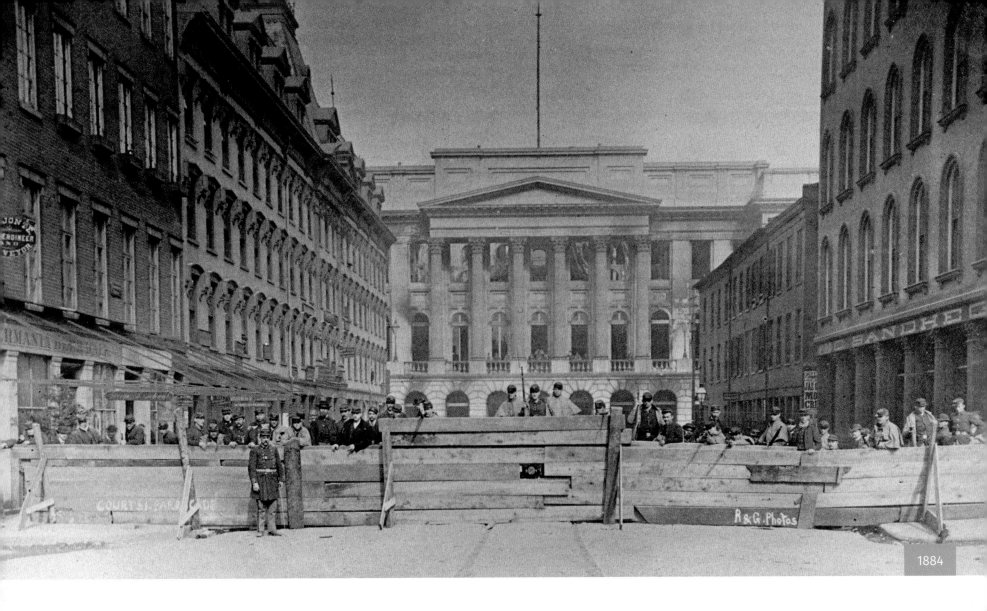

1884

THE 1884 COURTHOUSE RIOT
Citizens were fed up with their justice system and took it into their own hands

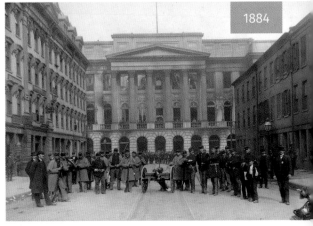

1884

ABOVE AND RIGHT: The Cincinnati Courthouse Riot in March 1884 was one of the deadliest in American history. Crime had run rampant in the city, and the citizens were fed up after the murder of William H. Kirk on Christmas Eve 1883. The liveryman had been robbed and strangled by two employees, but a jury found William Berner guilty only of manslaughter. Decrying the injustice, and fanned by incendiary editorials in the *Enquirer*, a mob abandoned the community meeting at Music Hall and stormed the jail on Main Street to mete out their own justice. The Ohio National Guard built a makeshift barricade on Court Street. The Hamilton County Courthouse next to the jail was left unguarded, so rioters broke in and set it on fire, destroying irreplaceable county records. While the courthouse burned, the militia fired a Gatling gun upon the rioters with deadly results. The riot was finally quelled after three days. More than fifty people were killed, including Captain John J. Desmond of the First Regiment.

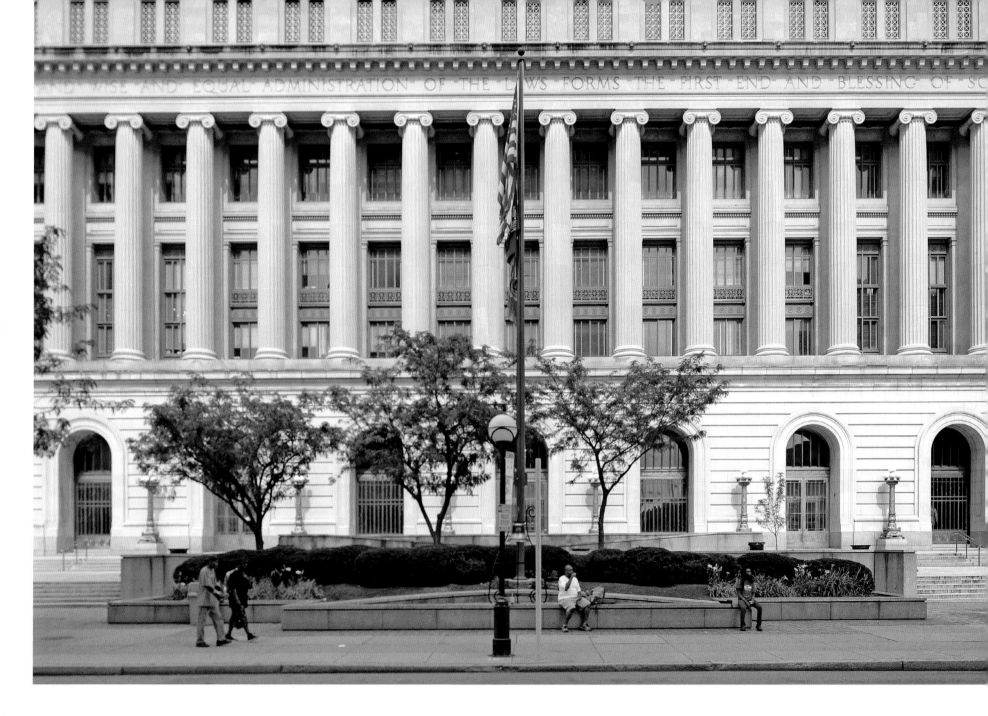

ABOVE: The Hamilton County Courthouse that burned down in 1884 had been built in 1851 from a design by Isaiah Rogers, the architect who had designed the Burnet House. It was a monumental stone structure with a row of Corinthian columns. Architect James W. McLaughlin designed the replacement courthouse after the riots. It had a less judicial design, using rough stone in a Romanesque style. It wasn't received as warmly as its predecessor, and it was demolished in 1915 for a more spacious building. The current courthouse designed by John H. Rankin was constructed during World War I and dedicated in 1919. Its Beaux-Arts style echoes the ill-fated courthouse building designed by Rogers, including a row of Ionic columns and similar arched doorways in the pediment. A statue of Captain Desmond stands near the entrance as a reminder of the tragic past. This courthouse has enjoyed greater longevity than all the others, as it's still going strong after nearly a century.

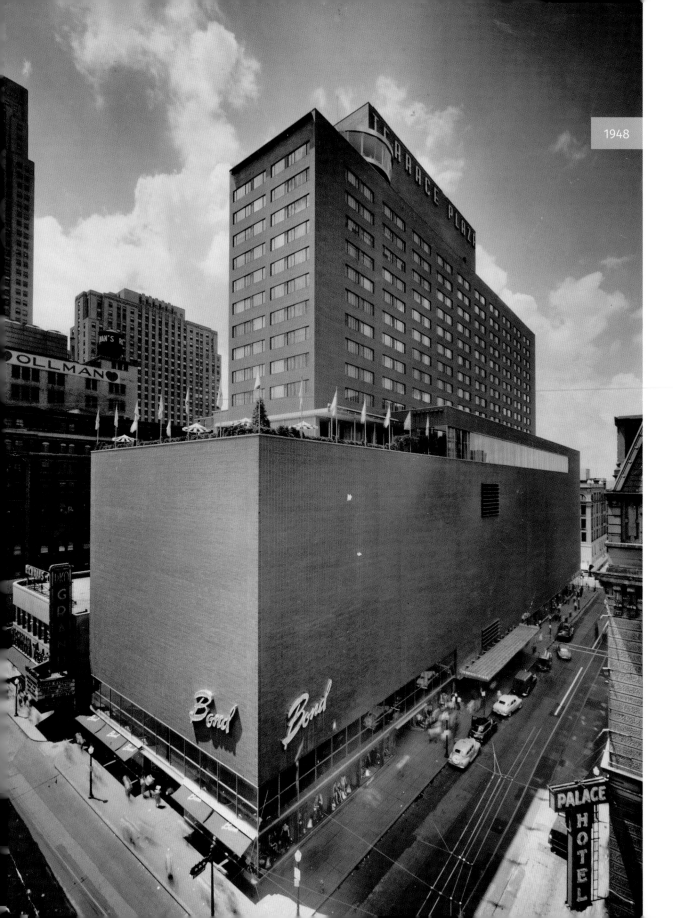

1948

TERRACE PLAZA HOTEL

An icon of Modernism in sore need of redevelopment

LEFT: When the Terrace Plaza Hotel opened in 1948, no one had seen anything like it. *Time, Life,* and *Harper's Magazine* ran write-ups on the first major post-war hotel. Developer John J. Emery had also made Carew Tower in 1930, but Terrace Plaza was something different, a mid-century marvel of Modernism in pink brick. The hotel lobby was on the eighth floor, above retail space for J. C. Penny and Bond department stores. Rooms were fitted with cutting-edge amenities, air conditioning, and beds that slid out of the walls at the push of a button. Modern art murals from Joan Miró and Saul Steinberg adorned the walls. The circular Gourmet Room restaurant sat like a flying saucer that had landed on the twentieth floor, offering a fine dining experience along with a spectacular view of the city from above. It was the most celebrated hotel in Cincinnati since the Burnet House a century earlier.

RIGHT: For some, the Terrace Plaza was the beginning. Architectural firm Skidmore, Ownings & Merrill went on to design some of the tallest buildings in the world, including Sears Tower and the Burj Khalifa in Dubai. Lead architect Nathalie De Blois, a female pioneer in the field, designed the Lever House and Pepsi Cola World Headquarters in New York City. But, what was modern becomes outdated. For all its innovation and influence, the Terrace Plaza had a short heyday. Hilton Hotels Corporation purchased the hotel in 1956 and Emery donated most of the art to the Cincinnati Art Museum. The department stores closed, and the windows were bricked over. The hotel changed hands and names, but never recovered its prestige. The Gourmet Room closed in 1992. The hotel had its last guest in 2008. Long before that, what made the Terrace Plaza Hotel so remarkable had become outdated. The hotel sits empty, awaiting someone to breathe life into it once more.

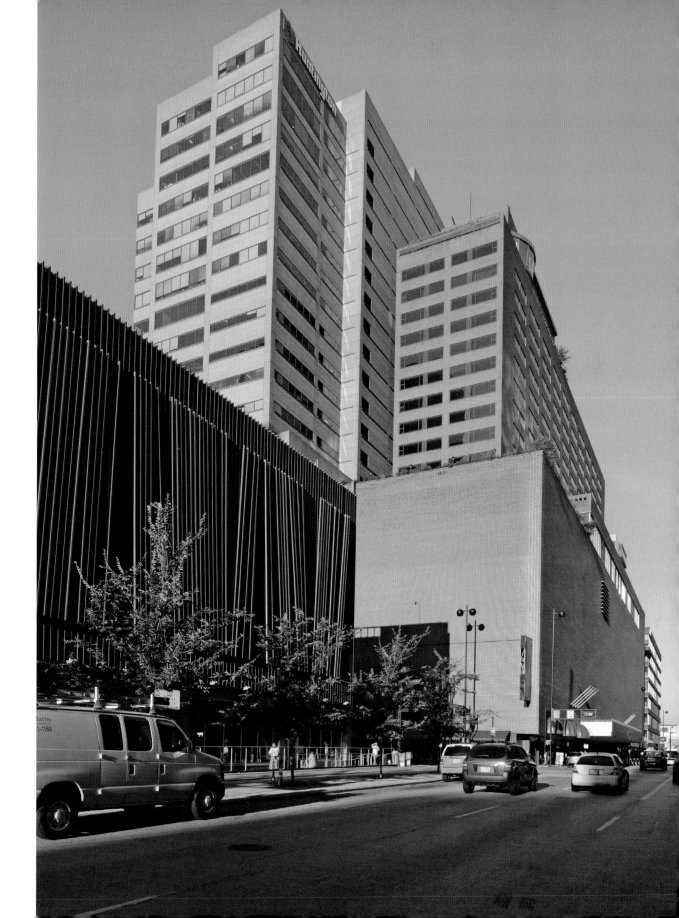

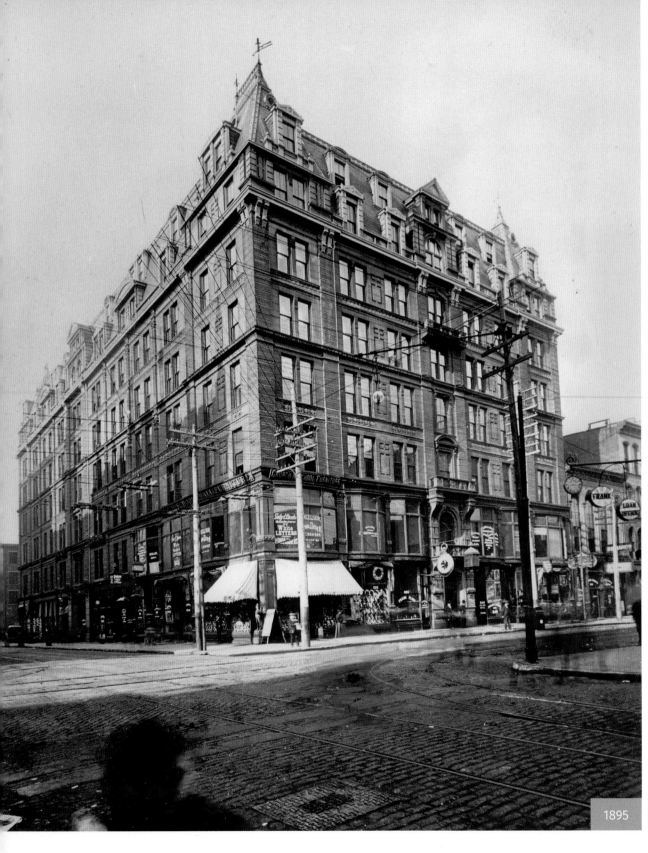

1895

PALACE HOTEL
The current Cincinnatian is the city's oldest hotel

LEFT: The Palace Hotel at Sixth and Vine streets opened in 1882. At eight stories, it was the city's tallest building at the time. Samuel Hannaford's Second French Empire design featured a steep mansard roof and gabled windows, making for an attractive façade. It was part of a movement to create grand palace hotels modeled after elegant European townhouses. Developer Thomas J. Emery had wanted a deluxe hotel for those who found the Burnet House too expensive, and he vowed to keep the price at two dollars a night. The 300-room hotel had a marble-and-walnut grand staircase and modern incandescent lights and hydraulic elevators, but, as was typical at the time, each floor had only two shared bathrooms. The Palace Theater, built on the northeast corner in 1918, was named for the hotel. In the photo from 1895, the Palace Hotel dominates the block, but by the mid-twentieth century it would be dwarfed from all sides.

RIGHT: The Palace Hotel was modernized in 1948, perhaps a reaction to the ultra-modern Terrace Plaza Hotel built across the street. The name was changed to Palace Hotel Cincinnatian, then just the Cincinnatian Hotel in 1951. The hotel's Cricket Restaurant was a popular haunt for *Enquirer* reporters from next door. Over time, the city's oldest hotel felt its age. It became a residential and transient hotel, and there was even talk of demolition. Instead, it underwent a major overhaul in 1987 that converted the 300 rooms into 167 luxury suites. The exterior base was altered in a Postmodern fashion, as though the elegant old building were wearing a modern disguise. While the décor has been modernized and a vast skylight was added, the hotel has retained the grand staircase along with a semblance of its nineteenth-century charm. Rather than hitching posts at the entrance, the hotel had its own London-style black taxicab. In a nod to the past, the remodel included the Palace Restaurant and Cricket Lounge.

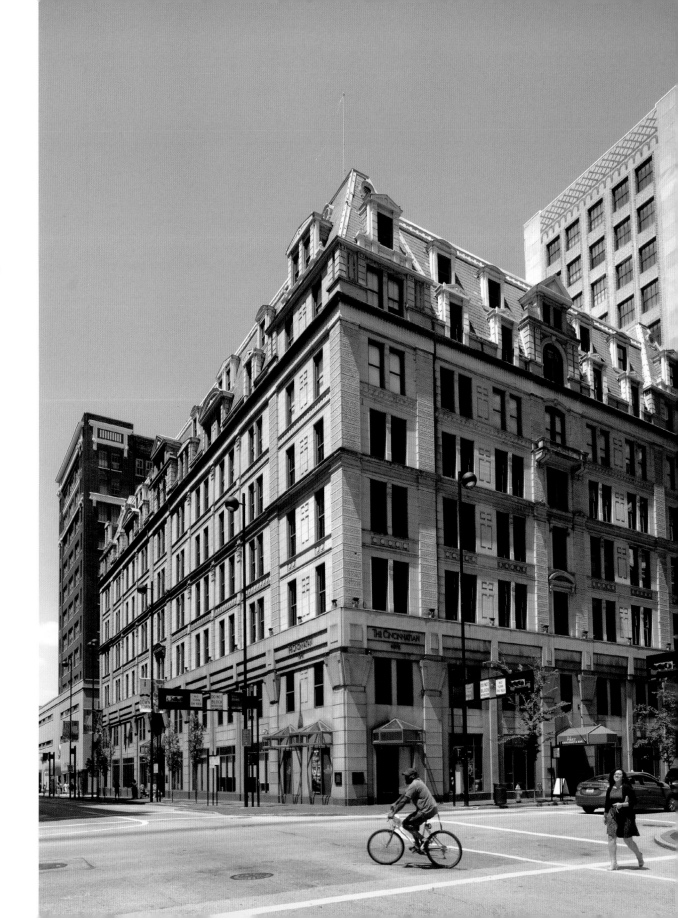

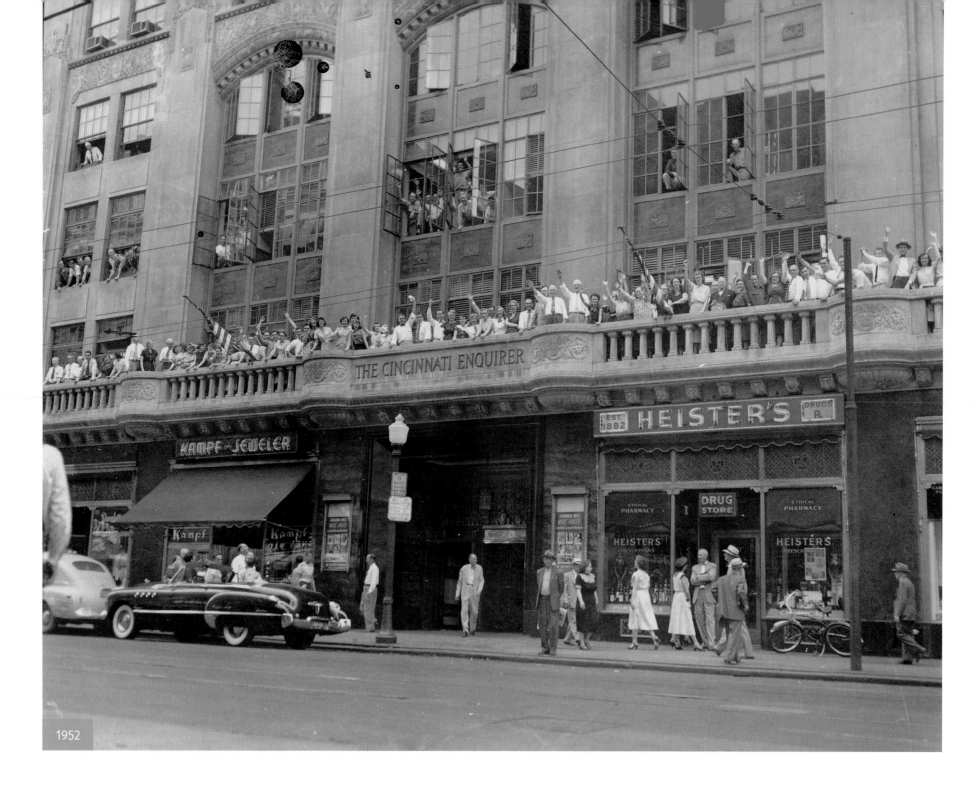

CINCINNATI ENQUIRER BUILDING

The Grand Old Lady of Vine Street

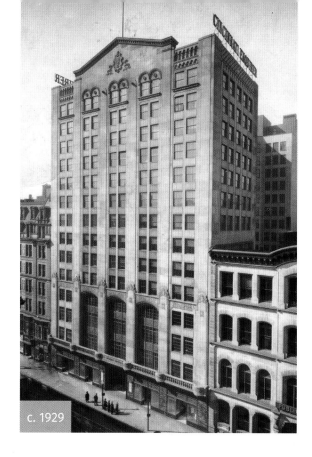

c. 1929

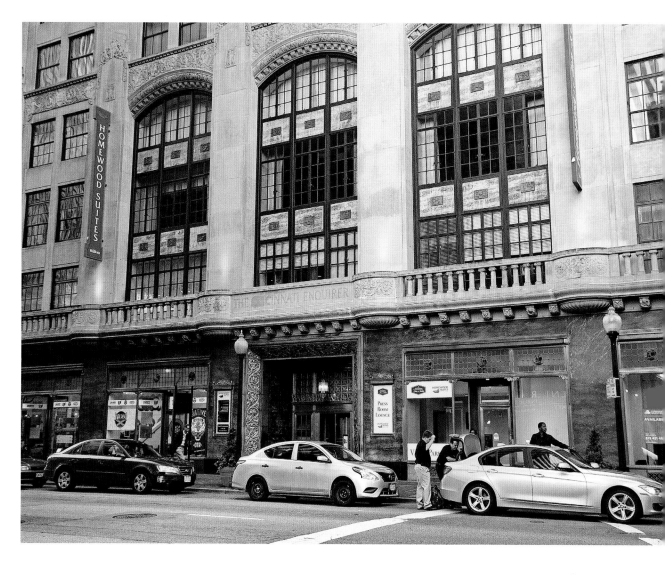

LEFT: The *Cincinnati Enquirer* debuted April 10, 1841, with a four-page newspaper. The *Daily Enquirer* started a Sunday edition in 1848, making it the oldest in the country still publishing. The *Enquirer* offices at Vine and Baker streets were destroyed in the fire at Pike's Opera House in 1866, so the newspaper moved to the old Wesleyan Female College on Vine Street. The Cincinnati Enquirer Building, a new fourteen-story home by Lockwood, Green & Company, was constructed around the old building and completed in 1929. In all, the *Enquirer* spent 125 years at 617 Vine Street, earning the nickname the Grand Old Lady of Vine Street. In 1952, the *Cincinnati Times-Star* attempted to buy the *Enquirer* for $7.5 million, but the employees, led by columnist James H. Ratliff Jr., raised $7.6 million, and a judge allowed their bid. So, on June 6, 1952, the new *Enquirer* owners—the employees themselves—climbed out onto the second-floor balcony to celebrate. It was a short-lived victory. The employees were ousted from the board and the newspaper was sold the next year.

ABOVE: In 1929, the *Enquirer* built a beautiful home that longtime employees still affectionately regard as "617 Vine."

ABOVE: The *Enquirer* has been resilient, outlasting all its competitors. After the failed *Times-Star* bid, E. W. Scripps purchased the *Enquirer*, then merged the *Post* and *Times-Star*. But the government doesn't like a monopoly, so Scripps sold the *Enquirer* to local businessman Carl Lindner. Since 1978, the *Enquirer* has been part of the Gannett media chain. The *Enquirer's* Jim Borgman won the 1991 Pulitzer Prize in editorial cartooning. In 1992, the paper relocated to 312 Elm Street, where it remains today. A thirty-year joint operating agreement between the *Enquirer* and *Post*, in which they shared production facilities, expired in 2007 and the *Post* closed. In 2015, the old Enquirer Building was converted into two hotels: Homewood Suites and Hampton Inn & Suites. Part of the renovation of the building listed on the National Register of Historic Places was restoring the lobby to how it appeared in the 1920s. The gold and marble entrance glistens. The Rococo ceiling, bas-relief carvings, and decorative elevator doors look like they have been frozen in time.

1953

OLD MAIN LIBRARY
This Victorian gem was lost to mid-century reurbanization

LEFT: The original Public Library at 629 Vine Street was supposed to be Handy's Opera House. Only the façade had been completed when the backer ran out of money. Architect James W. McLaughlin worked with librarian William Frederick Poole to convert his design into a library, completed in 1874. The handsome exterior, featuring busts of Shakespeare, John Milton, and Benjamin Franklin and "Public Library" spelled out in lights, gave little indication of the splendor inside. The Main Hall was four stories tall with towering wrought-iron bookshelves lined on both sides like dominoes, all underneath a massive skylight. Checkerboard marble floors, spiral staircases, and stained-glass windows bathed in shafts of natural light made the old Main Library a treasure of a bygone age. Not so, thought the people of the twentieth century. In 1890, not long after the library opened, the librarians started lobbying for a replacement, decrying the stuffiness, the lack of space and the inaccessibility of the books. When voters finally passed a bond for a new library, there were no tears about losing Old Main.

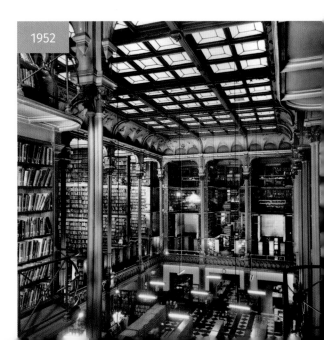

1952

RIGHT: The old Main Library is one of the city's lost treasures, a victim of the change of aesthetic in the mid-twentieth century. Photos of the Victorian interior bring to mind the great libraries of Europe. But in 1955, when the doors closed and the new Main Library was built up the street, folks preferred Modernism's streamlines and blocks of glass and brick. The 1.25 million volumes were carried a block and a half up Vine Street to the new modern library, where patrons could browse the collection more easily. No one thought that Old Main would be missed, although a few patrons bought fixtures, even a staircase, as souvenirs. Author busts and stained-glass windows were taken to the new library, but the rest of the art was given away or discarded. Old Main was fated to the wrecking ball, replaced by a nondescript parking garage and office building. Still, whenever the subject of the old Public Library comes up, folks mourn the loss of an old gem.

BELOW LEFT: The public library's Main Hall was stunning under the skylight.

THE PUBLIC LIBRARY OF CINCINNATI AND HAMILTON COUNTY

The library has expanded its collection and reach

BELOW: Voters finally approved a $3.5 million bond to build a new library in 1944. Librarian Carl Vitz was brought in to make it a reality. The new main Library was built at 800 Vine Street, two blocks north of the original library. The contemporary International Style design by Cincinnati architect Woodie Garber featured modern angles and a red-brick block with touches of granite, marble, and Venetian tile. The entrance was inset on the Eighth Street side, along with a garden area enclosed behind a serpentine wall inspired by Thomas Jefferson's main plantation Monticello. When it opened in 1955, the library was a fraction of its current size, but it still felt spacious, like a department store where patrons could browse through the collection.

The Main Library shared the block with the Gayety Burlesk, a striptease theater that had once been the Empress Theater, which had shown vaudeville acts including Charlie Chaplin. Not everyone was happy about the proximity to the Gayety, which offered a different sort of education until it closed in 1970.

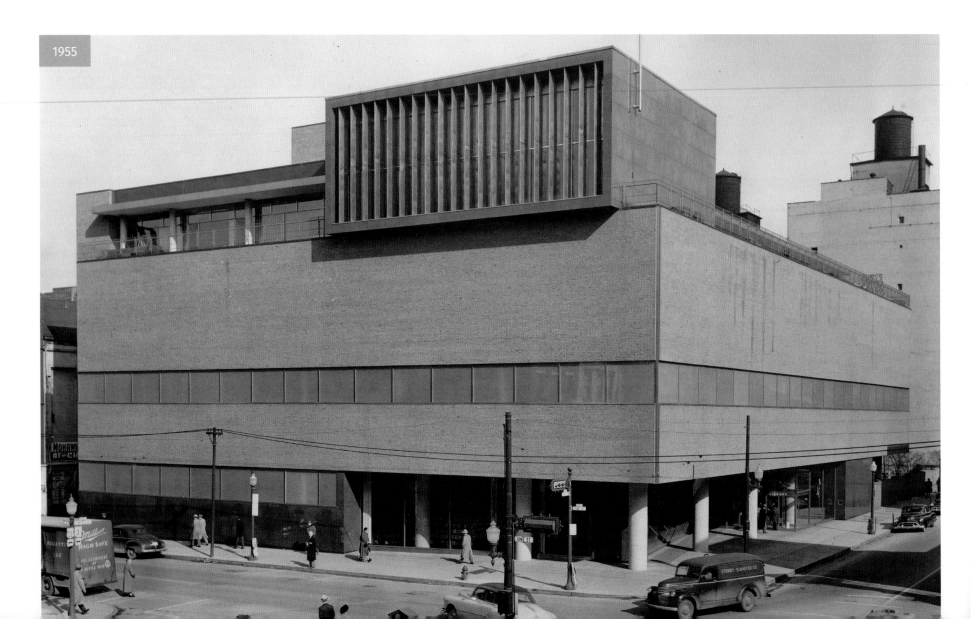

1955

c. 1968

BELOW: The library gobbled up its neighbors, the Gayety and the Drake Hotel, and filled out the entire block with an expansion in 1982 that more than doubled its size. The library entrance was moved to Vine Street and opened to a new spacious atrium and skylight that was built as a tribute to the old library's Main Hall. A fountain pouring from a stack of oversized ceramic books was added outside the entrance. In 1997, the library added a north building across Ninth Street connected by a skywalk. The Public Library of Cincinnati and Hamilton County is one of the nation's busiest library systems, with forty-one branches countywide. In 2015, the library opened MakerSpace, a shared creative workspace where patrons can print vinyl banners, make buttons, carry out laser engraving, or use a 3-D printer. In 2017, the library announced plans to sell the north building and consolidate into the main building.

LEFT: The Gayety Burlesk was right next door to the Main Library.

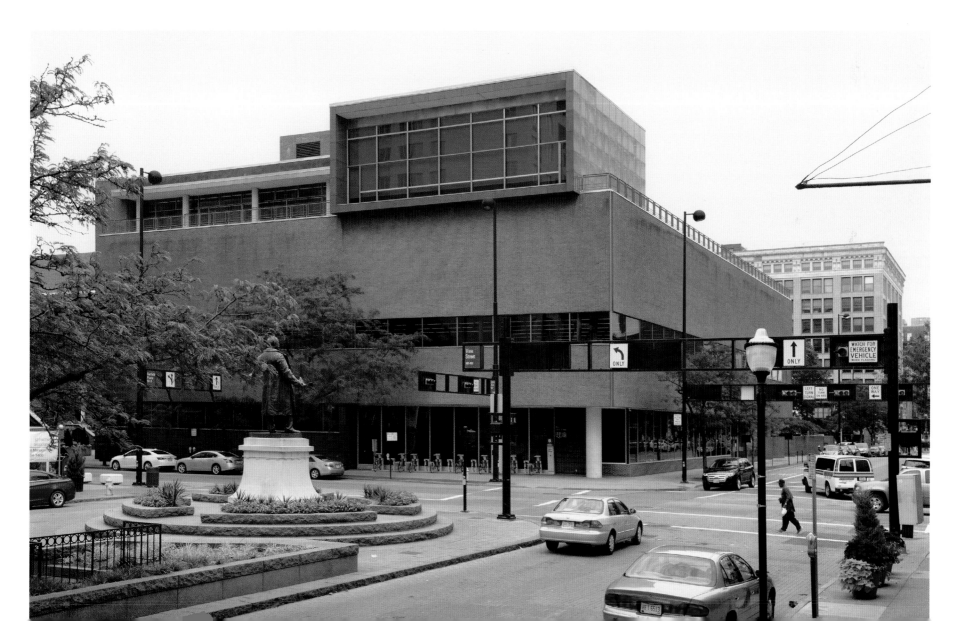

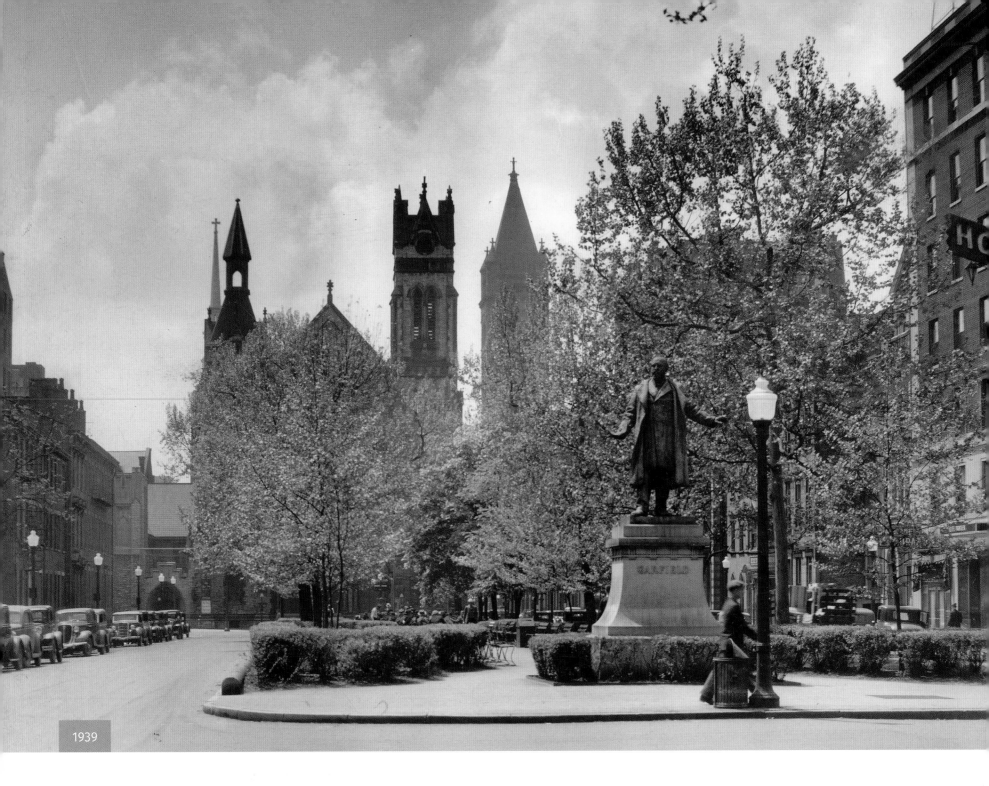

1939

GARFIELD PLACE / PIATT PARK
Ohio's presidents have a unique place in U.S. history

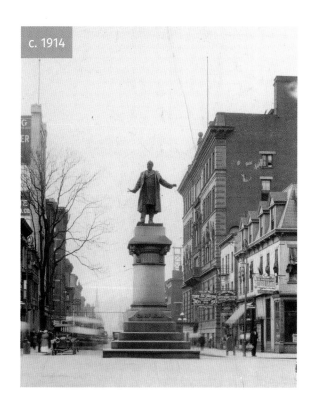

c. 1914

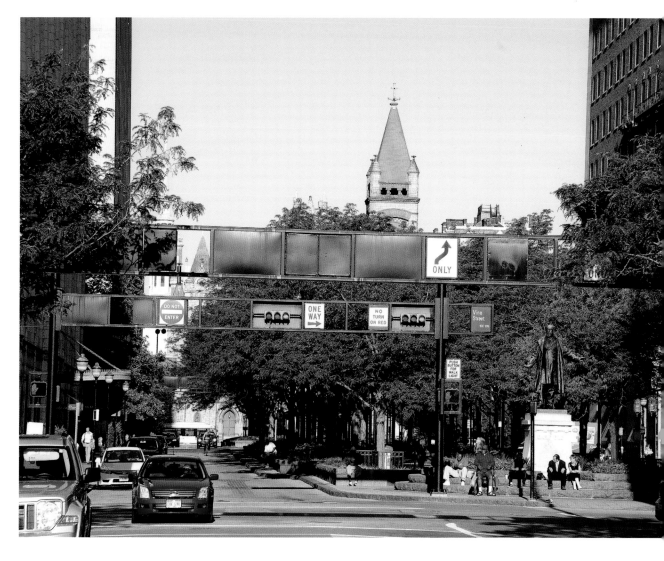

LEFT: Two hundred years ago, in 1817, brothers John H. Piatt and Benjamin J. Piatt donated land along Eighth Street between Vine and Elm to be used as a market space. Instead, it became Cincinnati's first park in the 1840s. It has gone by the names Eighth Street Park, Piatt Park, and Garfield Place. Statues of presidents James A. Garfield and William Henry Harrison are found in the park. Both were from Ohio and died in office, serving the two shortest presidencies in U.S. history. The Garfield statue, made by local sculptor Charles Henry Niehaus in Rome, was unveiled in 1887 atop a high granite pedestal in the road at Eighth and Race. Drivers became aggravated, so in 1915 the statue was moved to the Race Street section of the park, as seen in the 1939 photo. Above the trees is a collection of steeples from St. Peter in Chains, Church of the Covenant, and City Hall.

ABOVE: The statue of President James A. Garfield originally stood on a pedestal in the middle of Eighth and Race.

ABOVE: The Harrison statue, not pictured, was placed at the Vine Street end of the park in 1896. The statue depicting General Harrison on horseback is the only equestrian statue in Cincinnati. Curiously, sculptors Louis T. Rebisso and Clement Barnhorn didn't carve a saddle, so it is a mystery what holds up the stirrups. Both statues were relocated during redevelopment of the park in 1988. Harrison was moved to the Elm Street end, facing west toward his burial site in North Bend. Garfield took up Harrison's former spot at Vine Street, facing the Main Library. On Garfield's old spot at Race Street is a fountain dedicated to the late Isadore "Izzy" Kadetz, owner of Izzy's deli. The park officially became Piatt Park to honor the original donors, but many still call it Garfield Place. Because the Piatts had specified the land as public space, in 2011 the Occupy Cincinnati protestors were allowed to camp out at the base of the Garfield statue.

SIXTH STREET MARKET

A public market doomed by supermarkets and urban renewal

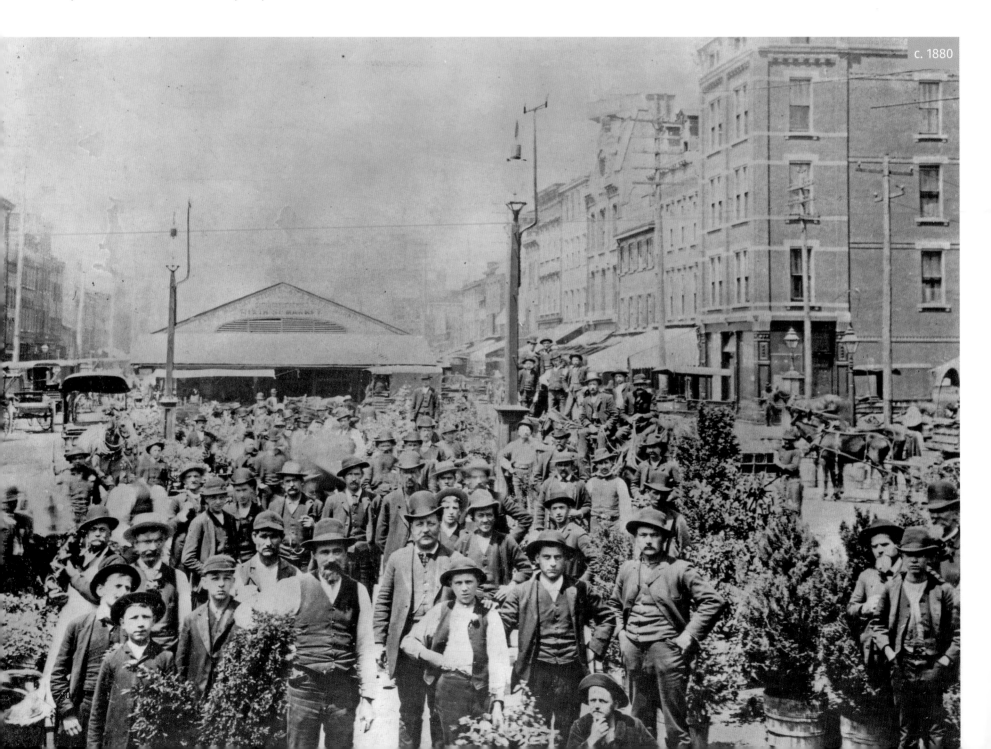

c. 1880

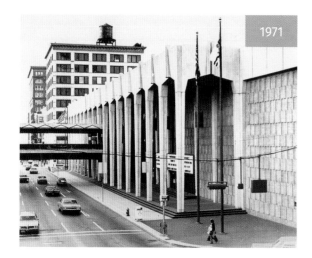

1971

ABOVE: The original Convention Center design by Hake & Hake was wrapped in white concrete structures, as seen in 1971. The building was completely remodeled in 1986.

OPPOSITE: Several markets served downtown at Pearl Street, Fifth Street, and Court Street. A market had been on Sixth Street since at least 1829. It eventually covered two blocks between Elm and Western Row (now Central Avenue). The flower market, shown about 1880, was especially popular, but Jabez Elliott was distressed that the flowers suffered in the cold weather. After he passed away, his wife, Mary E. Holroyd, donated $10,000 to build a flower market stand facing Elm Street. The elegant Jabez Elliott Flower Market, designed by Samuel Hannaford in 1890, was claimed to be the largest indoor market that exclusively sold flowers. Hannaford also designed the meat house at Plum Street in 1895. The buff-brick masonry building with German-styled tiered faces housed sixty-four stalls for butchers and dairy merchants, but had no heating, which made for rather cold winters.

BELOW: Supermarkets and suburbs doomed the public markets. The Sixth Street Market was the last of the downtown markets to close—only Findlay Market in Over-the-Rhine is still around. Urban renewal shifted the focus to cars. The flower market was torn down in 1950 to create metered parking spaces. Then, a Sixth Street entrance to the Mill Creek Expressway (part of I-75) was needed, and so the market bell rang for the last time on New Year's Eve, 1959. The market was cleared. A parking garage was built on the north side of Sixth Street, the new Convention Center to the south. Built in 1967, the Convention Center (now the Duke Energy Center) was enlarged and remodeled in 1986, and named for a time after Dr. Albert B. Sabin, who discovered the oral polio vaccine. An ArtWorks mural on the Sixth and Elm Street corner depicts hands from Winold Reiss's Union Terminal murals. In 2016, nine of the murals were installed outside on the Central Avenue side of the Duke Energy Center.

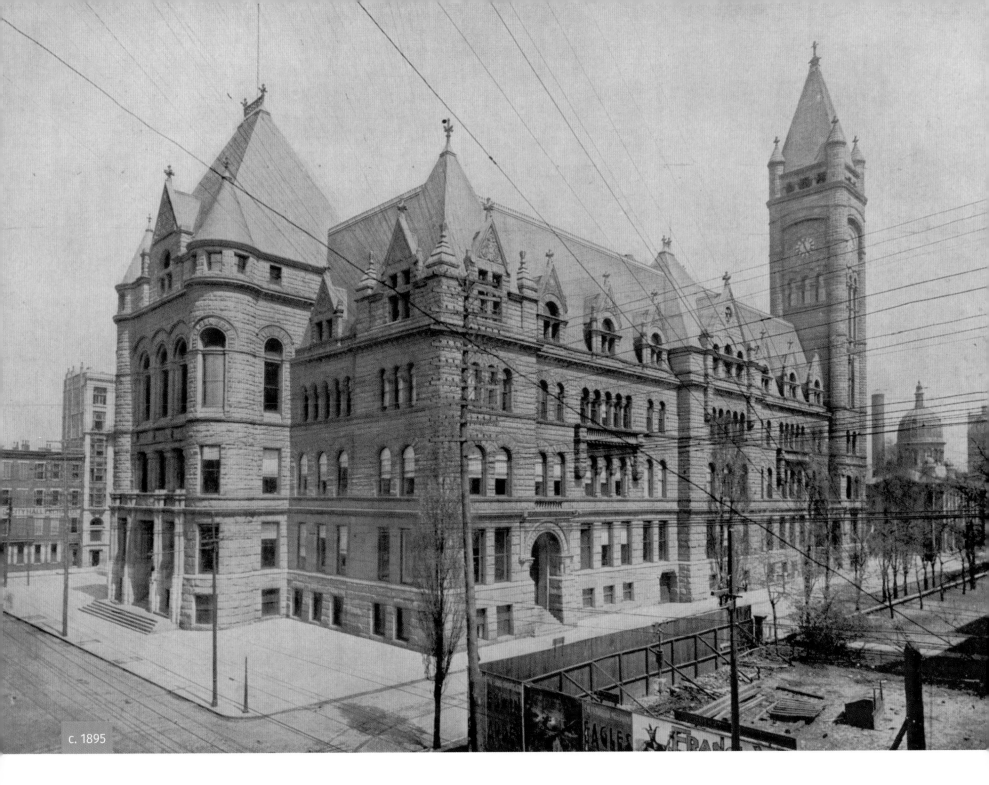

c. 1895

CITY HALL
The building survived a five-alarm fire

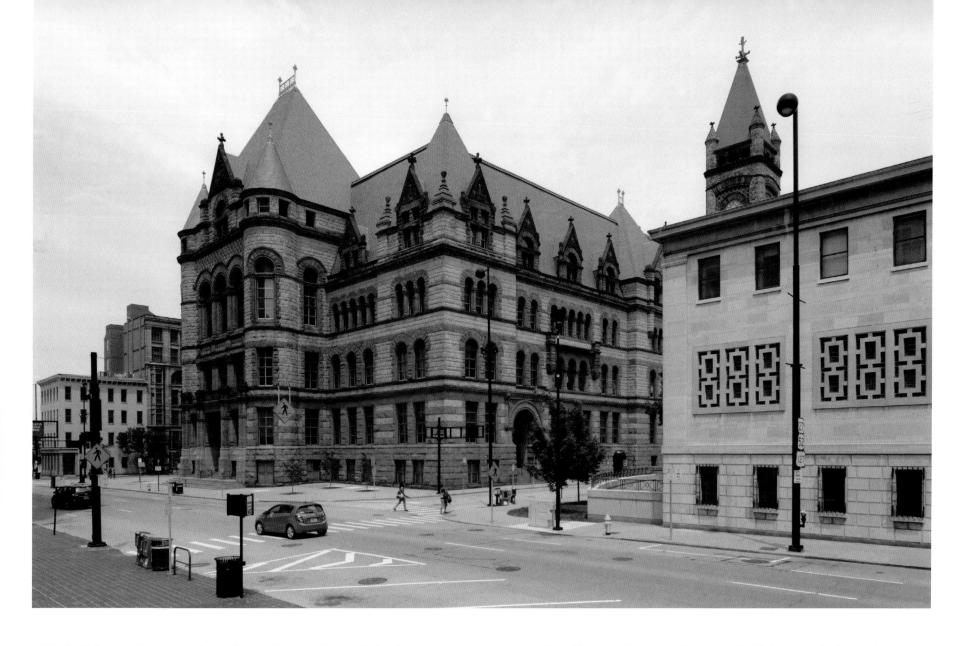

LEFT: City Hall at 801 Plum Street is usually seen from the front with the clock tower prominent in the foreground. This atypical view from Central Avenue, a couple years after City Hall was completed in 1893, allows for more attention to the architectural details of this iconic Samuel Hannaford design. A city hall had occupied the site since 1851. Hannaford's City Hall is the city's best example of Richardsonian Romanesque architecture, using H.H. Richardson's signature arched windows, towers, and rough stone, which echoes Richardson's Alleghany County Courthouse in Pittsburgh. Hannaford's original design had placed the clock tower at the Eighth Street and Central Avenue corner, but workers found quicksand at the spot, so the plan was altered. The rectangular clock tower is striking and, combined with the rocky granite, declares the building to be of great importance. The windows and stones get gradually smaller on each floor, creating the illusion of more height.

ABOVE: City Hall, along with Music Hall, is Hannaford's legacy in Cincinnati. The building has held up remarkably well after more than a century with most of its artistic features intact. The enormous stained-glass windows greet visitors at both the Plum Street and Central Avenue entrances, featuring allegorical images of early Cincinnati history, from Cincinnatus to the "Queen of the West." An iron portcullis still peeks out over the steps where it once descended to close off City Hall on Sundays or in the case of a riot. Charles Pedretti murals on the ceiling of the City Council chambers have been painted over. A fiberglass finial atop the tower has replaced the original. On October 11, 1957, a five-alarm fire threatened the building as flames spit through the roof, but firefighters contained the fire to a fourth-floor records room where a backlog of records was destroyed. City Hall, listed on the National Register of Historic Places, remains one of the city's most treasured landmarks.

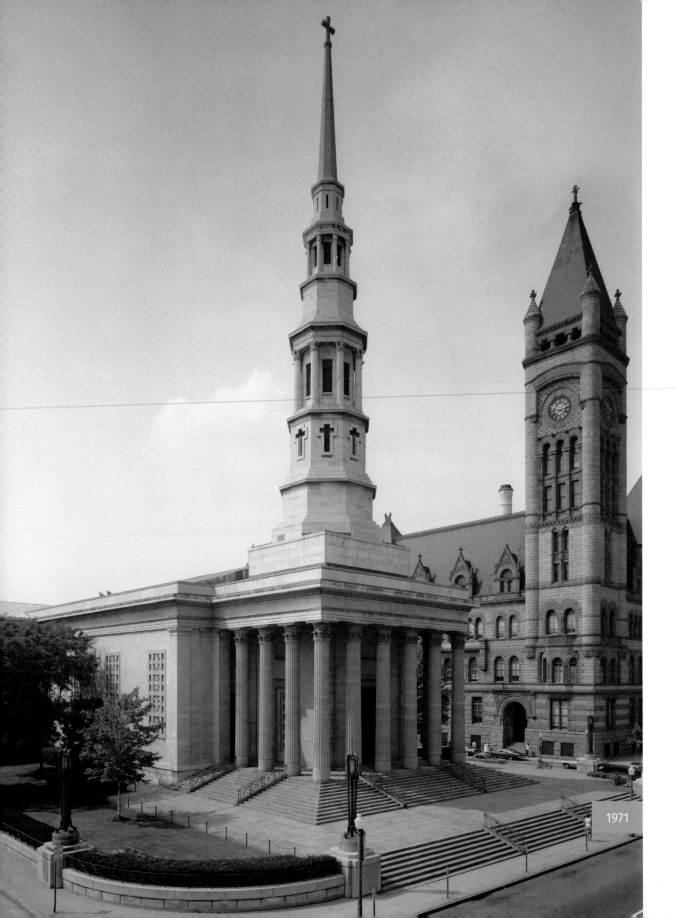

1971

ST. PETER IN CHAINS CATHEDRAL

A unique place of worship

LEFT: St. Peter in Chains Cathedral stands out even on a street with such astounding architecture as City Hall and Plum Street Temple. Not many Catholic churches made in the Greek Revival style are still around, but it's the awe-inspiring tower that catches the eye. Bishop John Baptist Purcell ordered a new cathedral to accommodate the flood of immigrants to the city. Work started in 1841, and St. Peter in Chains was dedicated in 1845, making it the city's second oldest church after St. Mary's Church in Over-the-Rhine. Architect Henry Walter also designed the Greek Revival statehouse in Columbus. The name St. Peter in Chains comes from a painting of the angel liberating St. Peter from prison. The painting was a gift to Cincinnati's first bishop, Edward D. Fenwick, from Cardinal Fesch, the art-collecting uncle of Napoleon Bonaparte. In 1876, reporter Lafcadio Hearn wrote a gripping story of accompanying climbers to the top of the 225-foot steeple, the highest point in the city at that time, and described the spectacular view he saw.

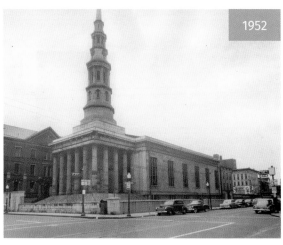

1952

RIGHT: As the church aged, the cathedral seat was moved in 1938 to St. Monica Church in Clifton Heights. Archbishop Karl Alter restored St. Peter in Chains as the cathedral along with a $5 million renovation in 1957. The rear wall was taken down and the sanctuary was gutted and remodeled. New art features carried the Greek styling inside. The shimmering gold Venetian glass mosaic on the apse wall grabs immediate attention. The design by artist Anton Wendling centers on a stylized Christ figure, young and beardless, sitting on a throne. Skilled craftsmen were brought in from Germany to install the thousands of tiles. Along the sanctuary walls are eight large murals by Carl Zimmerman, an instructor at Cincinnati Art Academy. Black figures set against red brick, inspired by Greek vases, depict the Stations of the Cross of Christ's crucifixion. St. Peter in Chains is listed on the National Register of Historic Places, and remains today an active church.

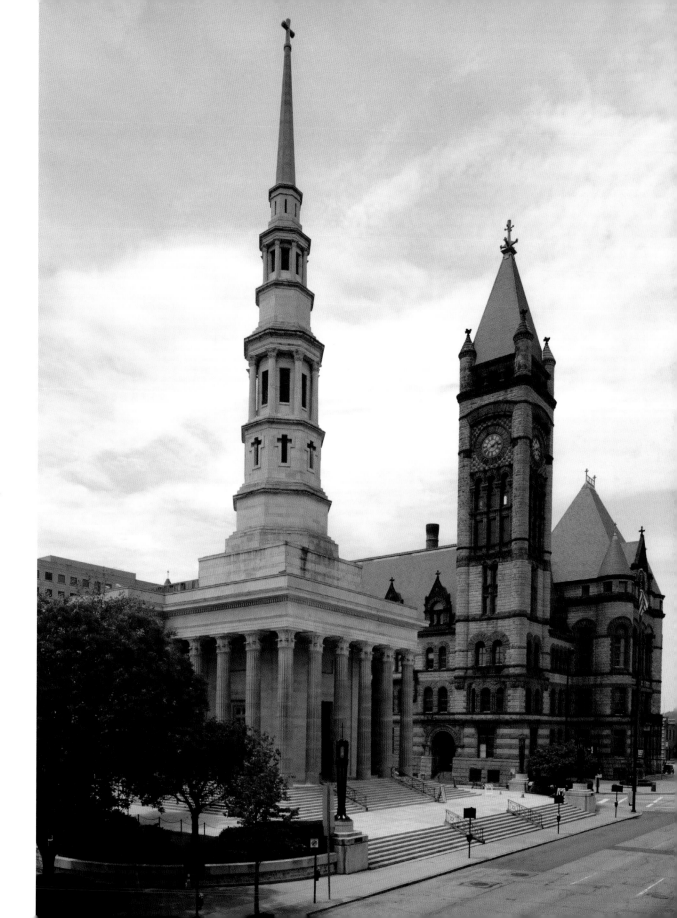

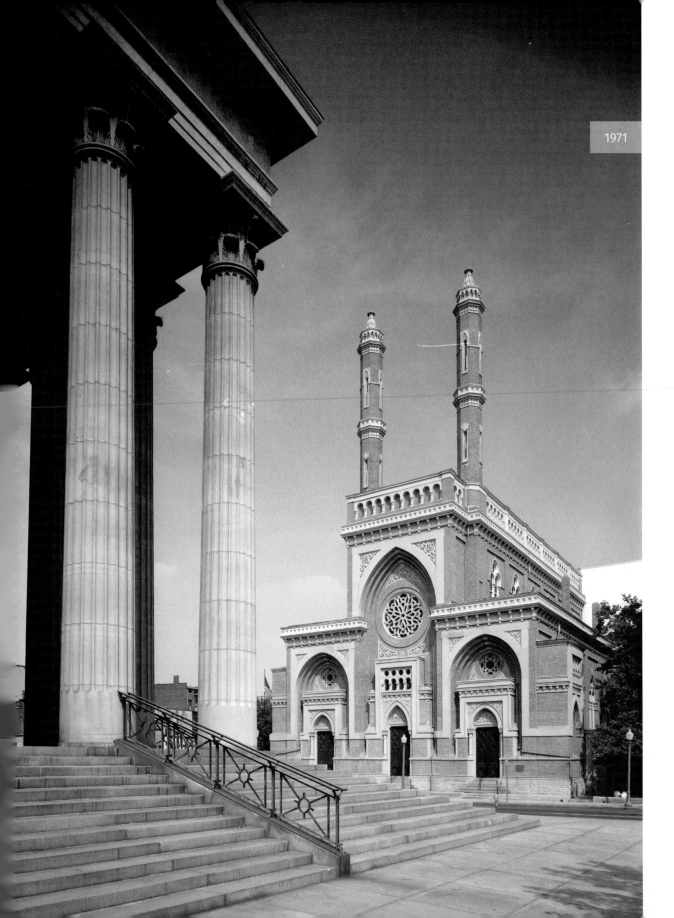

PLUM STREET TEMPLE

The Isaac M. Wise Temple was at the forefront of American Reform Judaism

LEFT: Set against the steps of St. Peter in Chains Cathedral in this 1971 photo, Plum Street Temple appears to be from a completely different country rather than across the street. The synagogue designed by Cincinnati architect James Keys Wilson is a mix of Moorish and Byzantine styles with a strong Gothic influence, inspired by the Alhambra palace in Granada, Spain. The rose windows, squared roofs, and twin minaret spires give the Jewish temple an exotic Eastern flavor. Plum Street Temple was built at Eighth and Plum streets in 1866 for the K. K. Bene Yeshurun congregation led by Rabbi Isaac M. Wise, the German-born founder of American Reform Judaism. Rabbi Wise spearheaded the national reform movement from Plum Street, and in 1875 he helped found Hebrew Union College, the oldest Jewish seminary in America. HUC now has campuses in Cincinnati, New York, Los Angeles, and Jerusalem. After the rabbi's death in 1900, the synagogue became Isaac M. Wise Temple, but is still often called Plum Street Temple.

RIGHT: The historic Isaac M. Wise Temple, now more than 150 years old, has been well preserved. The stone details still pop out against the red brick with no sign of deterioration. The interior is stunning and immaculate, thanks to a renovation between 1994-1995. Slim archways lead the eye to the concave domes set in the ceiling. The walls are colorful and delicately decorated. The flooring, pulpit, pews, and organ are all original, as are the chandeliers, although the gaslights have been converted to electric. On June 3, 1972, Hebrew Union College held the ordination of Rabbi Sally Priesand in Plum Street Temple. Rabbi Sally, as she preferred to be called, was the first female rabbi in America, and only the second woman rabbi in the history of Judaism. Wise Temple was named a National Historic Landmark. It is open most weeks for Sabbath services.

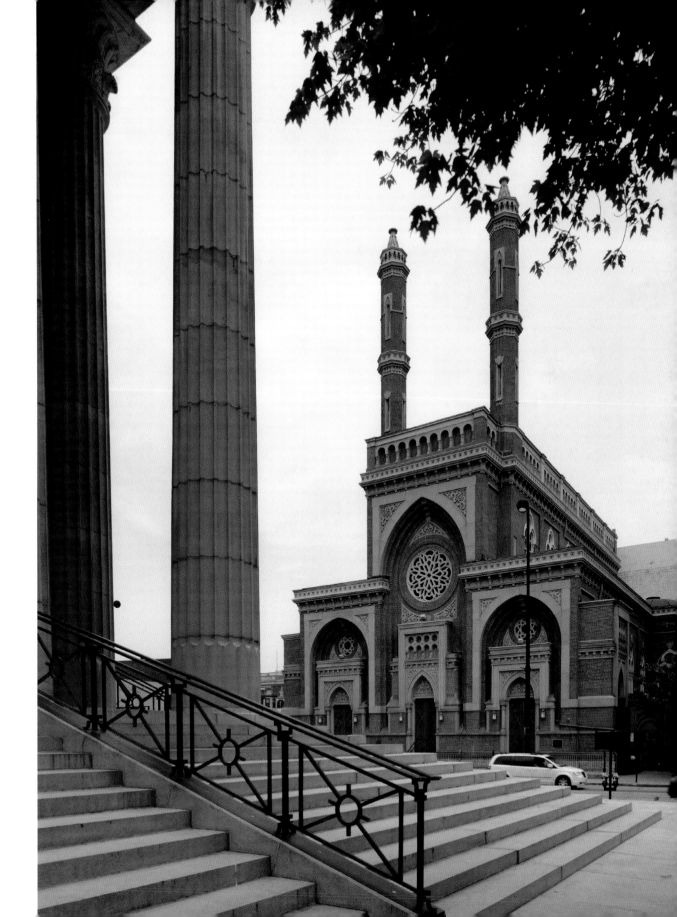

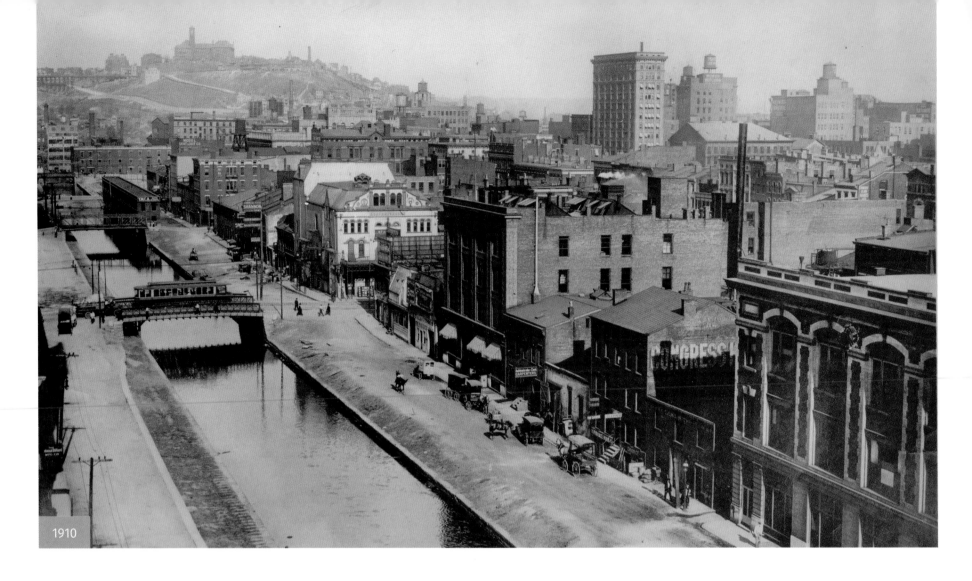

1910

MIAMI AND ERIE CANAL / SUBWAY

The canal made way for a subway system that was never opened

ABOVE: This 1910 photograph shows the Miami and Erie Canal along the current path of Central Parkway, looking east from Race Street, with Mount Adams in the distance. The canal was part of an inland waterway first proposed by George Washington connecting Lake Erie with the Ohio River. Construction lasted from 1825 to 1845, and reached the Ohio River in 1833. The path through Cincinnati, using current landmarks as reference, followed Central Parkway, turned down Eggleston Avenue, and emptied near the Daniel Carter Beard Bridge. Canal boats eighty feet long and fourteen feet wide hauled cargo or passengers on a

waterway which was as little as four feet deep. A mule walking along a towpath pulled the boat along at two-and-a-half miles per hour. The canal was a huge boost for Cincinnati as a transportation center, but railroads were soon ready to take its place. Use dwindled, and the canals became foul and septic. The Miami and Erie Canal shut down in 1929, but the Cincinnati section was already gone by then.

RIGHT: Construction of the twin subway tunnels was underway at the Plum Street "elbow" about 1920.

c. 1920

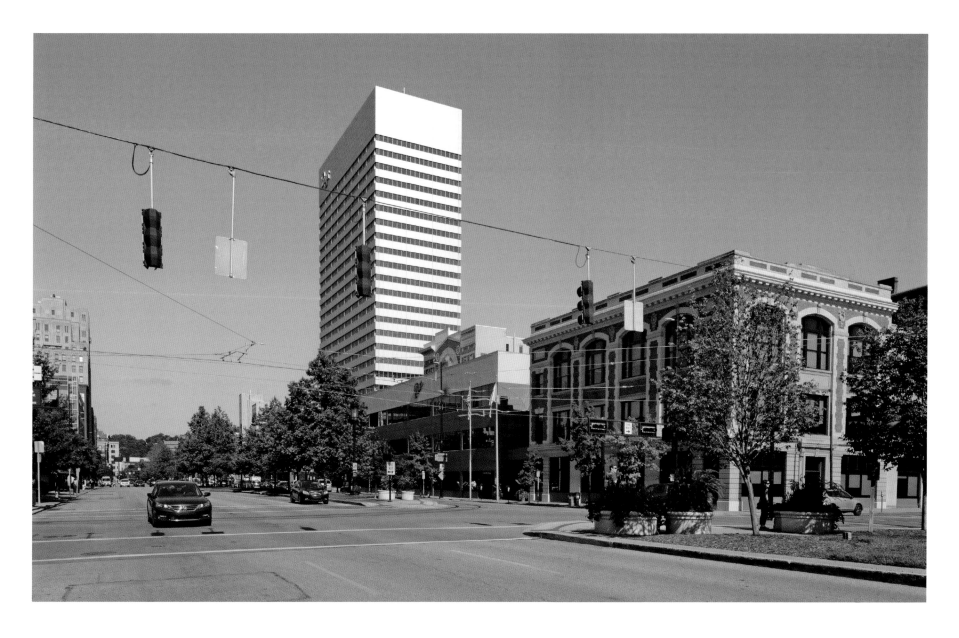

ABOVE: In 1907, landscape planner George E. Kessler proposed replacing the canal with Central Parkway, an attractive boulevard with strips of parkland. Plans for a new rapid transit system were folded in, and voters approved $6 million for a subway to run along the canal path. But World War I hit and costs skyrocketed. Voters were unwilling to approve more funds.

Construction of the scaled-back subway began in 1919. The canal was drained and 2.2 miles of tunnels and track were placed, but politics and funding problems got in the way and the project stalled even as Central Parkway was opened in 1928. When the Great Depression hit, the subway was no longer a priority and the project was never resurrected. Because the tunnels

help support Central Parkway, the city keeps them maintained. Never-used subway stations are relatively untouched in pitch-blackness. The Cincinnati Museum Center offered occasional tours of the abandoned subway, which has continued to fascinate people.

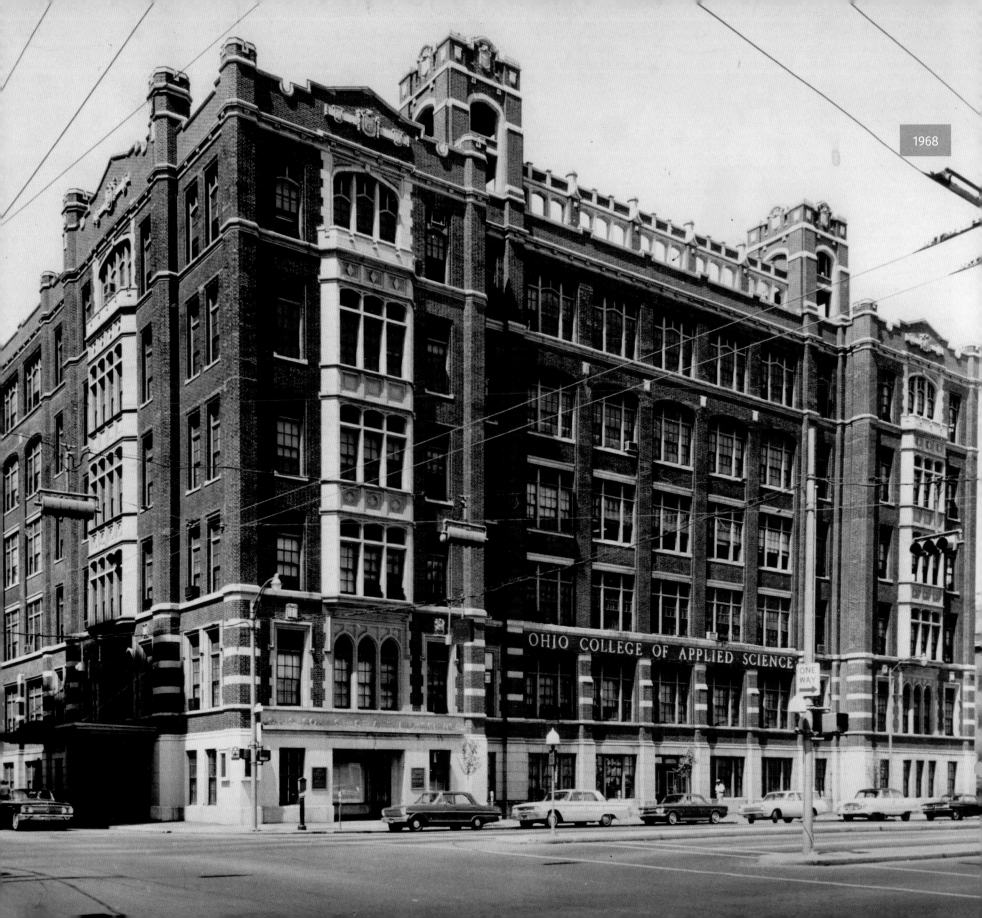

1968

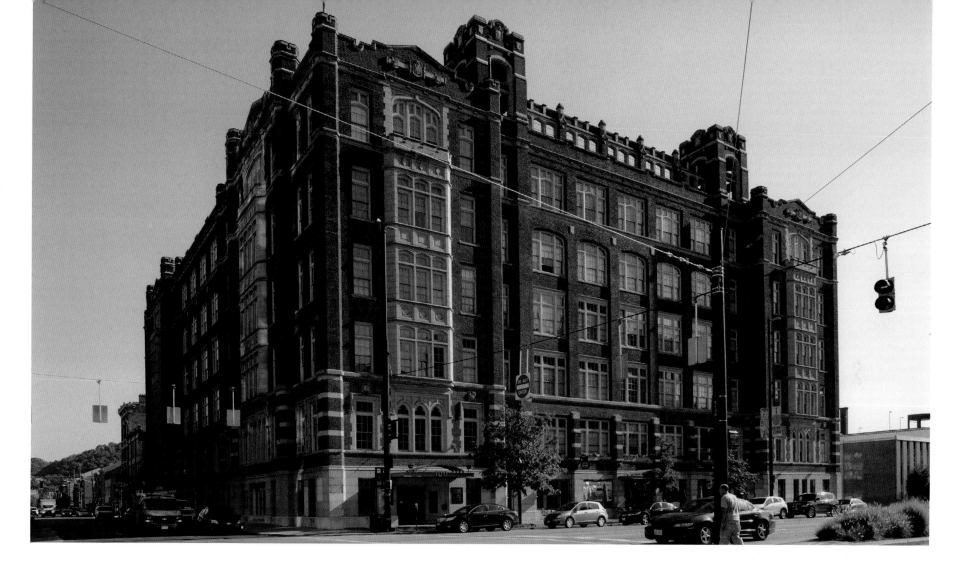

OHIO MECHANICS INSTITUTE & EMERY AUDITORIUM

Thomas Edison found inspiration in the OMI library

LEFT: Ohio Mechanics Institute was founded in Cincinnati in 1828 as a trade school for mechanics and other skilled workers. Their first home was Greenwood Hall, built in 1848 at Sixth and Vine streets. It was named for industrialist Miles Greenwood, who kept the institute afloat. Back in 1867, Thomas Edison often shirked his work as a telegraph operator to spend hours in the library reading every book he could find on electricity. Edison later sent an autographed photo to OMI and commented on its role in his education. The school moved to the English Tudor-style building along the canal at Walnut Street in 1911. Mary Emery funded the building and the auditorium built inside it for the Cincinnati Symphony Orchestra. In 1912, Leopold Stokowski conducted the inaugural concert at Emery Auditorium. A major blot on OMI's history was its refusal to allow African-American students until 1951. It was renamed the Ohio College of Applied Science in 1958, and absorbed into the University of Cincinnati in 1969.

ABOVE: Renovation of the large OMI building at 100 East Central Parkway was deemed too expensive, so UC moved the College of Applied Science to the main campus in 1989. Preservationists saved the Emery Theatre, which was renowned for its acoustic purity but hadn't seen much use since the CSO returned to Music Hall in 1936. The Mighty Wurlitzer organ from the Albee Theater was installed in the Emery in 1977, but when the auditorium was closed for renovation, the massive organ was moved to the Music Hall Ballroom in 2009. The OMI building is still owned by UC, but was leased to Emery Center Apartments, which converted the old engineering classrooms into apartments in 2001. Coffee Emporium, an artisan coffee roaster, occupies the street level space. Plans to restore the Emery Theatre have been mired in litigation for several years, but there is hope that music will once again resound from the historic theater.

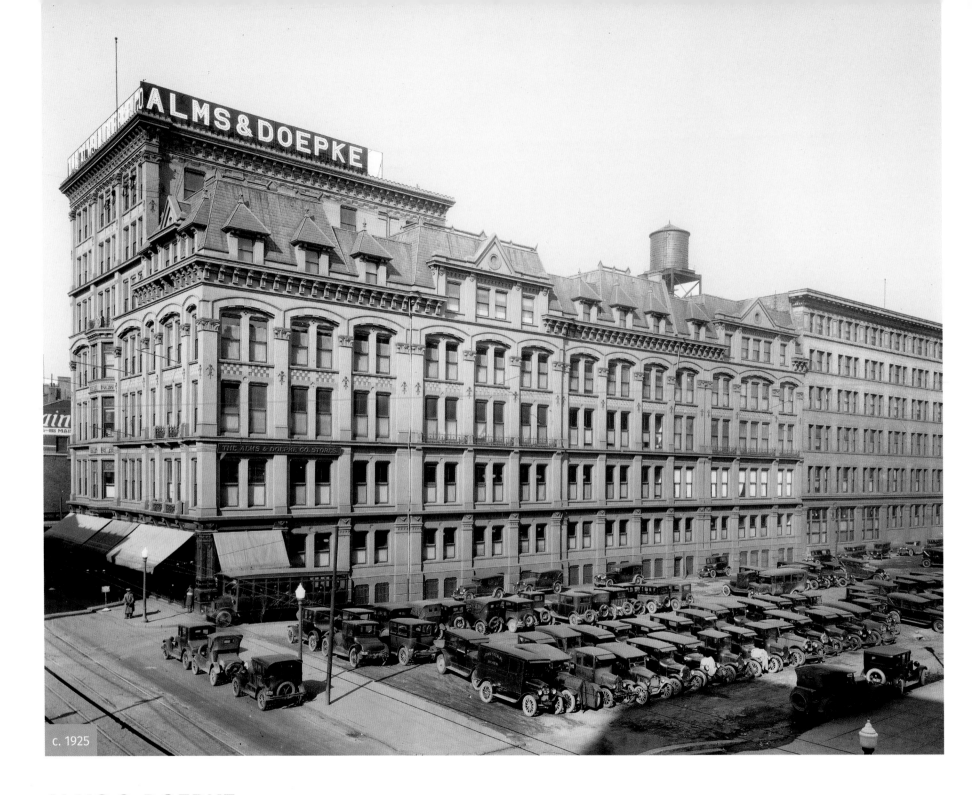

c. 1925

ALMS & DOEPKE

A department store with its own buses to transport customers

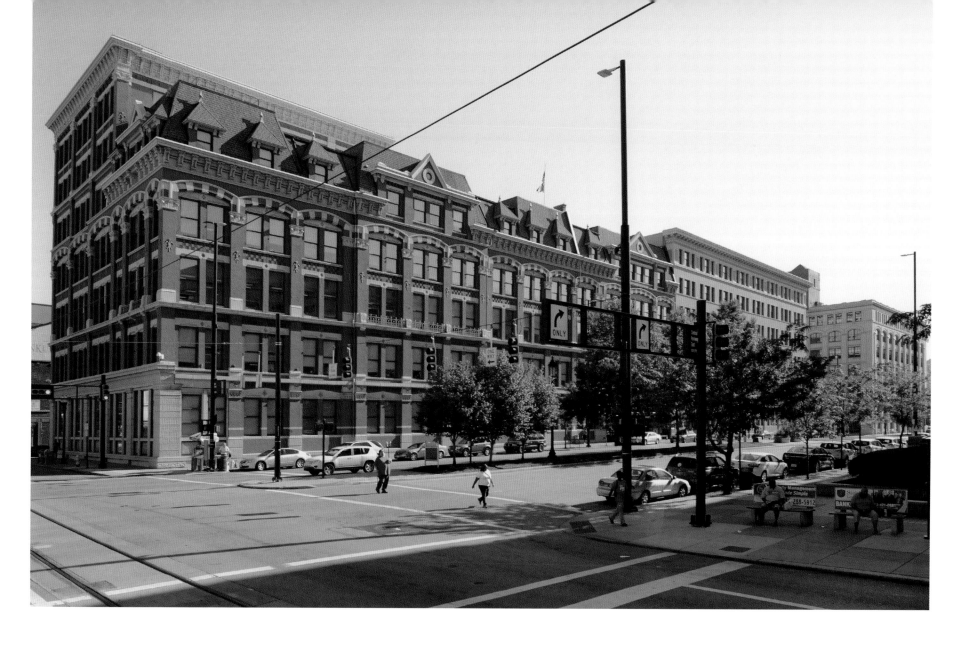

LEFT: The mammoth Alms & Doepke department store, shown in this photo around 1925, fills an entire block along Central Parkway between Main and Sycamore streets. The Alms & Doepke Company began as a three-way partnership between brothers William H. Alms and Frederick H. Alms, and their cousin William F. Doepke in 1865. By the end of the century, Alms & Doepke had grown to become the second-largest dry-goods store west of New York. They opened their first store on Main Street in Over-the-Rhine, and then moved to the property fronting the canal. The store was built in stages starting in 1878. Samuel Hannaford designed the main six-story Second Empire-style red-brick structure with stone trim, as well as the taller addition with the store sign in 1886 and the eastern extension in 1890. Chicago architect Daniel Burnham designed the less ornamental buff-colored section that fills out the block in 1906.

ABOVE: Since Alms & Doepke was so far from the city center, the store offered two buses, green and gold, in a loop around the shopping district and back to their Over-the-Rhine store. The buses were available for anyone, even non-customers, for less fare than local transit (five cents in 1920), and the receipt could be redeemed for the same price off merchandise at the store. As population declined in Over-the-Rhine, business dried up and Alms & Doepke closed in 1955. Their bus line was taken over by the Cincinnati Transit Company. The enormous Alms & Doepke building at 222 East Central Parkway has been used for local government offices, and currently houses Hamilton County Department of Jobs and Family Services. An overhanging canopy and modern glass doors at the entrance mar the building's aesthetics. In 1994, a $22 million renovation spruced up the building and removed a dull brick wall that had hidden the first-floor features for thirty-three years.

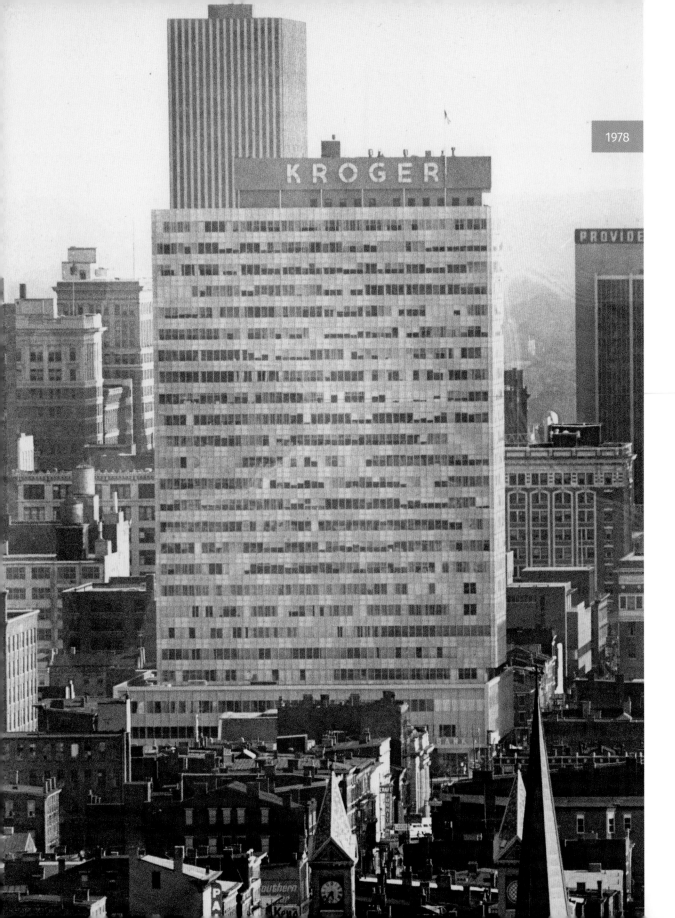

1978

KROGER BUILDING

Headquarters for Kroger grocery stores and Kenner toys

LEFT: The Kroger Building at Vine and Court streets overlooks Vine Street in Over-the-Rhine in 1978. Built in 1954, the glass and steel skyscraper covered in checkered blue-and-white steel plates wasn't as well received as other Modernist structures. It gave rise to the comment that the best view of the city was from inside the building. A renovation in 1980 replaced the colored tiles with uniform white stripes. Kenner Products moved into the Kroger Building in 1976. Founded in 1947 by the Steiner brothers, the toy company produced the Easy-Bake Oven and Spirograph. In 1977, filmmaker George Lucas partnered with Kenner to make toys for his then-unknown science-fiction movie, *Star Wars*. Kenner pioneered the 3¾-inch-size action figures to interact with the spaceship playsets. The movie became a smash hit, but the toys wouldn't be out by Christmas, so Kenner offered an "early bird certificate," an empty box with a promise to ship the figures when they were ready. Hasbro purchased Kenner in 1991, and the Cincinnati offices were closed in 2000. The original Kenner *Star Wars* action figures are now worth hunderds of dollars, collected by discerning aficionados the world over.

RIGHT: The Kroger Company owns the largest chain of grocery stores in the U.S. Barney Kroger established his first store, the Great Western Tea Company, on Pearl Street in 1883. By 1902, Kroger had forty stores under his name. Kroger now operates more than 2,500 supermarkets. Despite having its headquarters at 1014 Vine Street, Kroger hasn't had a grocery store in downtown Cincinnati since 1969. The company announced plans to build a two-story supermarket at Court and Walnut streets, to be completed in 2019. The section of Vine Street in Over-the-Rhine has undergone a recent resurgence. The giant PAINT sign is still a landmark, but rather than a paint supply store, the building houses a Japanese gastropub. Old Italianate buildings have been rehabbed for boutique stores and trendy restaurants. Upper parts of Over-the-Rhine, north of Liberty, haven't received that sort of attention yet. The double spires in the foreground belong to St. Francis Seraph Church, designed by James W. McLaughlin.

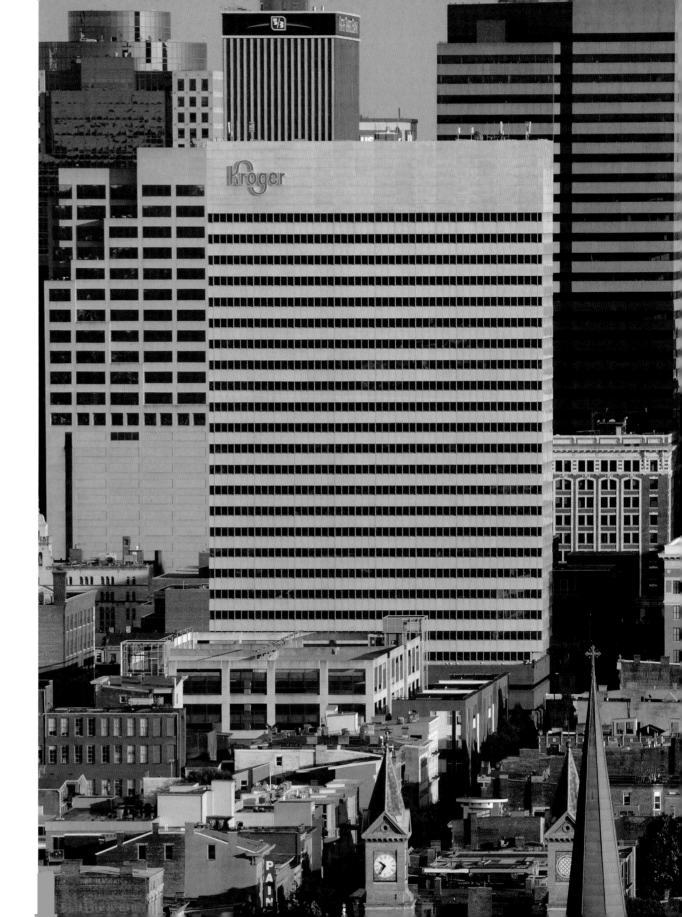

MEMORIAL HALL

Hall honoring Civil War veterans restored as theater

BELOW: The Hamilton County Memorial Building, commonly called Memorial Hall, was built at 1225 Elm Street in 1908 by the Grand Army of the Republic, a fraternal order of Union Army veterans, as a tribute to the Hamilton County residents who served in the Civil War and Spanish-American War. Designed by Samuel Hannaford & Sons in the Beaux Arts style, Memorial Hall is classical and solemn. Six Corinthian columns frame the three doors, while keystone busts of Mars, the Roman god of war, loom overhead. On a frieze above the entrance rest six figures in military uniforms from the Revolutionary War to the Spanish-American War by prominent local sculptor Clement Barnhorn. Inside, twin marble staircases lead to the 600-seat proscenium theater. For several decades, the G.A.R. and other military organizations used the hall for meetings and events, but as those groups faded the hall was empty and neglected. Although it was listed on the historic register, by 1981 Memorial Hall was an over-looked neighbor to Music Hall.

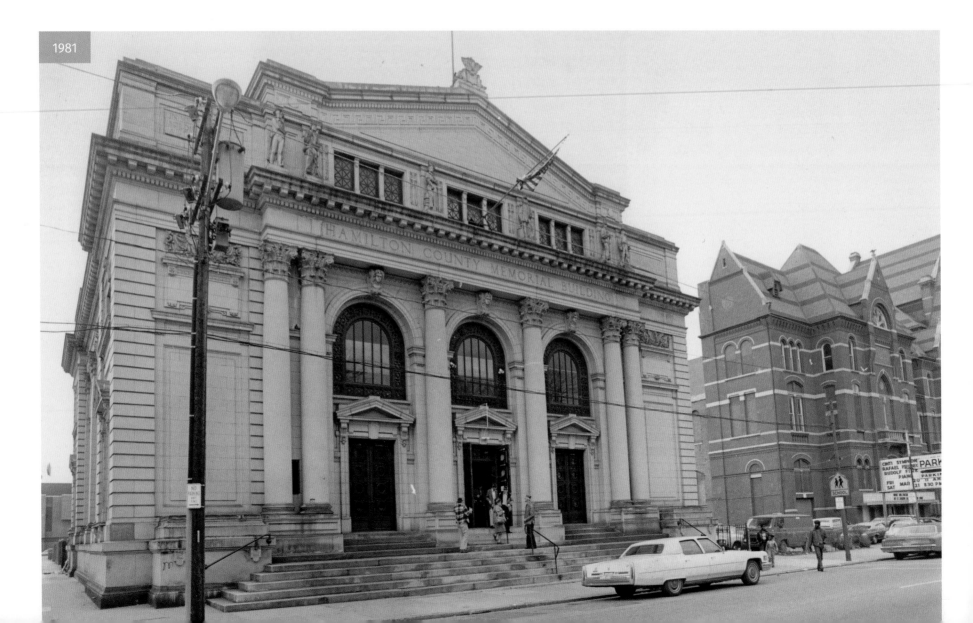

1981

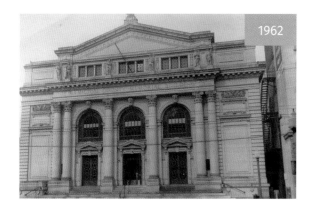

1962

BELOW: Over the years, the Cincinnati Preservation Association, under several names, has not only kept Memorial Hall from crumbling, but carefully restored it as an attractive asset to Over-the-Rhine. In 2016, a major $11 million renovation overseen by 3CDC completely restored the historic hall to its glory, while updating the amenities. The interior is stunning as natural light pours through the second-story arched windows, marble and woodwork glistens, and plaster bas-relief ornamentation looks brand new. The theater, renewed to its turn-of-the-century elegance with Tiffany chandeliers and ceiling mural, was intended for speeches, but the acoustics make it perfect for music and theater as well. Rebranded as Memo, it also houses the American Classical Music Hall of Fame and Museum. Memorial Hall overlooks the recently restored Washington Park and is a neighbor to Music Hall, the School for Creative and Performing Arts, and the new Cincinnati Shakespeare Company theater, as part of a revitalized arts and culture enclave.

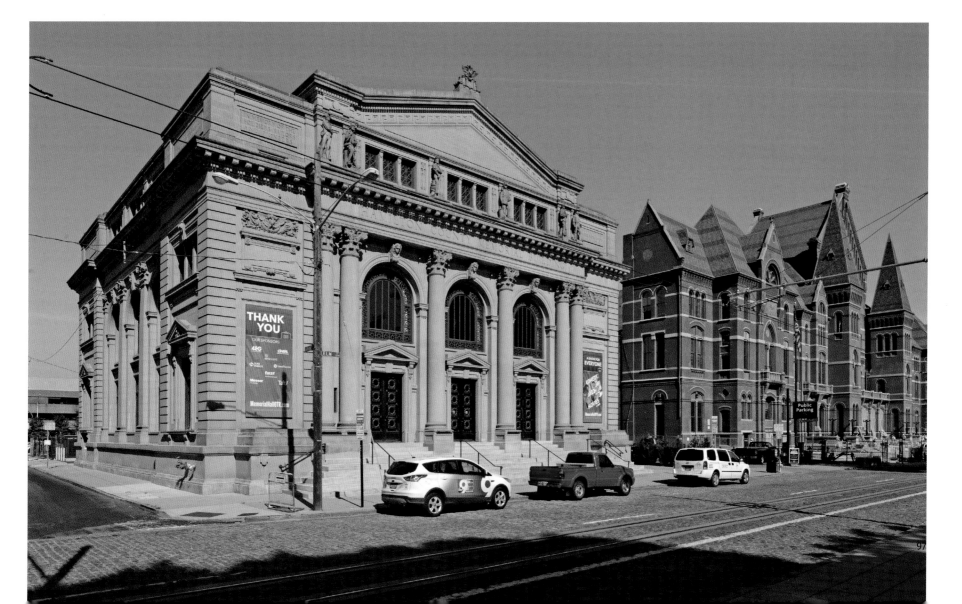

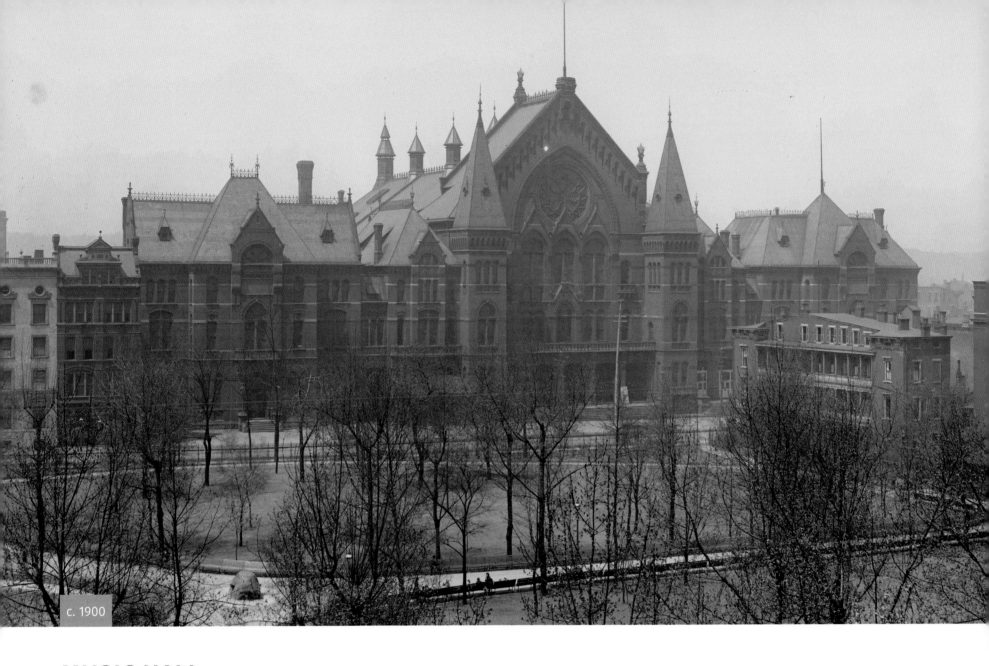

c. 1900

MUSIC HALL
Cincinnati's grand "temple to music"

ABOVE: Music Hall is the jewel in the Queen City's crown. Although credited to partners Samuel Hannaford and Edwin R. Procter, Music Hall is Hannaford's masterpiece and established his reputation as the city's premier architect. Completed in 1878, the Victorian Gothic hall at 1241 Elm Street was built as a temple to music, with a vast auditorium and superb acoustics. Music Hall replaced Saenger Halle, built for May Festival choral concerts. Reuben R. Springer offered to pay half the cost if the citizens matched it. Exhibition halls were added as wings to accommodate expositions. Music Hall has hosted the 1880 Democratic National Convention, the 1888 Centennial Exposition, Leopold Stokowski's American debut, and George Gershwin's first performance of *Rhapsody in Blue* outside New York. The Over-the-Rhine site had previously been a potter's field and orphan asylum, which has led to Music Hall's reputation of being haunted. Washington Park across from Music Hall had also been a burial ground until 1855. The city asked families to relocate loved ones' remains, but many were not moved. Gravestones were laid flat and the park built on top of them.

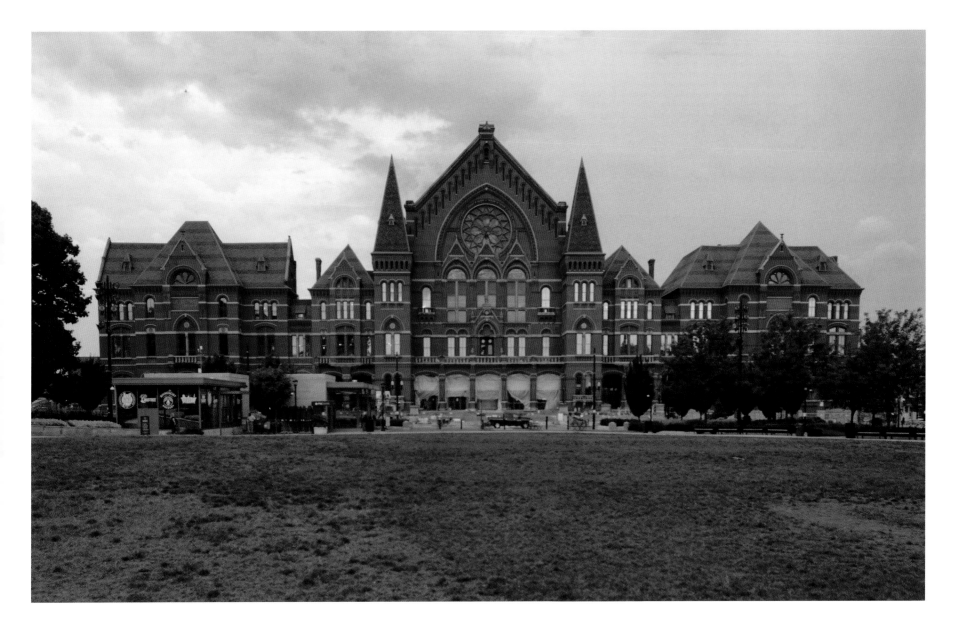

ABOVE: Music Hall was recognized as a National Historic Landmark in 1975, but it has been a treasured icon since it opened. It's the current home of the Cincinnati Symphony Orchestra, May Festival, Cincinnati Opera, and Cincinnati Pops. For many people, attending a performance at Music Hall was their only venture into Over-the-Rhine, which may have been otherwise impoverished until recent efforts by the city and groups like 3CDC have turned the neighborhood around. A major renovation of Washington Park in 2010 restored the park to its former glory, with a venue for outdoor concerts, a dog park, a children's playground, and water features. In 2013, the CSO presented the first "LumenoCity," a free live concert in Washington Park that accompanied an animated light show projected onto the face of Music Hall. More than 35,000 people attended the first shows. In 2016, Music Hall began a $135 million renovation throughout to upgrade the auditorium with new seating, remodel the foyer, and attend to much-needed structural repairs. The restored Music Hall reopened in October 2017.

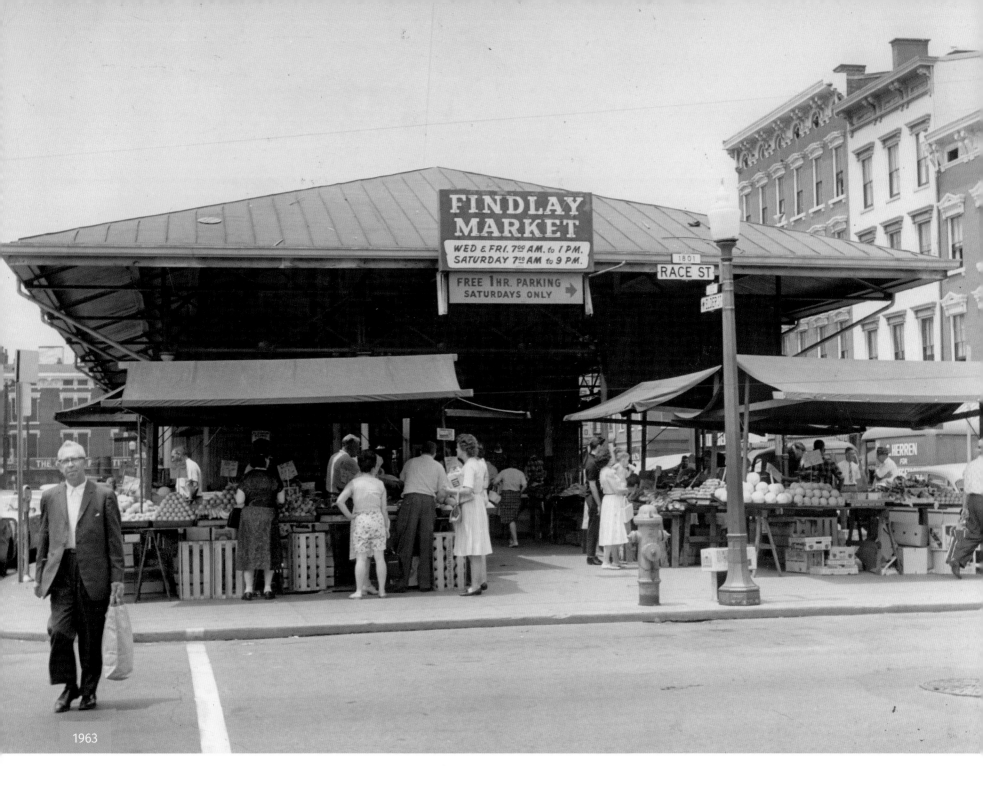

1963

FINDLAY MARKET

A public market at the heart of Over-the-Rhine

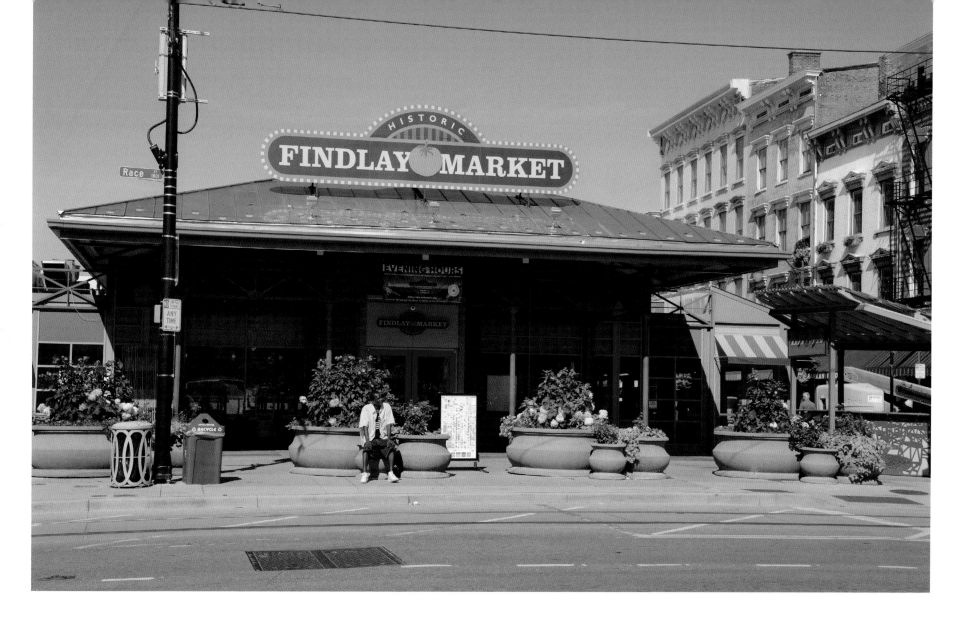

LEFT: Findlay Market has been called the heart of Over-the-Rhine. It has served the neighborhood throughout the years while all around it changes. Before 1849, the area north of Liberty Street was called the "Northern Liberties" because it was outside Cincinnati's corporation line and the city's laws did not apply. The heirs of General James Findlay, an early Cincinnati settler, donated a parcel of his land to be used for a public market. Findlay Market's first market house opened in 1855. Some of the original cast-iron supports of the open shed are still visible. German immigrants settled into the area, which they called "Over the Rhine" because it was across the canal. With Germans came breweries and sausage making that defined the neighborhood. Since 1921, Findlay Market has sponsored the Opening Day parade, which starts at the market, celebrating the city's unofficial holiday of the Cincinnati Reds' first game of the season. The photo of Findlay Market's Race Street entrance in 1963 captures the neighborhood market in a moment of transition.

ABOVE: As urban development gobbled up the public markets downtown, Findlay Market has remained because Over-the-Rhine is a walking neighborhood. Germans gave Over-the-Rhine its name, but since the mid-twentieth century, it has been predominantly African-American. Construction of the interstate and Union Terminal wiped out much of the West End, displacing the mostly black population to Avondale, Bond Hill, and Over-the-Rhine. The largest collection of original Italianate architecture in the world languished in poverty and neglect. People and organizations seeking to restore the neighborhood have invested in the buildings and sparked redevelopment. Improvements go hand in hand with higher prices, and as Vine Street and Main Street became OTR hotspots for restaurants, boutique shops, and bars, the poorer residents no longer had a home. Findlay Market has managed to straddle both worlds. The restored, colorful market house attracts OTR residents and visitors alike. When the streetcar returned in 2016, the route was sure to connect to Findlay Market.

GERMANIA BUILDING

Now restored to its original name after a hundred-year cover up

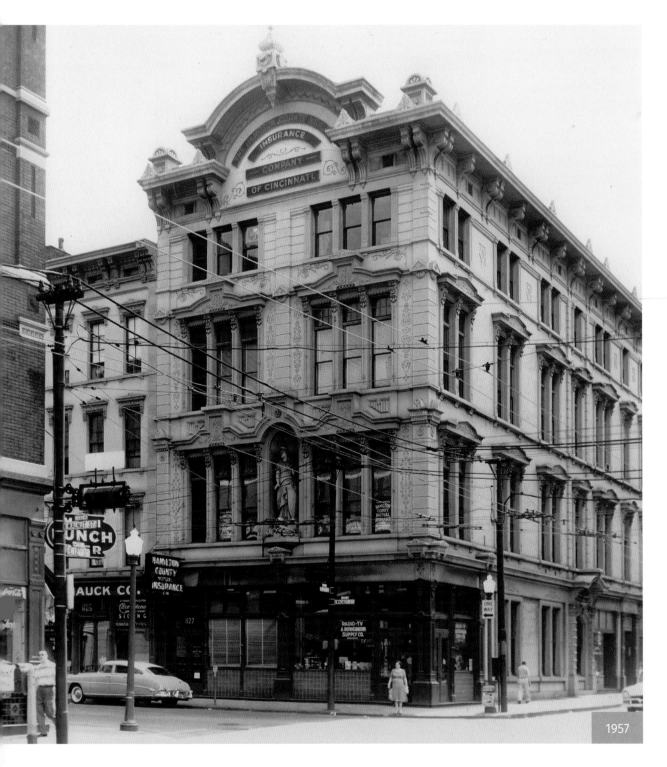

1957

LEFT: The twenty-five-foot-tall stone figure of Germania perched on the second-story niche of the Germania Building personifies the German spirit that flowed through Over-the-Rhine throughout the nineteenth century. The Germania Building at 1129 Walnut Street was built in 1877 as the headquarters of Heinrich A. Rattermann's German Mutual Insurance Company. German-American architect Johann Bast designed the limestone Renaissance Revival building noted for its ornate cornice and features. The star is Germania herself, who defends culture represented by symbols of art and science at her feet. During World War I, anti-German hysteria swept through the city. German language classes were dropped from Cincinnati schools. German books were relegated to the library basement. Fearing a backlash, Rattermann changed the name to the Hamilton County Insurance Company of Cincinnati and the Germanic name on the pediment was covered up. Germania herself was rechristened Columbia and draped in an American flag. The U.S. motto "E Pluribus Unum" was chiseled into her hem, and an eagle was added to her breastplate.

RIGHT: In 2014, one hundred years after the start of the Great War, the Germania Building's original business name was finally restored. Crews removed the plates covering the original lettering that spelled out "Deutsche Gegenseitige Versicherungs Gesellschaft von Cincinnati" (German Mutual Insurance Company of Cincinnati). Spruced up, the Germania Building basks in the sun the way it must have looked in 1877. Cincinnati's German-American heritage, particularly the beer-brewing portion, is alive and well these days. Bockfest, an annual celebration of Cincinnati's brewing history, has been around for a quarter of a century. Historic breweries shuttered for decades are back in working order producing new Rhinegeist and Christian Moerlein beers. And wearing lederhosen seems perfectly natural at Oktoberfest Zinzinnati.

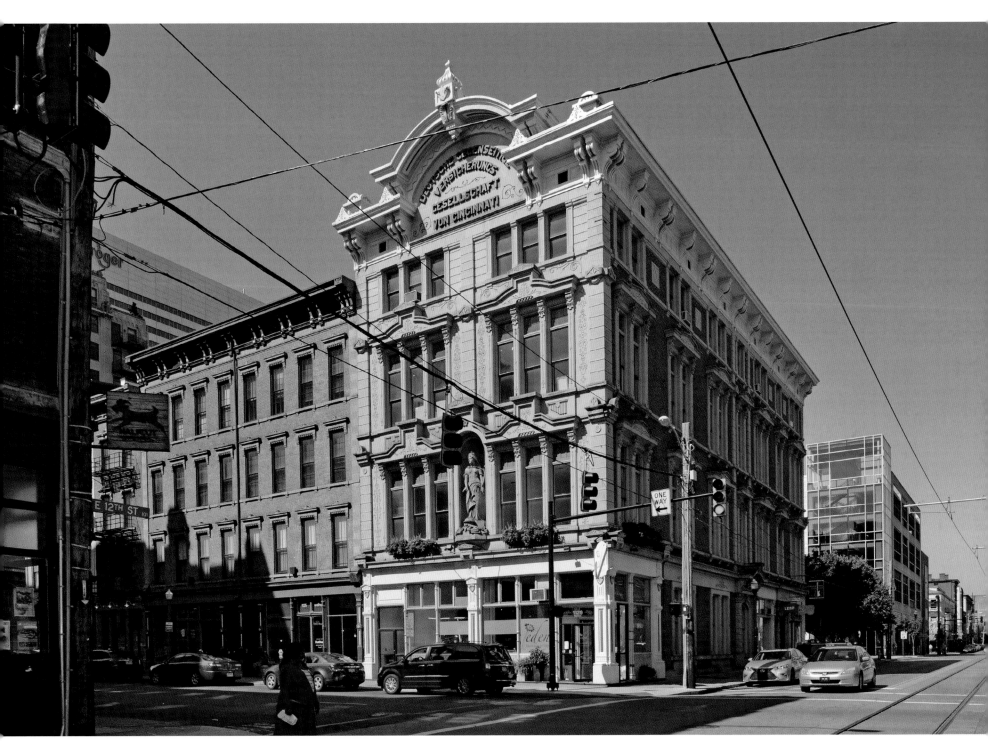

UNION TERMINAL
One of the greatest designs of the Art Deco era

1933

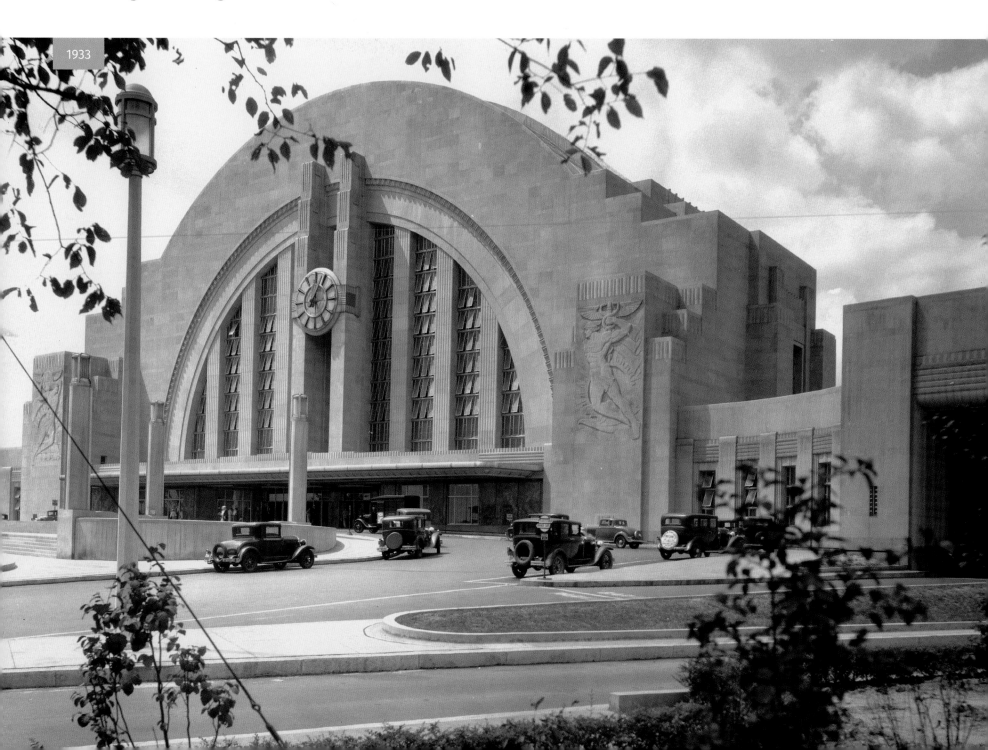

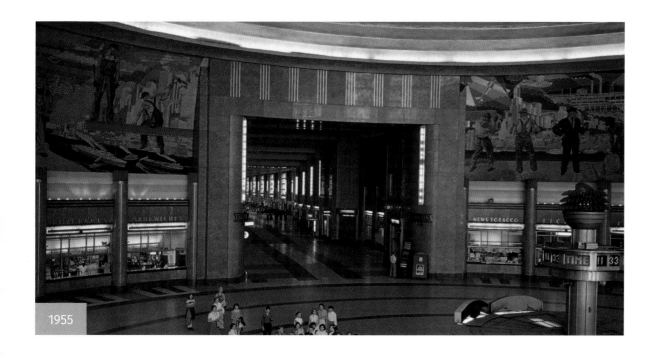

1955

BELOW: Trains eventually stopped coming as freeways and automobiles dominated transportation. The last passenger train left Union Terminal in 1972. Amtrak returned for limited use in 1991, but the concourse had been torn down in 1974. Reiss's murals, all but the large map mosaic, were saved and transported to the Cincinnati and Northern Kentucky International Airport in Hebron, Kentucky. When the airport terminal closed, the murals were installed along the Central Avenue exterior of the Duke Energy Center. In 1990, Union Terminal was transformed into the Cincinnati Museum Center, which houses the Cincinnati History Museum, the Museum of Natural History & Science, Duke Energy Children's Museum, an Omnimax theater, and the Cincinnati History Library and Archives. In 2014, voters passed Issue 8, a temporary sales tax increase to fund much-needed repairs on Union Terminal so that the National Historic Landmark will continue to be one of the city's treasures.

LEFT: Union Terminal opened in 1933 as a solution to Cincinnati's need for a centralized train depot. In the 1920s there were five train stations spread across the city, so passengers had to traverse several blocks with their luggage to switch trains. Authorization for a new union station came a few months before the stock market crash in 1929 triggered the Great Depression. Construction began in 1930. The New York firm of Alfred Fellheimer and Stewart Wagner designed the Art Deco masterpiece. The half dome has become iconic, even serving as inspiration for the Hall of Justice in the *Super Friends* cartoon. The remarkable interior design by Winold Reiss, which complements the Art Deco in warm 1930s colors, welcomed travelers with the incredible mosaic murals painstakingly made by Reiss. The rotunda murals depict the evolution of travel and the region, while the concourse murals paid tribute to the city's working class and industries, from P&G and Rookwood to Kahn's meatpackers, U.S. Playing Card, and Cincinnati Milling Machine.

ABOVE: The mosaic murals by Winold Reiss greet travelers to Union Terminal in 1955.

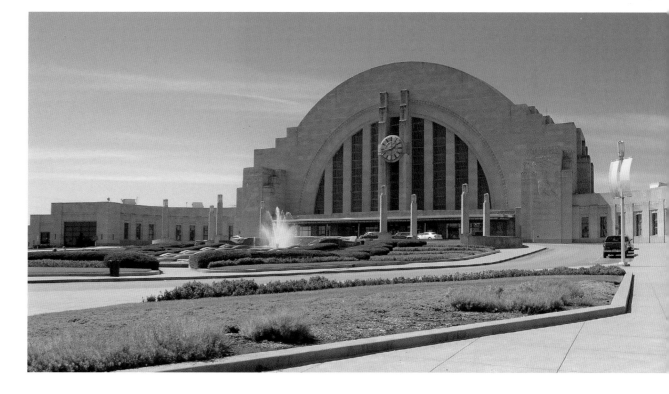

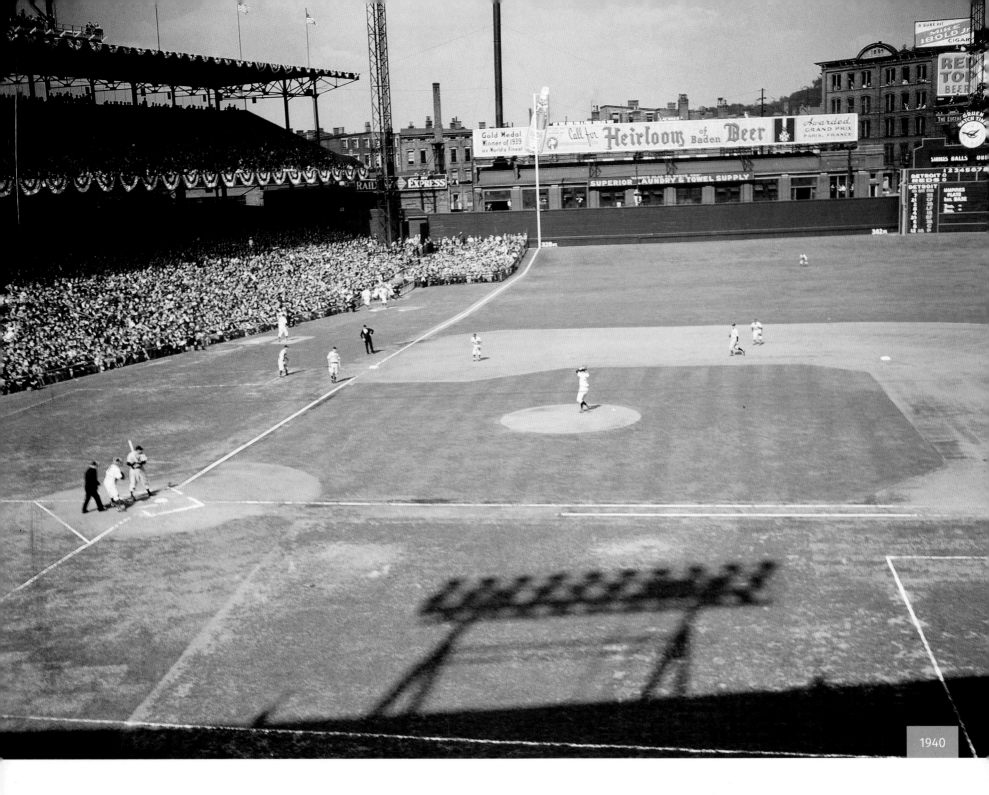

1940

CROSLEY FIELD

Reds' historic ballpark, a place where history was made

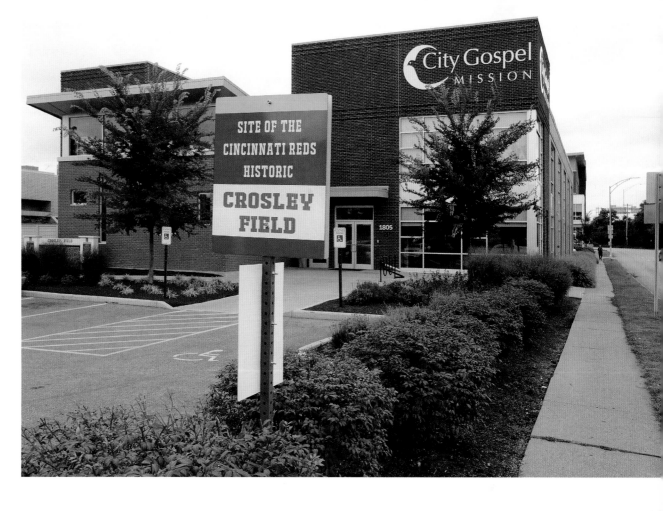

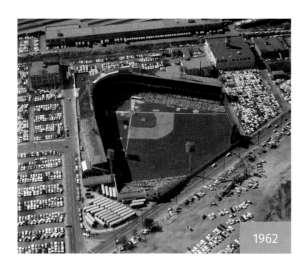

1962

LEFT: If it were around today, Crosley Field would be regarded with the same reverence as Wrigley Field or Fenway Park. Built in 1912, it replaced League Park and the distinctive Greco-Roman grandstand known as Palace of the Fans at the same location at Finlay Street and Western Avenue. Harry Hake's design was a working-class ballpark among warehouses and rail yards. The stands were close to the players. The quirky left-field terrace was at a fifteen-degree incline, which confounded visiting players. The ballpark was known as Redland Field until 1934, when Powel Crosley Jr. purchased the team. Crosley was a field where memories were made: the 1919 World Series, tainted by the "Black Sox" scandal; the 1937 flood that left the field twenty-one feet underwater; the Beatles' rain-delayed concert in 1966; and the night of May 24, 1935, when President Franklin D. Roosevelt flipped a switch in the White House that turned on the lights at Crosley Field for the first night game in Major League Baseball history. In this rare color photo of the period, the Reds face the Detroit Tigers in the 1940 World Series.

ABOVE: Aerial view of Crosley Field from 1962.

ABOVE AND RIGHT: The final game at Crosley Field was played on June 24, 1970. Home plate was delivered by helicopter to Riverfront Stadium to play the next game in the multipurpose arena to be shared by the Reds and the Bengals. Many of the players had tired of Crosley's antiquated locker room and were excited about the new facilities, but fans were not ready to give up Crosley Field from their hearts. Crosley's seats were sold as memorabilia. A fan built a replica of the field in Blue Ash and used the original blueprints to re-create the Longines scoreboard. The abandoned ballpark sat empty, overgrown with weeds, until the wrecking ball came in 1972. The field was paved over as part of Queensgate, and Dalton Avenue was extended through what used to be right field. When City Gospel Mission opened a new homeless rehab shelter at the site in 2015, they incorporated original seats, markers, and murals to commemorate historic Crosley Field.

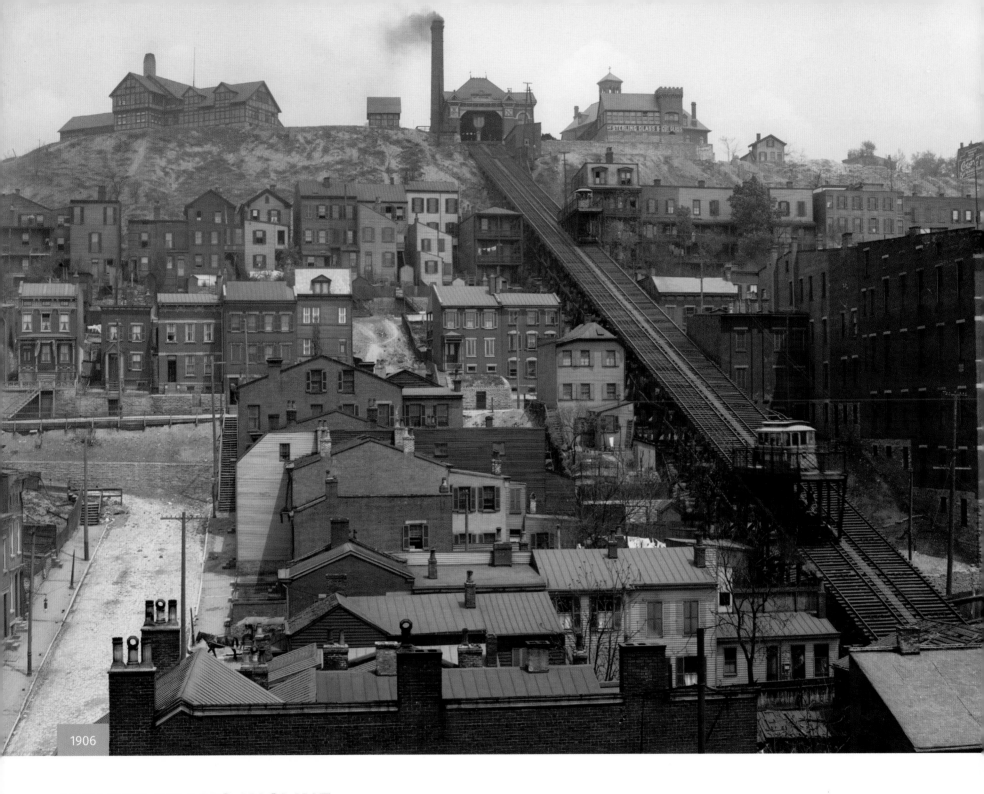

1906

MOUNT ADAMS INCLINE

The last of the inclines closed in 1948

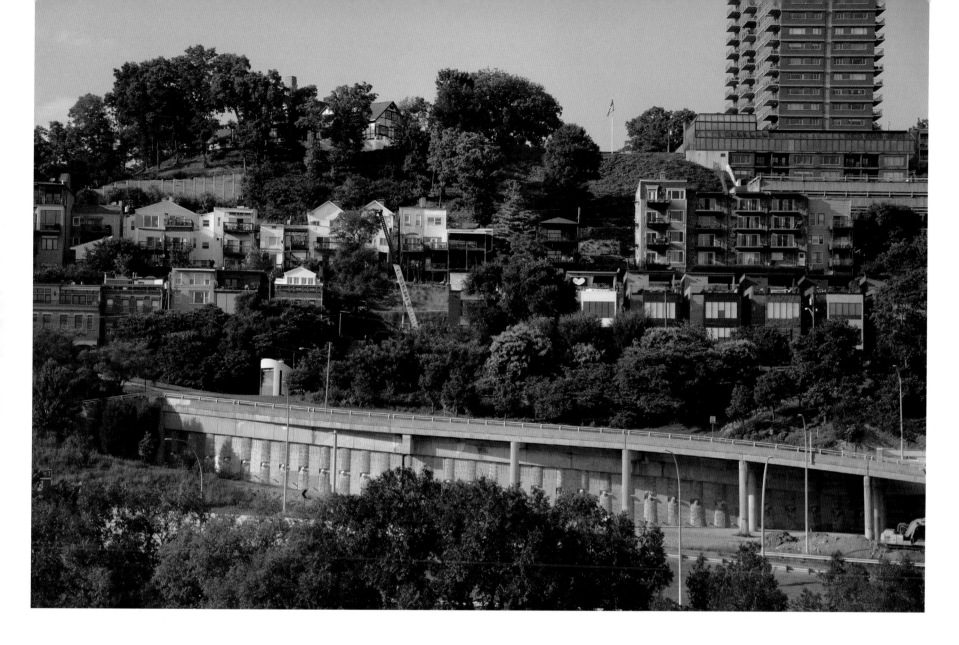

LEFT: Folks are still nostalgic about the Mount Adams Incline, the last of Cincinnati's five inclines, recalling streetcar rides up the hill on the way to the zoo or Eden Park. The incline was more than a novelty. It was a solution to the problem of scaling the hills to give folks some room. By the 1870s, the city basin was cramped and choked by smoke and soot. Only the rich could afford transport to the hilltop suburbs, until the inclines were introduced in 1872. The inclines, or funiculars, had twin railroad tracks on an inclined plane on the hillside. The powerhouse on the summit held two steam engines that cranked passenger cars along steel cables. As one car went up, the other went down. The Mount Adams Incline opened in 1876. The Highland House, a hilltop resort next door, supplied ample beer and shows to attract passengers. In this 1906 photo, the Sterling Glass Works had replaced the Highland House, and Rookwood Pottery is pictured on the left.

ABOVE: The Cincinnati Traction Company, which ran the streetcars, also took over the inclines (except for the Price Hill Incline). As far as they were concerned, the inclines were a nuisance that slowed down streetcar traffic, but they were popular so they stayed. However, whenever an incline was closed for repairs, it was never reopened. The Mount Adams Incline lasted the longest, until 1948. By then, automobiles had replaced the need for a special transport up the hills. The inclines truly did become a novelty, although one fondly remembered. It is difficult to picture where the tracks to the Mount Adams Incline went now that the pylons have been demolished. The toe of Mount Adams, where the station house was located, was chopped off for the interstate. Rookwood Pottery is still there, while the Highland Tower Apartments stand where the Highland House once beckoned passengers.

ROOKWOOD POTTERY

Cincinnati heiress Maria Longworth Nichols Storer made Rookwood Pottery world renowned

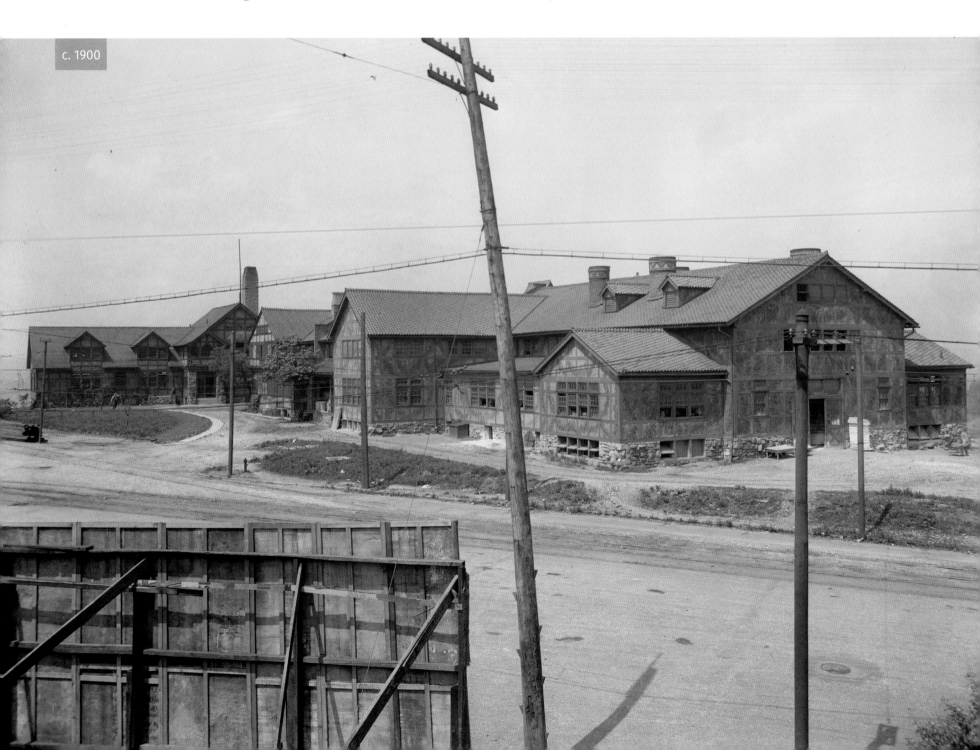

c. 1900

LEFT: Maria Longworth Nichols Storer was the force behind the world-famous Rookwood Pottery. Born into the wealthy Nicholas Longworth family, Maria found a passion for painting china. Some of her work was displayed at the 1876 Centennial Exposition in Philadelphia, and she was inspired by Japanese pottery. Her father offered her an old schoolhouse on Eastern Avenue in Fulton as a studio, which she named Rookwood Pottery after her father's country estate in Walnut Hills that had a large number of crows. The kiln produced Maria's first Rookwood wares on Thanksgiving Day, 1880. Many of her designers were wealthy women more interested in creating than building a business. The pottery quickly earned a reputation for its decorations, prompting a visit from Oscar Wilde in 1882. Rookwood Pottery's new studio in Mount Adams, designed by H. Neill Wilson, the son of architect James Keys Wilson, opened in 1892. The half-timber buildings reflect both English and Japanese influences. The gingko-leaf patterns on the stucco are especially noticeable in this photo from about 1900.

BELOW: Rookwood pottery was produced at the studio on Celestial Street in Mount Adams until 1941. Rookwood tiles are often found in decorative fireplaces and bathrooms in area homes of the period. Attempts to revive Rookwood over the years, starting in the 1940s, have had varying degrees of success. In the 1980s, Dr. Arthur Townley, a Michigan dentist and Rookwood pottery collector, used his life savings to purchase the Rookwood assets and stored the molds and notes in his basement to keep them from being sold overseas. The Rookwood Pottery Company returned to Cincinnati in 2004 and has set up a studio on Race Street in Over-the-Rhine where once again the decorative pottery and tiles are produced. A fine-dining restaurant known as The Rookwood opened up in the Mount Adams studio building in which diners could even be seated in the kiln. The latest version of the Rookwood restaurant closed at the end of 2016.

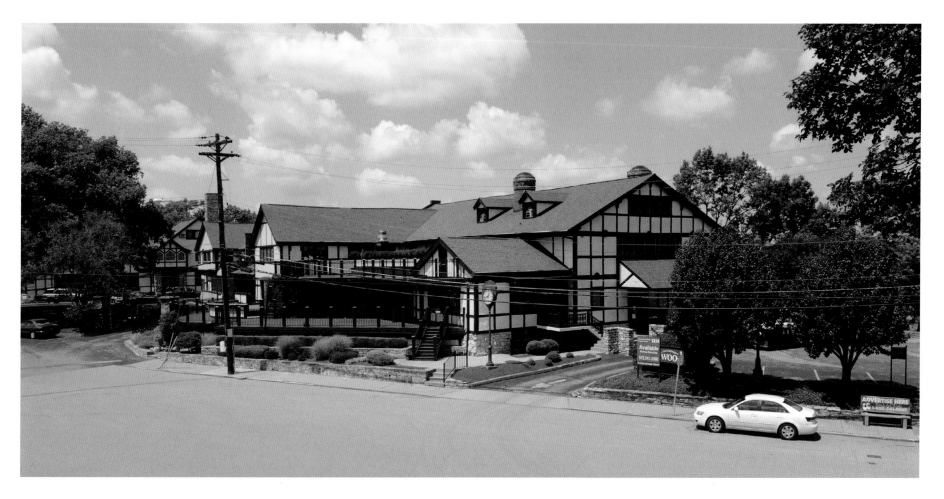

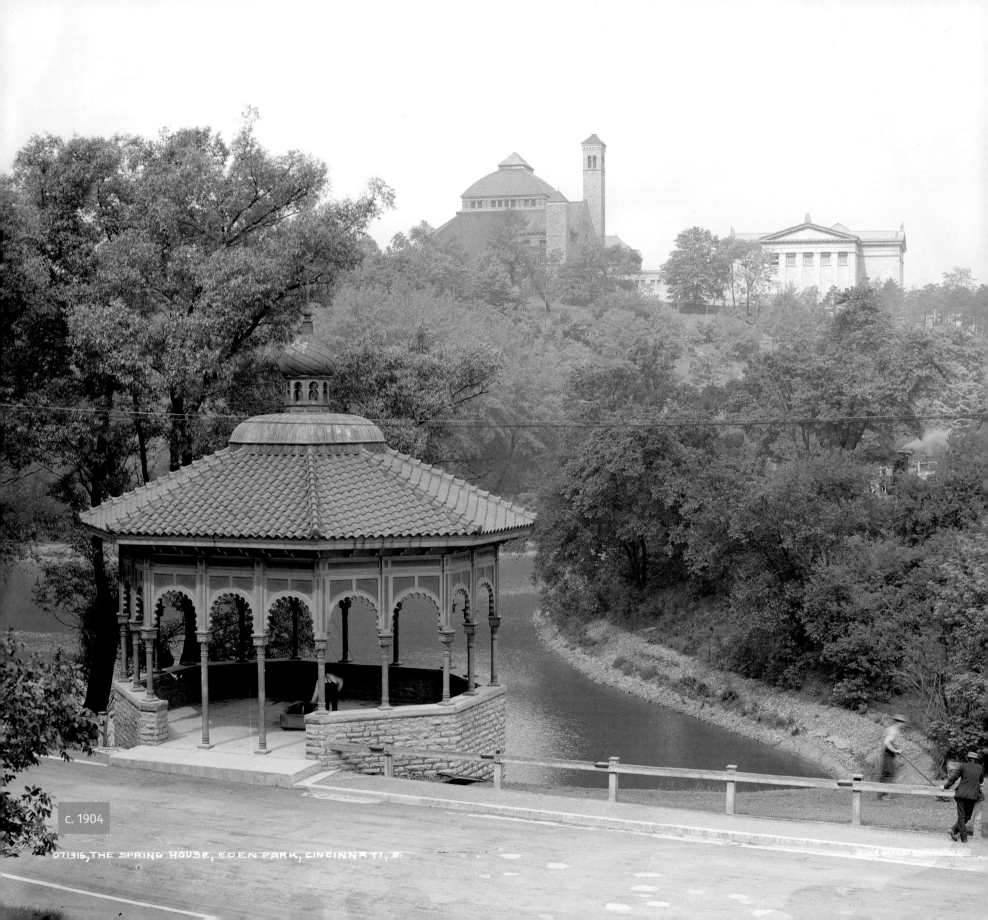

c. 1904

071316, THE SPRING HOUSE, EDEN PARK, CINCINNATI, O.

EDEN PARK
Indisputably Cincinnati's favorite park

LEFT: The Detroit Publishing Company took many turn-of-the-century photographs to be used for postcards, and Eden Park was a frequent subject. The city decided to use Mount Adams for a reservoir, and bought up acres of the aptly named Eden Park from Nicholas Longworth. The reservoir, completed in 1878, consisted of two basins. The eastern retaining wall had eight large elliptical archways. The drinking water wasn't treated until 1907, when a new water plant was built upriver, but it was always uncovered. Eden Park's lush foliage and winding paths were created by Adolph Strauch, the landscape architect responsible for Spring Grove Cemetery. The park is also blessed with striking architectural features. Samuel Hannaford designed pumps and water towers as Romanesque castle keeps. The park's centerpiece is the lovely Spring House Gazebo built in 1904 by architect Cornelius M. Foster. The colorful Moorish-style gazebo features scalloped arches and a tile roof topped with an onion-dome finial.

ABOVE: Eden Park continues to live up to its name, and is undisputed as the city's favorite park. The tower to the Cincinnati Art Museum, which opened in 1886, is just visible over the tree line. Cincinnati Playhouse in the Park is also beyond the foliage. Founded in 1960, the playhouse won Tony Awards for Regional Theatre (2004) and Best Revival of a Musical (*Company*, 2007). Further along Eden Park Drive we find Krohn Conservatory, formerly the Eden Park Greenhouse, built in 1933. The glass and aluminum Art Deco structure has a rain forest with exotic plants and a waterfall, a desert habitat with various cacti, and an orchid house. Every year, Krohn hosts a butterfly show in the spring, and a live nativity scene at Christmas. Eden Park's reservoir was demolished in the early 1960s, replaced by Mirror Lake, a shallow reflecting pool and fountain. Remnants of the reservoir retaining wall still stand, looking like the ruins of a Roman aqueduct, and are used for rock climbing.

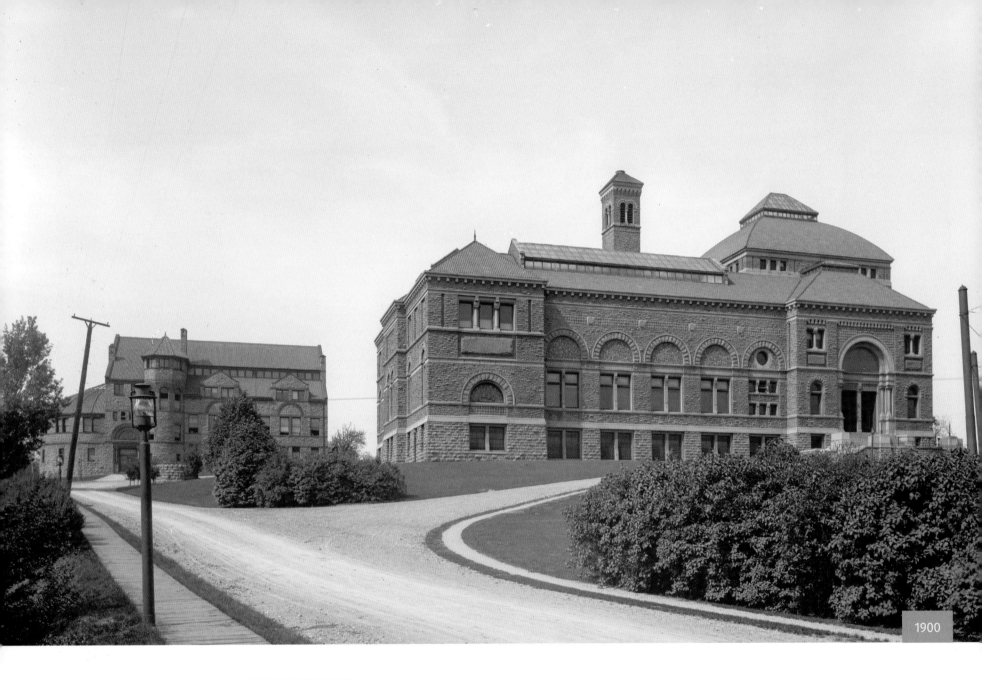

1900

CINCINNATI ART MUSEUM

The original buildings are still intact, but encased and hidden behind more recent additions

ABOVE: The Cincinnati Art Museum was part of the city's cultural renaissance in the late nineteenth century. The Cincinnati Art Museum Association was incorporated in 1881 and acquired the first objects for its collection. James W. McLaughlin was hired to design both the museum and the next-door Art Academy of Cincinnati, the smaller building on the left, on a hilltop in Eden Park. Both buildings, as seen in 1900, are in the Richardsonian Romanesque style and were originally separate buildings, though they have since become connected as the complex expanded. The Art Museum building was dedicated in 1886. McLaughlin's design had included a clock tower and a rounded eastern end of the museum that mimicked the Art Academy's western section, but they were never built. The Art Academy started as the McMicken School of Drawing and Design in 1869, then became a part of the University of Cincinnati from 1871 until this building was completed in 1887.

ABOVE: Today, the Cincinnati Art Museum (CAM) hardly resembles the one in the other photo. Incredibly, McLaughlin's original buildings are mostly intact, but nearly encased by expansions of other wings in different architectural styles. The Art Academy building now connects to the museum, and its roofline has been capped. Romanesque towers peek over the current structure. This isn't even the view most patrons identify with CAM. The Schmidlapp Wing, a classical façade with Doric columns and a triangular pediment around the back of the main building, is now the main entrance. Jacob

Schmidlapp had specified that architect Daniel Burnham design the wing, completed in 1907 as a tribute to his late daughter, and the new style completely altered the museum's style. In 2003, CAM opened the Cincinnati Wing, a permanent display of works by local artists such as Frank Duveneck and Hiram Powers. That same year, a gift from the Lois and Richard Rosenthal Foundation made it possible for free admission to the museum every day.

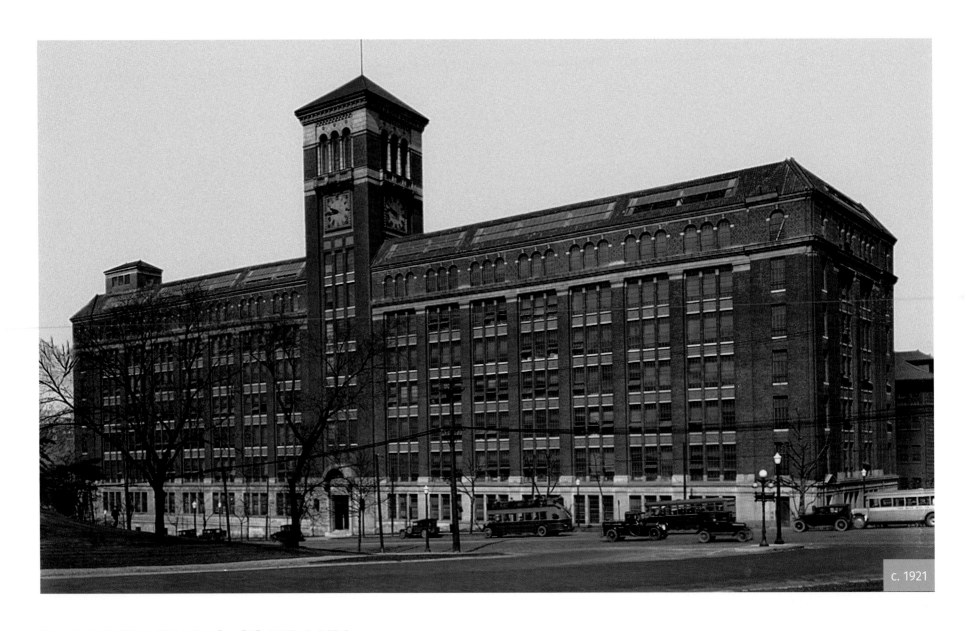

c. 1921

BALDWIN PIANO COMPANY
Makers of America's favorite piano

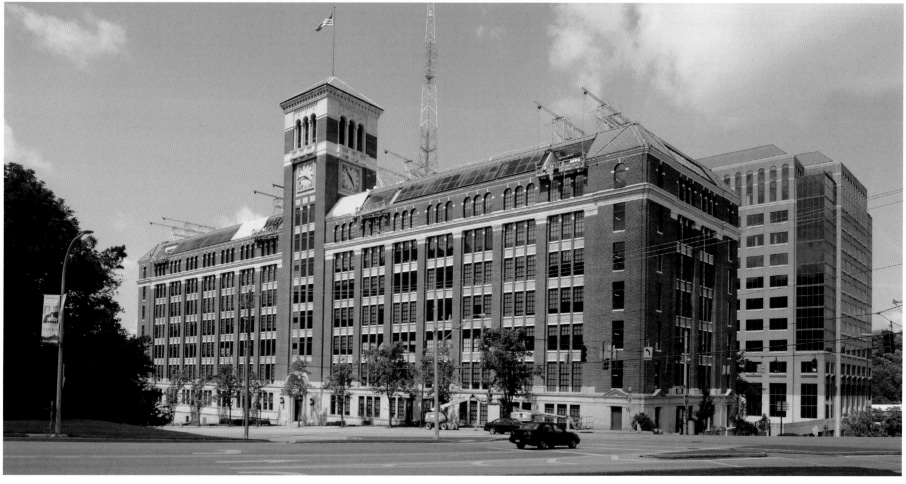

LEFT: The Grand Baldwin Building, with its prominent clock tower, has been a dominant presence on Gilbert Avenue since 1921. The eight-story Italian Renaissance Revival building was the headquarters and manufacturing plant for the world-renowned Baldwin Piano Company. Cincinnati piano teacher Dwight Hamilton Baldwin went into business as a Decker Brothers piano dealer in 1862. Though it's Baldwin's name that is famous, much of the credit goes to the Wulsin family. After the Civil War, Baldwin hired Lucien Wulsin as a clerk, and the two became partners in the D.H. Baldwin & Company in 1873. Wulsin instructed staff piano tuner John Warren Macy to "make the best piano that can be made." Macy's piano fit the bill, and the first Baldwin pianos were sold in 1891. When Baldwin died in 1899, he left his estate to his Presbyterian church. Wulsin and some partners bought back the estate to keep the company running. The next year, a Baldwin piano won the Grand Prix at the Paris Exposition, which launched Baldwin's reputation as a maker of fine instruments.

ABOVE: During World War II, the U.S. government ordered a cease in production of pianos so the factories could be used for the war effort. Baldwin's plant instead turned out plywood airplane parts—wings and center sections—for the Aeronca PT-23 trainer plane and the Curtiss-Wright C-76 Caravan cargo transport. In the 1970s, Baldwin diversified its investments and merged with United Corporation, dealing in insurance and mortgage holdings. Baldwin-United borrowed heavily and went bankrupt in 1983, one of the largest financial collapses in U.S. history at the time, although the piano business was not part of the bankruptcy. Baldwin moved away from Gilbert Avenue to the city suburbs in 1986, and Corporex Companies gutted the plant and converted the complex into offices. In 2001, Baldwin was acquired by Gibson Guitar, and now its pianos are manufactured in China. Neyer Properties purchased the Grand Baldwin Building in 2014 with plans to convert it into apartments as The Baldwin.

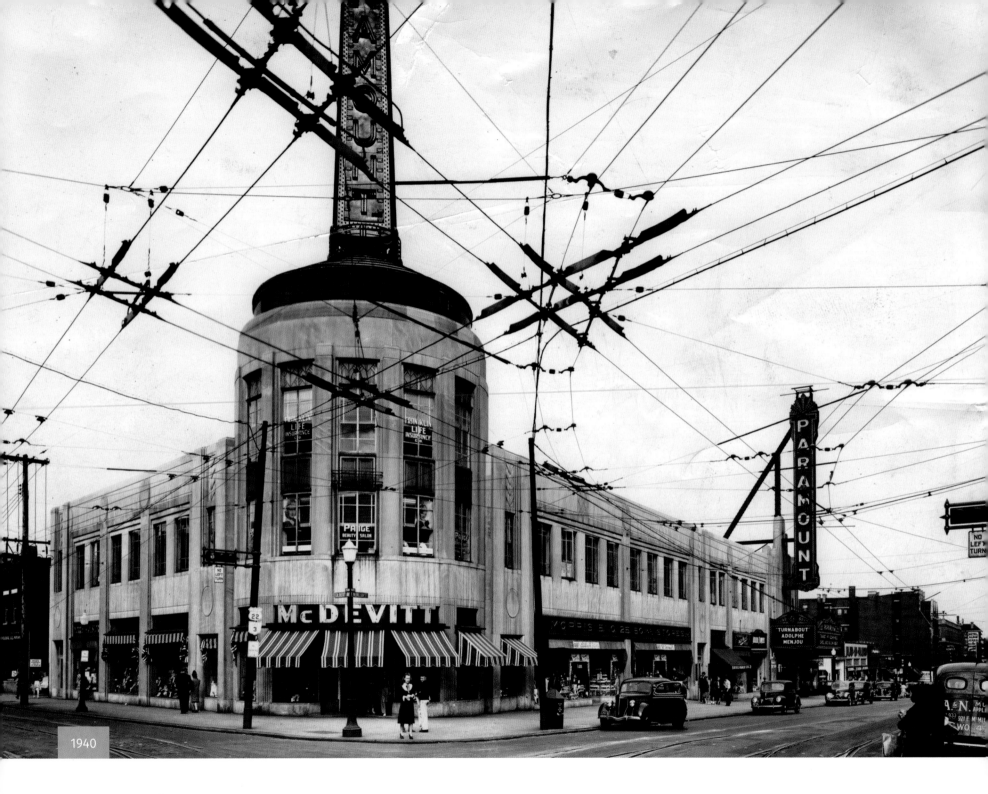

1940

PEEBLES' CORNER

Gilbert and McMillan was a bustling Walnut Hills corner

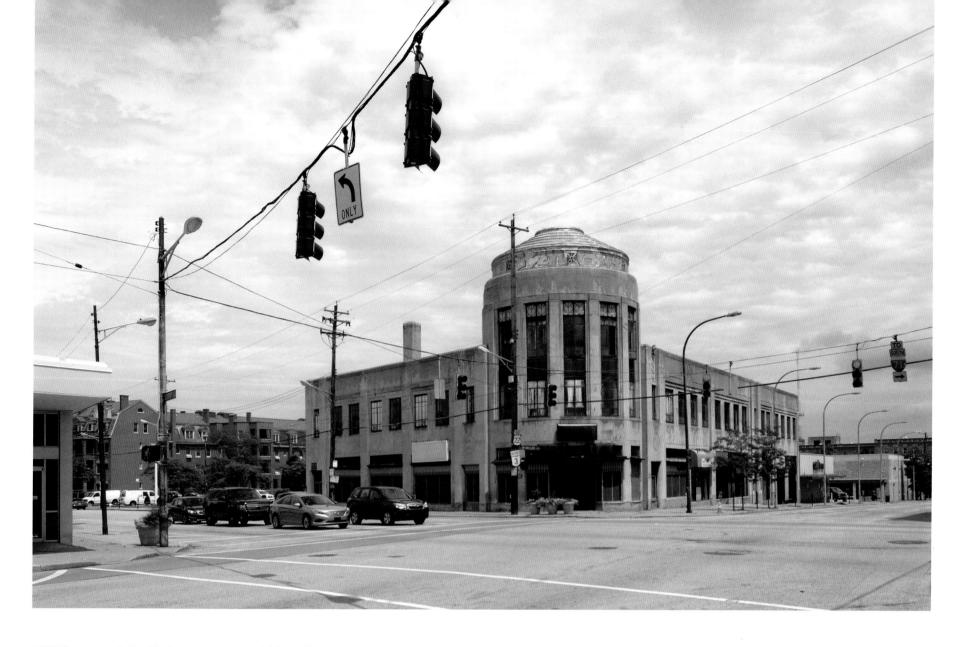

LEFT: The Joseph R. Peebles' Sons Company, a high-end import grocery, was started in 1840. They added a store in Walnut Hills at Gilbert Avenue and McMillan Street in 1883. The story goes that the owner bribed streetcar conductors with cigars or rum to announce "Peebles' Corner" rather than the street names. The name stuck, even after the store went out of business in the 1930s. Peebles' Corner became a major thoroughfare. Six streetcar lines passed through on the way to the fashionable eastern suburbs. The Orpheum Theater included a Wurlitzer organ and a rooftop garden used as an ice-skating rink in the winter. The first Graeter's Ice Cream shop was down the street. In 1931, the impressive Paramount building took over the corner spot with McDevitt's men's clothing store as the anchor. As seen in this 1940 photo, the Paramount Theater was further up McMillan, but an enormous metal spire capped the rounded tower of the Art Moderne building to attract attention.

ABOVE: The spire disappeared during World War II, used for scrap. The Peebles' Corner Historic District was added to the National Register of Historic Places in 1985, but it is a shadow of its former self. When Columbia Parkway was constructed in 1938, it allowed commuters to bypass Walnut Hills entirely. McMillan was a one-way street for years, which limited the traffic flow through the area. Inevitably, business activity in the neighborhood dwindled. Storefronts all along Gilbert and McMillan have been boarded up. The Orpheum and Paramount theaters are long gone. The Kroger grocery store up the street closed in 2017. The Paramount building, stripped of its signs, appears cold and lifeless. The only color is a splash of graffiti. All that's left of the old Peebles' Corner is the name. Still, folks have eyes on Walnut Hills as the next neighborhood to receive a boost like Over-the-Rhine has experienced.

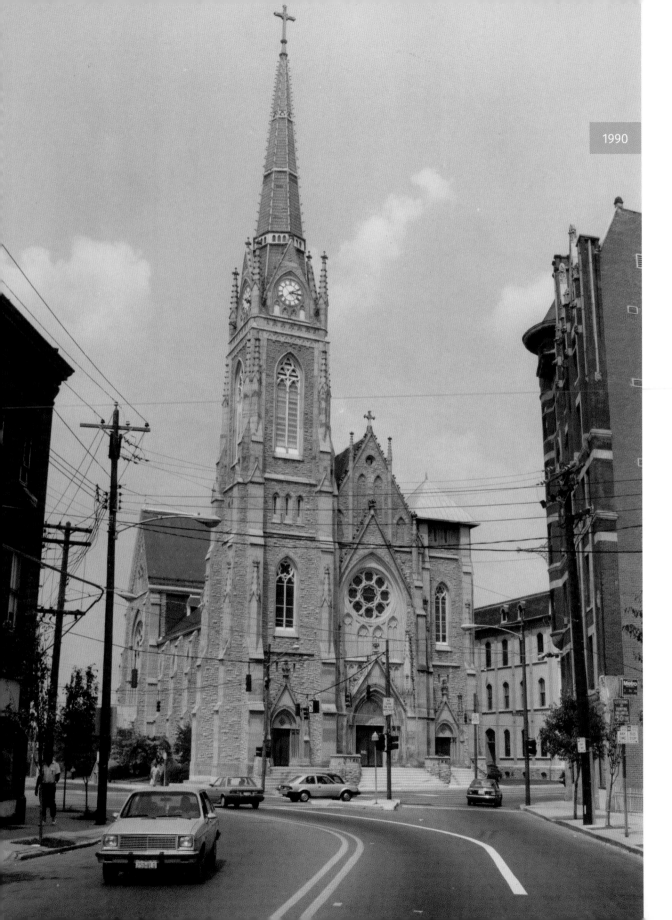

1990

DE SALES CORNER
London has Big Ben, De Sales has Big Joe

LEFT: De Sales Corner at Madison Road and Woodburn Avenue in East Walnut Hills is so named for the Francis de Sales Catholic Church that dominates the intersection. The Neo-Gothic limestone church with the ornate 263-foot spire wouldn't be out of place in a French village. The parish was started in 1849 and outgrew their first church. The new church with a school and rectory was dedicated in 1879. The prominent tower wasn't added until 1895, along with "Big Joe," the famous seven-foot-tall, nine-foot-diameter bell, said to be the largest swinging bell in the world. It was a gift dedicated to Joseph Buddeke, a wholesale dry-goods merchant. Cast at the Van Duzen foundry downtown, the 35,000-pound bell required a dozen horses to haul it up Gilbert Avenue to be fitted into the tower. Legend has it that the 640-pound clapper struck the bell once, sounding a beautiful E-flat that was too much for the tower. Since then a hammer has been used to strike the bell.

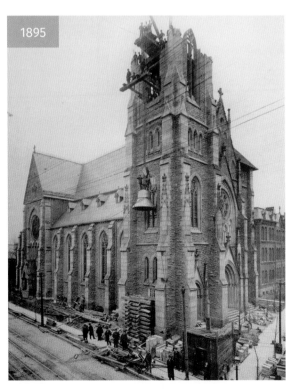

1895

RIGHT: Over the years, De Sales Corner has fared better than its Walnut Hills counterpart, Peebles' Corner. What is now East Walnut Hills was once the village of Woodburn, incorporated in 1866 and annexed to Cincinnati in 1873. The area had attracted wealthier residents who built mansions on five-acre estates. By the 1890s, the streetcar line had shifted the development from Madison Road and Hackberry Street to Madison and Woodburn Avenue. Anchored by the church, the corner was clustered with shops and businesses. But the streetcar disappeared in the 1950s and the neighborhood demographics changed with it. In the last few years, East Walnut Hills has been the focus of urban resurgence. People are buying old homes and rehabbing them. Trendy shops and restaurants, like Myrtle's Punch House, have cropped up on De Sales Corner, and the neighborhood is again buzzing.

LEFT: The bell "Big Joe" is hoisted up to the tower in 1895.

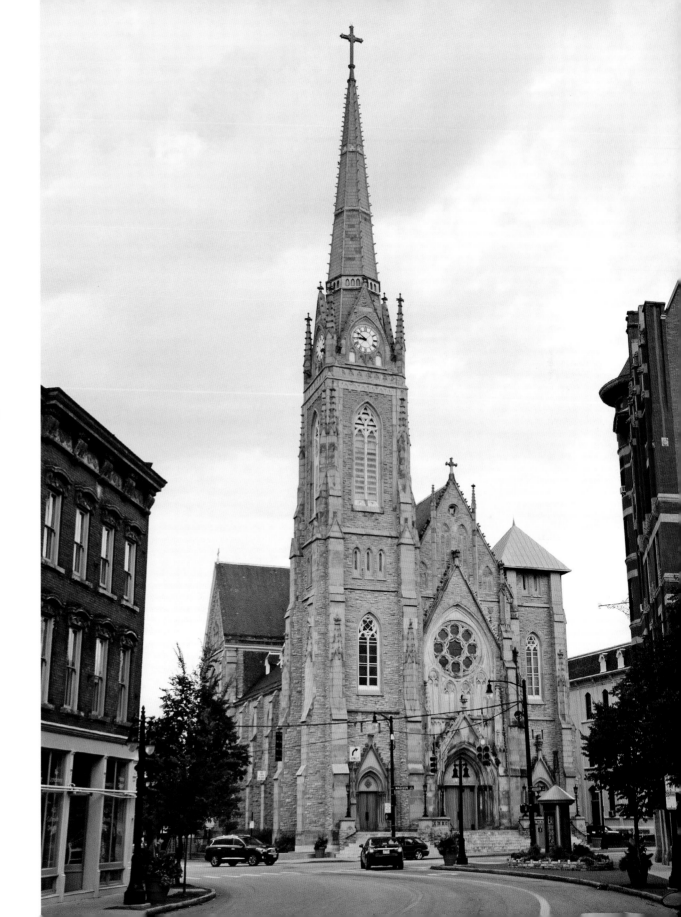

c. 1904

UNIVERSITY OF CINCINNATI
Featuring two distinct versions of McMicken Hall

LEFT: Businessman Charles McMicken willed his property to the city in 1858 to help establish a Cincinnati college. The University of Cincinnati was chartered in 1870. The first building was near McMicken's estate on a slope of Vine Street, earning the school the nickname "Hilltop University." In the 1890s, UC president James Cox created a new campus near Burnet Woods. This photo from about 1904 shows the "academic ridge" of buildings that were located along Clifton Avenue on the streetcar route. The large building with the short tower is McMicken Hall, completed in 1895 from a design by Samuel Hannaford. The Neo-Georgian hall was named for the university's original benefactor. Flanking the hall's entrance is a pair of marble lions named Mick and Mack, donated by Jacob Hoffner. The wings on either side of the hall are Hanna Hall, on the left, and Cunningham Hall. The domed building in the distance is the Van Wormer Library, completed in 1901. The library was funded by Asa Van Wormer and dedicated to his late wife.

ABOVE: The original McMicken Hall designed by Hannaford was worn out and demolished in 1948. A replacement building, also called McMicken Hall, was built by architect Harry Hake using the same footprint and also in the colonial Georgian style. Some 650,000 bricks from the previous hall were used in its construction. Mick and Mack are also still around. The Van Wormer Library lost its dome in 1930 because of structural problems, but a new dome skylight was built in 2006 and a hole was cut in the first floor ceiling so the sunlight could shine throughout. After years of uninspired university buildings, a plan by landscape architect George Hargreaves helped transform the campus in the 1990s by infilling some of the existing structures with newer designs and utilizing more open spaces. Then followed a new wave of architecturally diverse buildings designed by the likes of Peter Eisenman, Michael Graves, Frank Gehry, Henry Cobb, and Gwathmey Siegel.

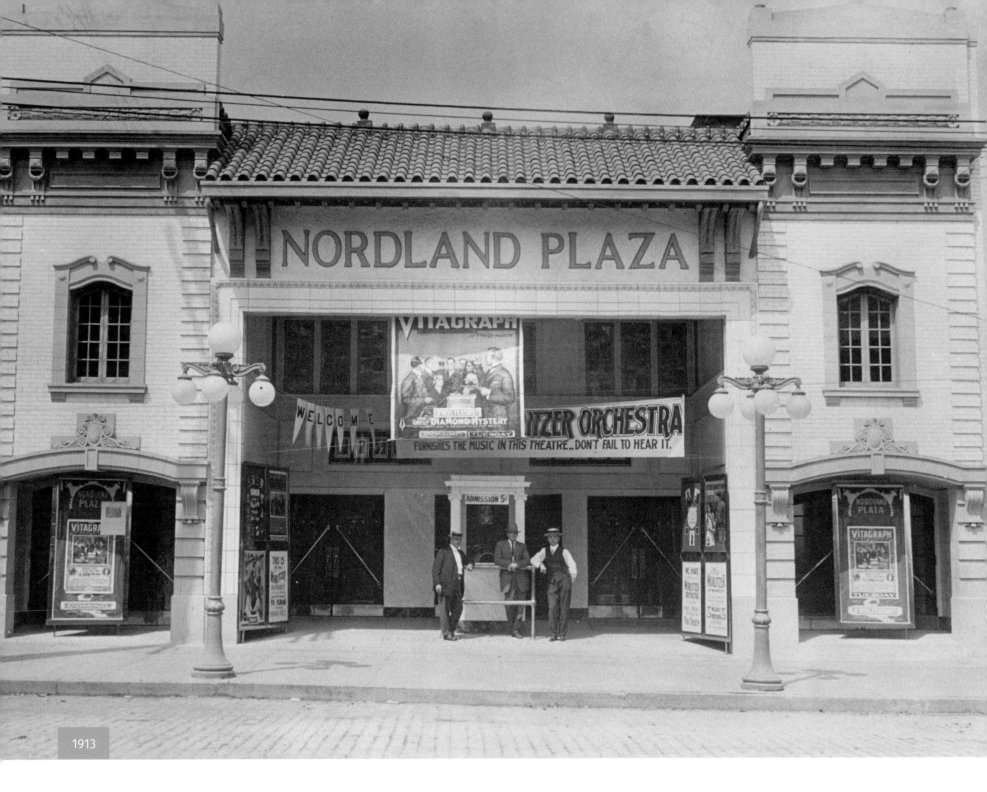

1913

NORDLAND PLAZA / BOGART'S
The former movie theater was given new life as a music venue

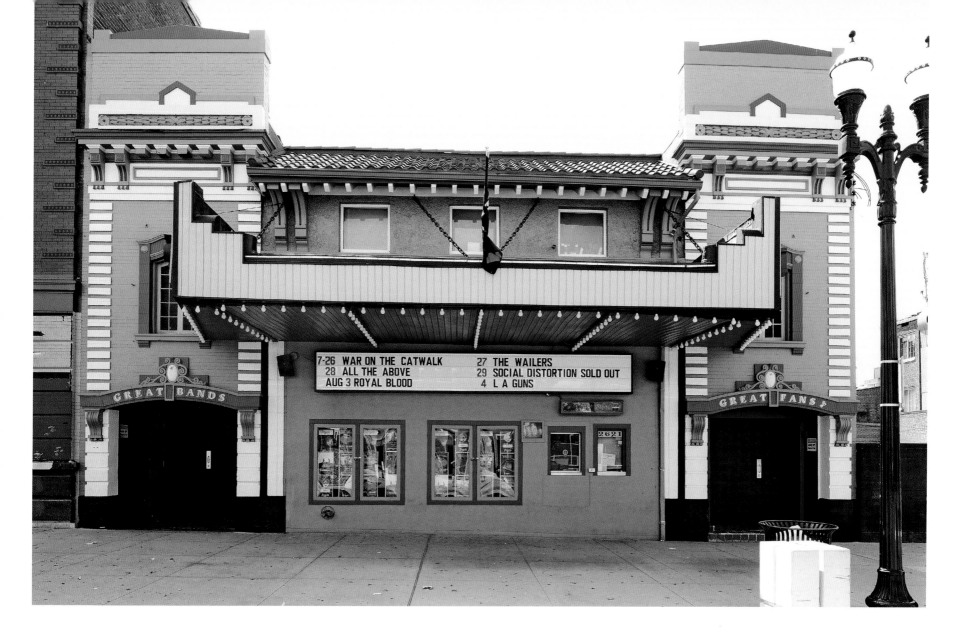

The marquee reads:

```
7-26  WAR ON THE CATWALK        27  THE WAILERS
28  ALL THE ABOVE               29  SOCIAL DISTORTION SOLD OUT
AUG 3  ROYAL BLOOD               4  L A GUNS
```

GREAT BANDS

GREAT FANS

2621

LEFT: Although most of the attention is paid to the lavish movie palaces downtown, neighborhood theaters like the Orpheum in Walnut Hills and the Plaza in Norwood provided the same sort of entertainment, vaudeville acts and nickel photoplays. The Nordland Plaza was built in 1909 at 2621 Vine Street in Corryville, near the University of Cincinnati, as a nickelodeon, showing pictures for a five-cent admission. Here, advertising the 1913 Vitagraph two-reeler *The Diamond Mystery*, the Nordland promises a Wurlitzer Orchestra to accompany the silent picture with live music. Wurlitzer was another Cincinnati company. Started in 1853 by German immigrant Rudolph Wurlitzer, the company was renowned for its pianos and organs, such as those played in movie houses. The Wurlitzer Orchestra organ could sound like an entire orchestra by itself, producing music from string, brass, woodwind, and percussion instruments all from one console.

ABOVE: Compared with other theater buildings from its day, the Nordland has had a charmed existence. As a movie theater it lasted until 1955, and then reopened in 1960 to show German films. A major remodel in 1965 transformed the theater into a nightclub and lounge called Inner Circle. A decade later, it was reborn in its current life as a hotspot music venue. Founded by Al Porkolab in 1975 as an intimate venue for national musical acts, it was briefly Bogart's Café Américain, a reference to *Casablanca* with a palm tree motif. Now, it is just Bogart's. Helped by its proximity to UC students, Bogart's has anchored Short Vine for more than forty years. A brick wall inside the club is marked with the names of the acts, big and small, who played there: James Brown, Bruce Springsteen, U2, the Police, They Might Be Giants. The biggest concert of all was Prince's "secret" show in 1984 as a warm-up for his blockbuster *Purple Rain* tour.

c. 1898

BOSS COX'S HOUSE

The former mansion of a political boss has been turned into Clifton library

ABOVE: George Barnsdale Cox enjoyed decades as the boss of Republican politics in Cincinnati from 1884 to 1916. He didn't hold office himself, except for two terms on City Council, but he handpicked candidates for local government and made sure they had enough votes. Boss Cox ruled out of his saloon in the West End, where political hopefuls would meet with him. His influence extended to all levels of the city, from the Cincinnati Reds to the local builders. In 1895, at the height of his power, Cox had Samuel Hannaford & Sons design his Clifton mansion, Parkview, the middle house

pictured about 1898. The French Renaissance manor at Brookline and Jefferson avenues is made of Indiana limestone and exposed Columbian freestone that was intended to be of uniform color but ended up shades ranging from buff to orange. The pronounced conical tower housed Cox's poker room. The interior was decorated in tile mosaics, stained-glass windows, extravagant light fixtures, and even secret passages. This was Boss Cox's home until his death in 1916.

126

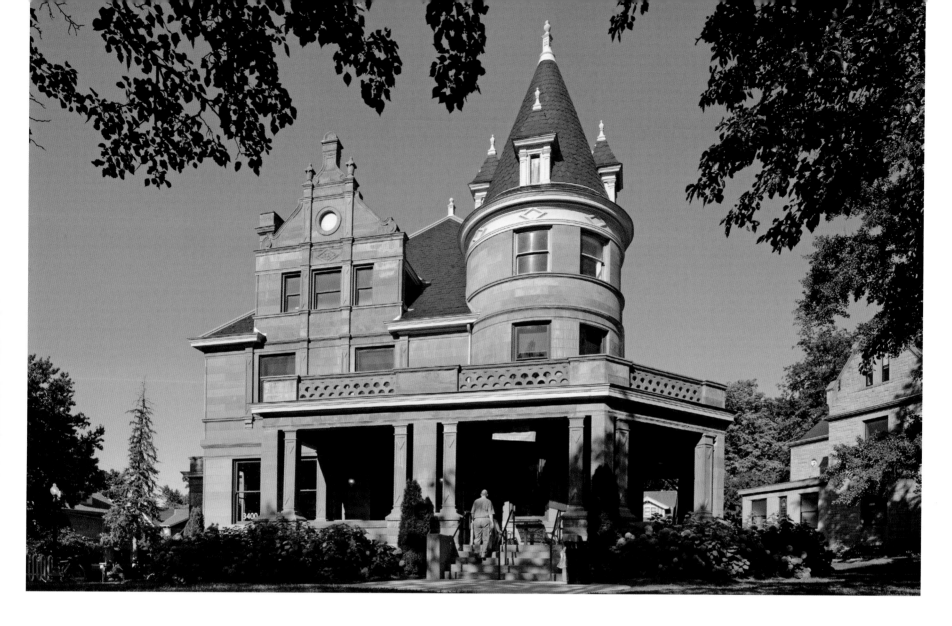

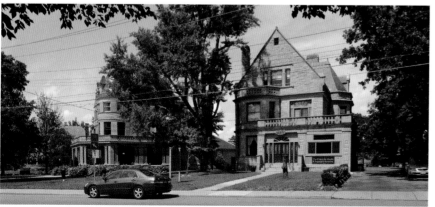

ABOVE AND LEFT: When Cox's widow passed away in 1938, she bequeathed the residence to Cincinnati Union Bethel, which used it as the women's dormitory. For nearly six decades, from 1948 until 2007, the residence was the Pi Kappa Alpha fraternity house. Remarkably, the historical features were left intact. Former fraternity brother Mike Dever acquired the house in the stately Gaslight District and donated it to the Public Library of Cincinnati and Hamilton County in 2010. The library spent five years and three million dollars restoring the house and the features—the painted glass windows, the staircase—and reinforcing it to be ADA compliant and to sustain the weight of books. The new Clifton Branch library opened in 2015. The other homes in the photos are also still around. The house on the right was the School of Scientific Right Thinking in the 1930s, and today is the Center for Health and Innovative Learning. On the left, the Charles B. Russell House with the egg-shaped cone tower is also a Hannaford design.

GRUEN WATCH COMPANY
Time Hill and Beau Brummel are beautiful hilltop businesses

c. 1937

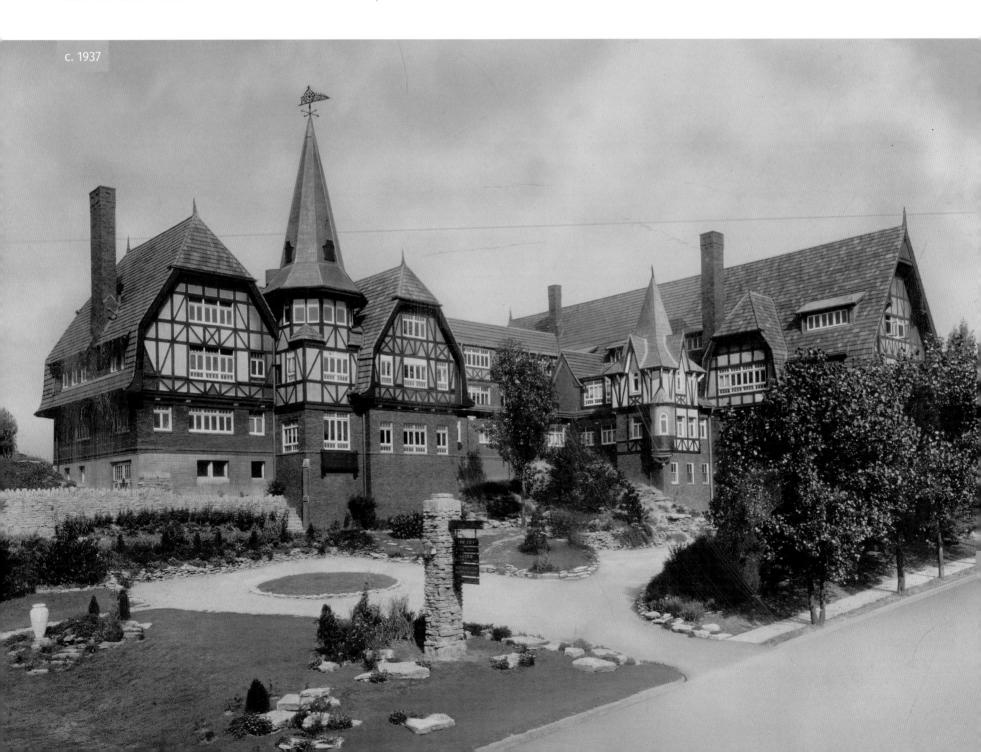

LEFT: Although it may look like a Swiss chalet, this half-timber Tudor building known as Time Hill was the headquarters of the Gruen Watch Company, known the world over for their quality timepieces. German-born watchmaker Dietrich Gruen and his son Frederick started the company in Columbus, Ohio, in 1894, after an earlier venture went bankrupt. D. Gruen & Son moved to Cincinnati in 1898 in the Johnson Building at Fifth and Walnut streets. In 1917, the Gruens built Time Hill at 401 East McMillan Street in Walnut Hills on what had been a pasture known as Nanny Goat Hill. Guy C. Burroughs designed a hall inspired by medieval guildhalls in Belgium. The building is more dramatic around the corner on Iowa Avenue, where the hall was expanded in the 1930s, as seen in this photo. Time Hill was featured prominently in their advertising, sometimes affording little space to show the watches. The watch movements were produced in Germany, then later in Switzerland, but cased and timed in Cincinnati.

BELOW: In 1921, the Procter & Collier advertising company built their offices across McMillan Street in the Tudor style to complement Gruen's Time Hill. The most dramatic feature was a water tower that wouldn't look out of place in an English town square. Both buildings were part of the City Beautiful Movement to create attractive business buildings that would elevate the aesthetic. The Beau Brummel Tie Company, named for an English dandy from the Regency period, took over the Procter & Collier building in 1936. After the Gruen sons passed away, the family sold the company in 1953, and the business collapsed a few years later. Time Hill was sold to the Osborne-Kemper-Thomas calendar company in 1959. Many of the attractive features, from the fireplace to the tile, were stripped out and the lobby was divided into offices. The Union Institute and University owns and maintains the Beau Brummel complex. Lighthouse Youth & Family Services, an agency that serves families in need, uses Time Hill as administrative offices.

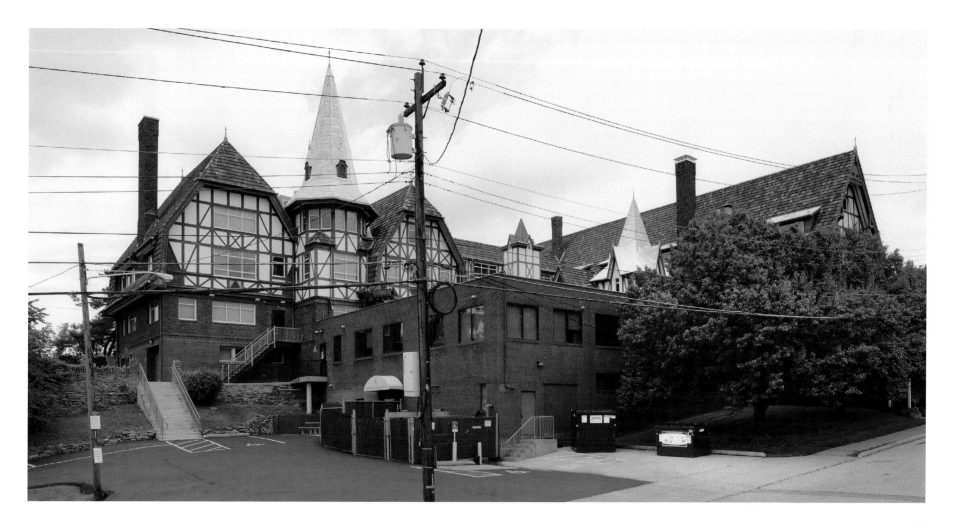

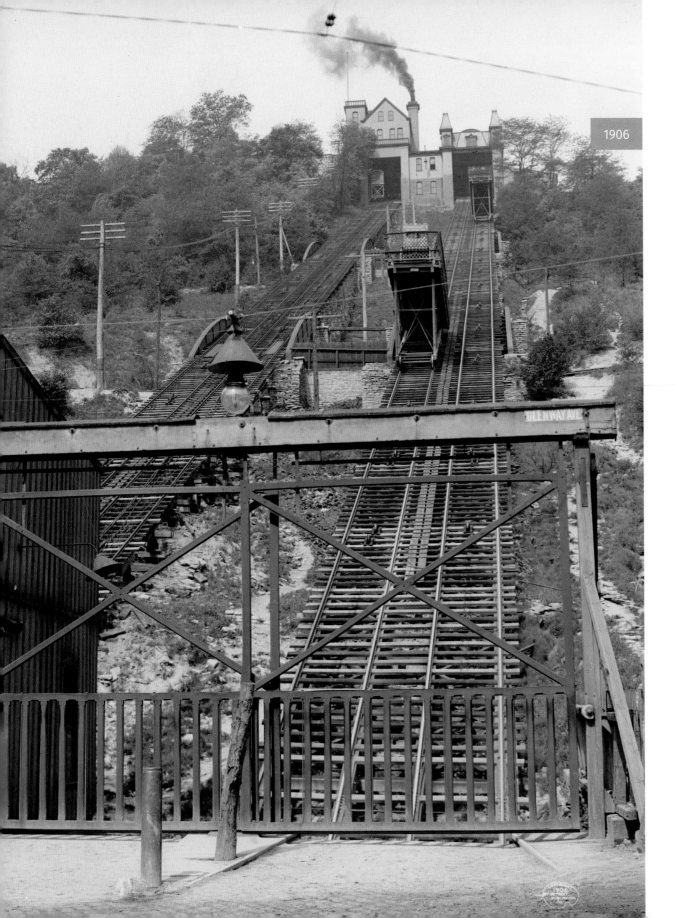

1906

PRICE HILL INCLINE
A steep ride to "Buttermilk Mountain"

LEFT: The Price Hill Incline opened in 1875. It was the second funicular built to access Cincinnati's hills, this one to reach the west side. Price Hill had the steepest slope of the five inclines, and was the only one with two sets of tracks, one used exclusively for freight. The incline started at West Eighth Street at the curve to Glenway Avenue, up to West Eighth and Matson Avenue. Built by William Price, the son of Price Hill founder General Rees E. Price, the incline was a real boon for the western hills suburbs, even if the Price family didn't allow alcohol to be served at the incline's Price Hill House, which earned the hilltop the nickname Buttermilk Mountain. In October 1906, the cable snapped on the freight tracks before the platform carrying two wagons with their teams and drivers had reached the top. The safety cable slowed the descent before it also broke, and the platform crashed at the bottom. The maimed horses had to be put down, but the two drivers miraculously had only minor injuries.

RIGHT: Although the Price Hill Incline was not operated by the Cincinnati Traction Company like the other inclines, it shared the same fate. The incline was popular with west-siders, but the trip wasn't worth the hassle of transferring to passenger cars when cars and buses were more efficient means of getting up the hill. The Price Hill Incline closed in 1943. The steep hill is now covered with foliage. Every so often there are rumblings of building a new incline, and Price Hill's location is the most suited to a reinstallation. East Price Hill has gone so far as to declare itself the Incline District. The Queen City Tower and the Incline House restaurant now have the gorgeous hilltop view once enjoyed by patrons of the Price Hill House. Unlike its predecessor, the Incline House has plenty of beers on tap.

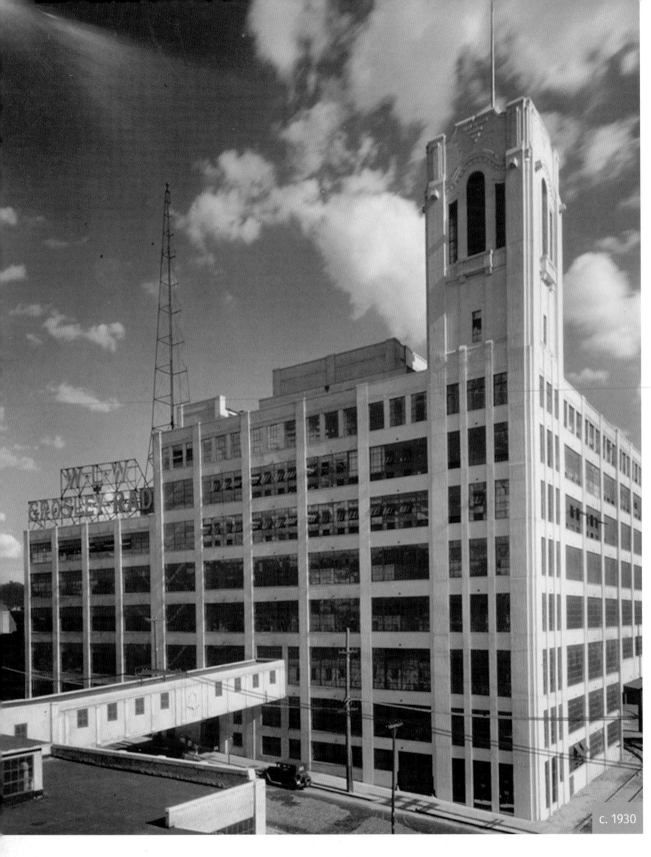

c. 1930

CROSLEY BUILDING
Home of Crosley Radio's manufacturing and some powerful radio broadcasts

LEFT: It is altogether fitting that Powel Crosley Jr.'s office was in the top level of the Crosley Building tower because he built the Crosley Radio Corporation from the ground up. The inventor and entrepreneur started making affordable radios in 1921, and by the next year was the leading radio manufacturer in the world. Crosley built a factory headquarters at 1329 Arlington Street in Camp Washington in 1930. The first seven floors were for manufacturing radios. The eighth floor was the WLW-Radio studio, which Crosley started in order to have better programming to listen to. A parade of future stars worked for WLW: Rosemary and Betty Clooney, Doris Day, Andy Williams, the Ink Spots, Fats Waller, Red Skelton, and Rod Serling. Crosley boosted the station's power to 500,000 watts, the most powerful radio signal in the world. During World War II, the station was used to broadcast the Voice of America all over the world. The FCC eventually limited the maximum wattage allowed at 50,000 watts.

RIGHT: Today the Crosley Building is a husk, empty and cracked. In 1942, WLW moved to the Crosley Square building at Ninth and Elm. Three years later, Powel Crosley sold off the radio and broadcast companies to AVCO in order to focus on his Crosley compact car. It was his one failure. AVCO closed the plant in 1960, and since then it has been used as a warehouse. Having suffered from years of neglect, the plant was condemned in 2006. Its dilapidated state is visible even from I-75: broken windows, peeling paint, and an industrial canvas rife with graffiti. Trees are growing on the roof. Despite its history, the building is not listed on any historic register. There is hope that the sturdy structure can be rehabbed, and a proposal for luxury apartments has been floated, but thus far no plan has moved forward. The former radio plant is silent.

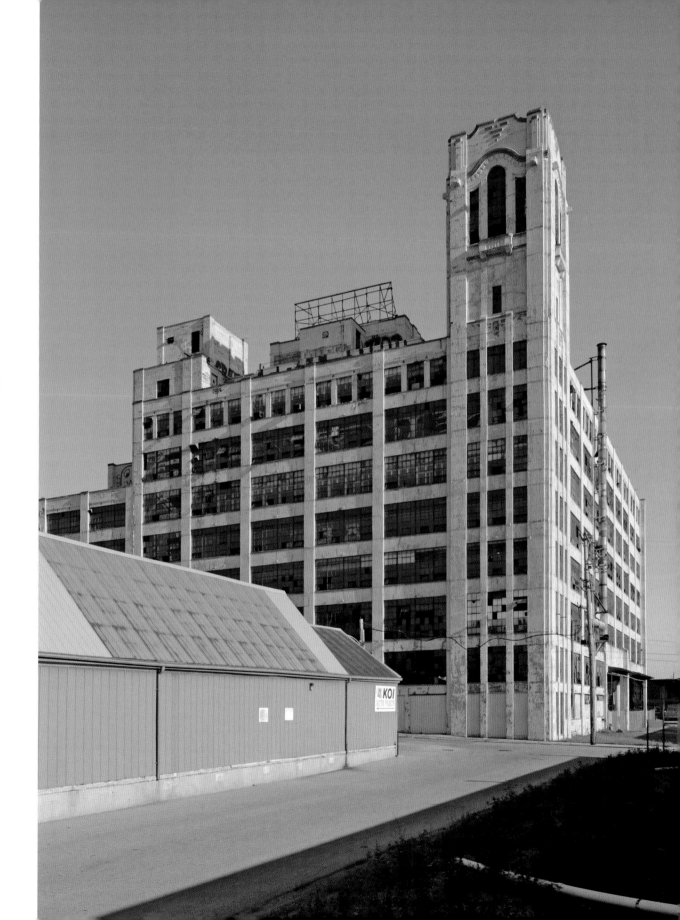

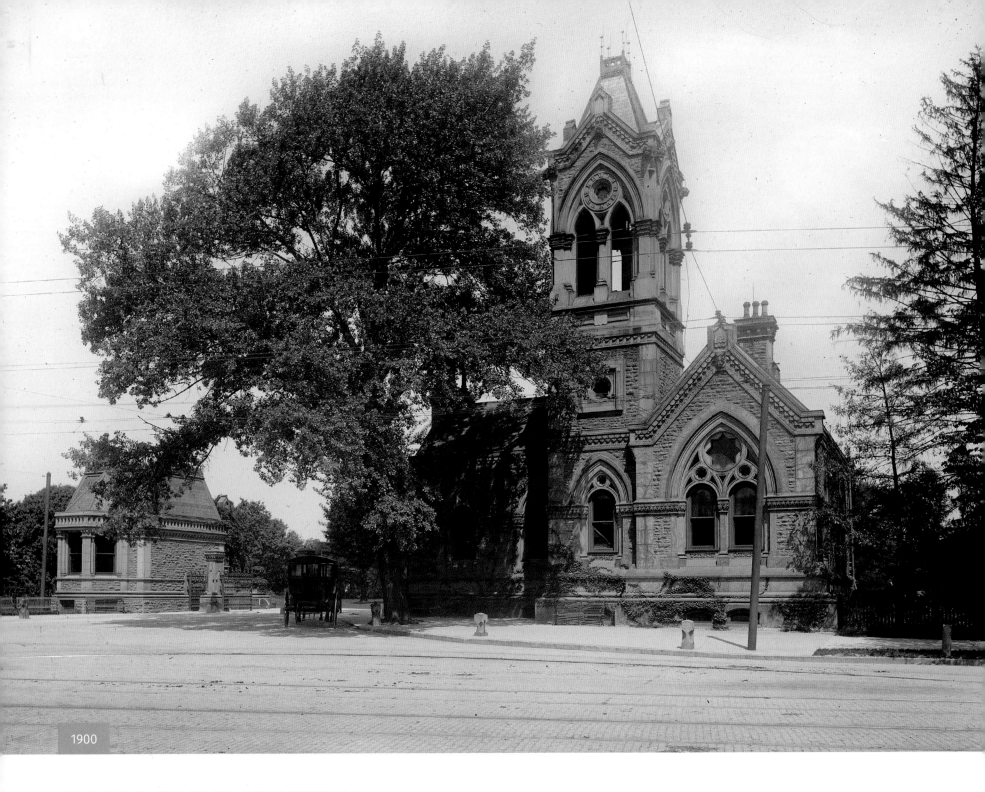

1900

SPRING GROVE CEMETERY
Idyllic nineteenth-century cemetery and beautiful arboretum

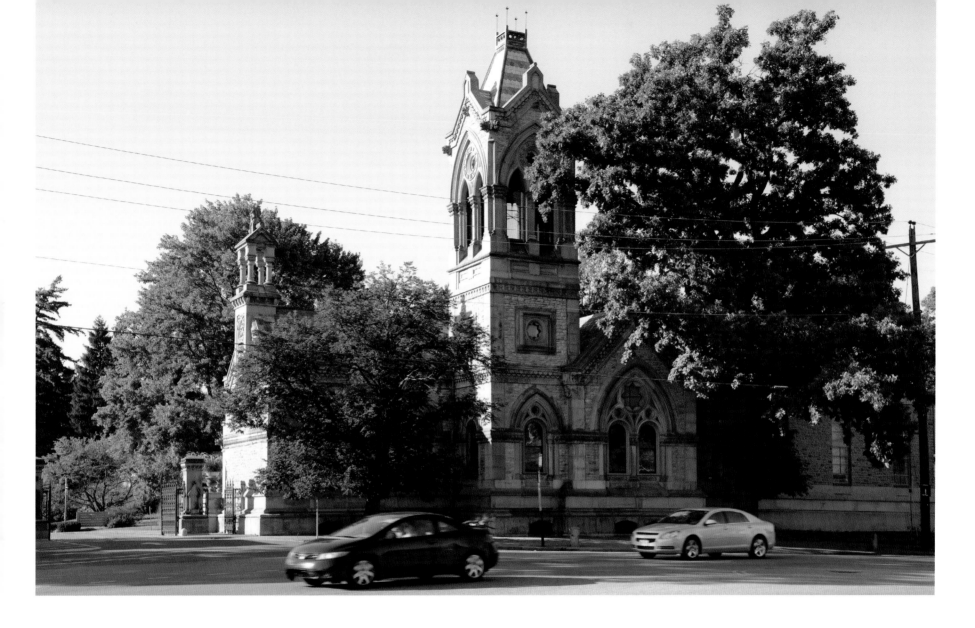

LEFT: The lush, serene Spring Grove Cemetery is as noted for its delicate, picturesque landscaping as for the impressive ornate tombstones and mausoleums. The cemetery was consecrated in 1845 to accommodate a need for more burial space for the fast-growing city. The cemetery board wished for an idyllic rural cemetery, and in 1855 hired German landscape architect Adolph Strauch, who had tended the park-like properties of Clifton mansions. Strauch's design utilized the rolling topography and turned natural springs into lakes. He was superintendent of the cemetery until his death in 1883. The Gothic gateway and carriage house seen in this 1900 photo were designed by Cincinnati architect James Keys Wilson in 1863. Spring Grove is the final resting place for forty-one Civil War generals, including hometown hero and poet General William Haines Lytle; plus Salmon P. Chase, a member of Abraham Lincoln's cabinet and Supreme Court chief justice; and many of the biggest names in Cincinnati history.

ABOVE: At 733 acres, Spring Grove Cemetery and Arboretum is one of the largest cemeteries in the country and a National Historic Landmark. It retains its nineteenth-century character, even as factories and warehouses have sprung up around it on Spring Grove Avenue. With its preponderance of evocative structures, from the Dexter Mausoleum, also designed by Wilson, set beside a lake like a compact Gothic cathedral to Samuel Hannaford's Romanesque-style Norman Chapel, the cemetery seems perfect for horror films, yet it is a quiet, calming park, perfect for an afternoon stroll. The grounds are often used for picnics and walking tours, or as the picturesque leg of a marathon. Researchers hunt for old tombstones of the many famous or familial names. Abolitionist Levi Coffin, Yankees manager Miller Huggins, Barney Kroger, Dr. Daniel Drake—even, for a time, *Superman* actor George Reeves. Forty-five Revolutionary War veterans have been relocated to Spring Grove Cemetery, and another ten whose graves were lost are listed in memoriam.

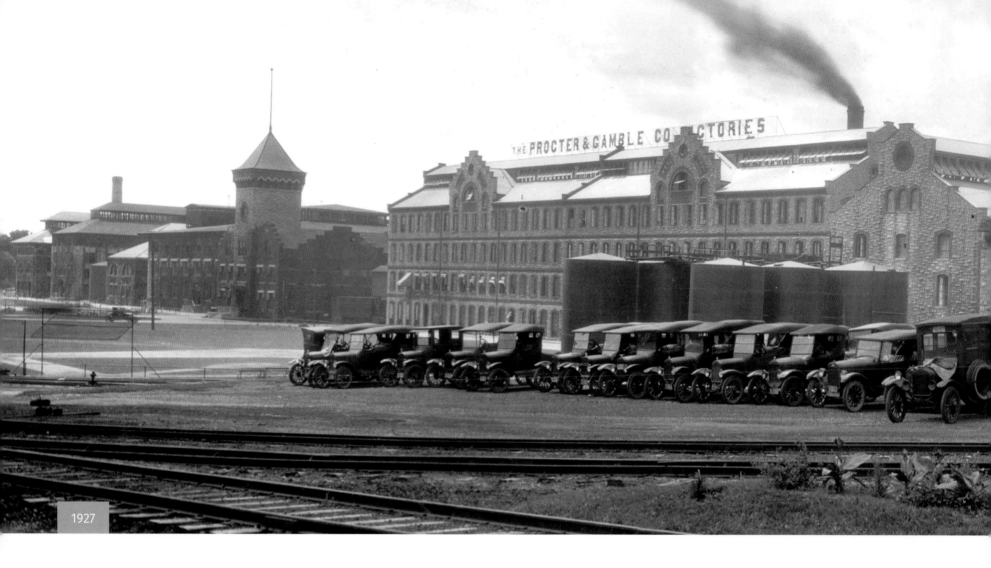

1927

IVORYDALE

P&G's factory complex was designed by the man responsible for Pullman

ABOVE: William Procter and James Gamble formed a partnership in 1837, boiling animal fats, a byproduct of the city's prodigious meatpacking industry, into soap, thus beginning Cincinnati's greatest success story. After Procter & Gamble's manufacturing plant on Central Avenue burned down in 1884, a new plant was built on Spring Grove Avenue in the Mill Creek Valley. It was sited near the town of Saint Bernard on the outskirts of the city in order to capitalize on the rail yards. Architect Solon Spencer Beman, who planned the company town Pullman near Chicago, was hired to build P&G's factory complex Ivorydale, named for the

company's latest success, the "99 and 44/100% pure" Ivory soap. Completed in 1886, Ivorydale is the size of a small town, with more than twenty buildings covering 55 acres in a park-like setting. As seen in 1927, workers' cars are lined up in front of the attractive limestone buildings trimmed with red brick. Inside the factories, workers manufactured bars of Ivory soap, Crest toothpaste, and Crisco shortening.

RIGHT: Ivorydale in 1988.

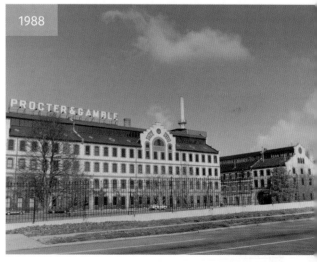

1988

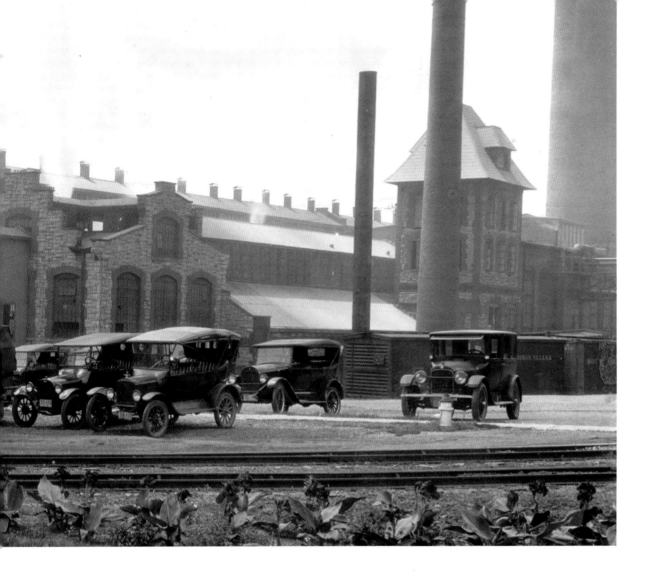

BELOW: Despite some changes over the years, Ivorydale retains much of the style of its original design, even if the white limestone is obscured from view by the newer builds. The complex has expanded to more than 240 acres and still seems like its own town along Spring Grove Avenue. Ivorydale was nominated as a National Historic Landmark in 1979, but worried about political and tax ramifications, P&G protested. The next year owner consent was added as a provision for historic landmark status, and Ivorydale remains off the register. As products evolved, such as the emergence of liquid soap, P&G has consolidated its holdings, moved some manufacturing overseas, and sold off product lines. In 2003, P&G sold the Ivorydale soap-making plant to Trillium Personal Care, which operates under the name St. Bernard Soap Co., after the nearby town. That's the name that now stretches across the building roof. Ironically, bars of Ivory soap are still made in the factories there, but so are bars for P&G's rivals.

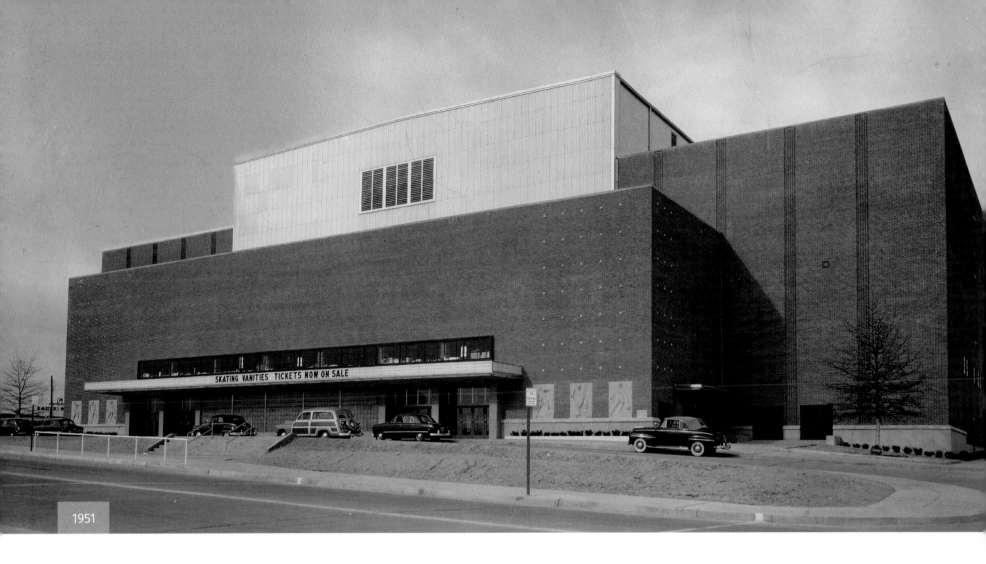

1951

CINCINNATI GARDENS

The venue for the Beatles and basketball will soon be turned to dust

ABOVE: Cincinnati Gardens (originally without the "s") opened in the suburb of Roselawn in 1949. Modeled after the Maple Leaf Gardens in Toronto, but without the dome, it was the seventh-largest indoor arena in the country, seating 11,000. Flanking the entrance are six angular bas-relief figures with boxing gloves, hockey sticks, and basketballs. The Gardens hosted a little of everything, from hockey to ice capades, circuses to roller derby. Ezzard Charles, the "Cincinnati Cobra," battled Joey Maxim on his way to the heavyweight title in 1949. The Gardens was the home of the Cincinnati Royals, the 1966 NBA All-Star Game, and Crosstown Shootouts between UC and Xavier basketball. Royals

star Oscar Robertson averaged triple-doubles in the 1961-62 season. Evel Knievel launched his motorcycle over a line of cars here. Elvis Presley played at the Gardens, as did Jimi Hendrix, the Monkees, the Jackson Five, the Grateful Dead, and Madonna. Beatlemania struck on August 27, 1964, when John, Paul, George, and Ringo played to a horde of screaming teenagers. What memories were made here.

1953

RIGHT: A circus performance inside Cincinnati Gardens in 1953.

ABOVE: But, memories were not enough to save Cincinnati Gardens. The facilities were inadequate and out of date. Its location at Seymour Avenue and Langdon Farm Road in Roselawn is too removed from downtown to attract a large crowd anymore. The Port of Greater Cincinnati Development Authority purchased the Gardens with plans to clear the site in late 2017 in order to attract manufacturers bringing jobs to the area. Despite the number of noteworthy events that occurred with its walls, the Gardens hasn't garnered the same level of outcry as other local historic sites. Some fans have saved memorabilia. The Cincinnati Gardens lettering, which was photographed in the background of countless snapshots taken by Beatles fans in 1964, will be donated to the American Sign Museum in Cincinnati. There is hope the bas-reliefs will be preserved as well. Then the building will soon be rubble and all that will be left are the memories of a lifetime.

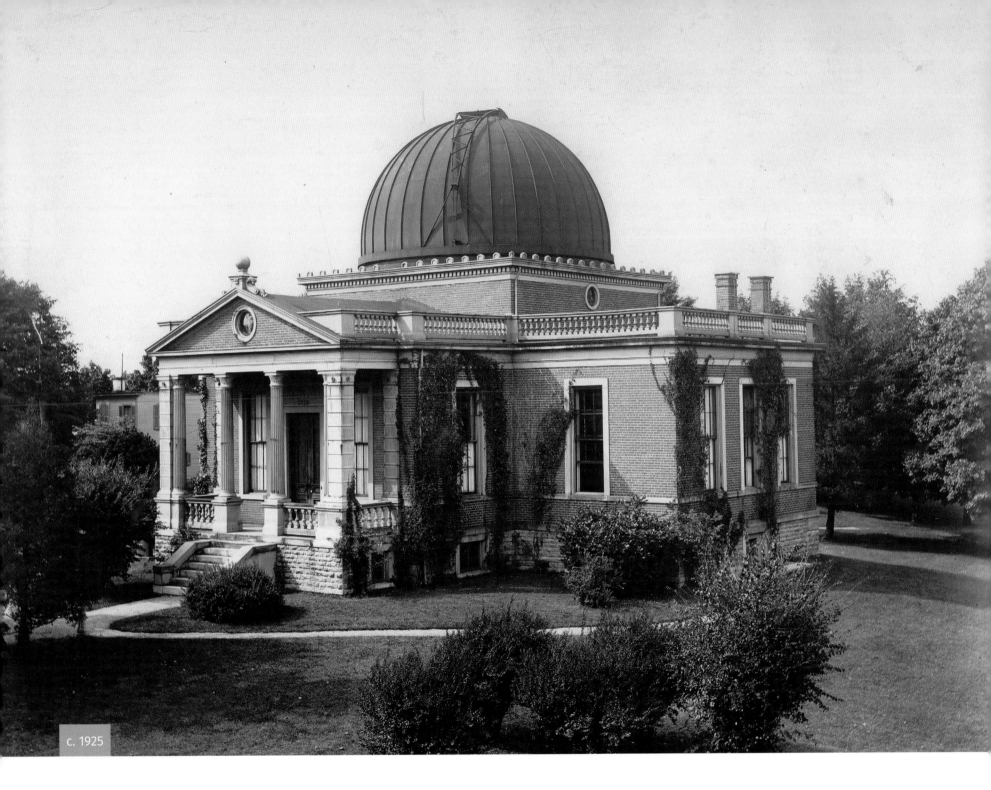

c. 1925

CINCINNATI OBSERVATORY

The oldest working telescope dates to the first observatory in 1843

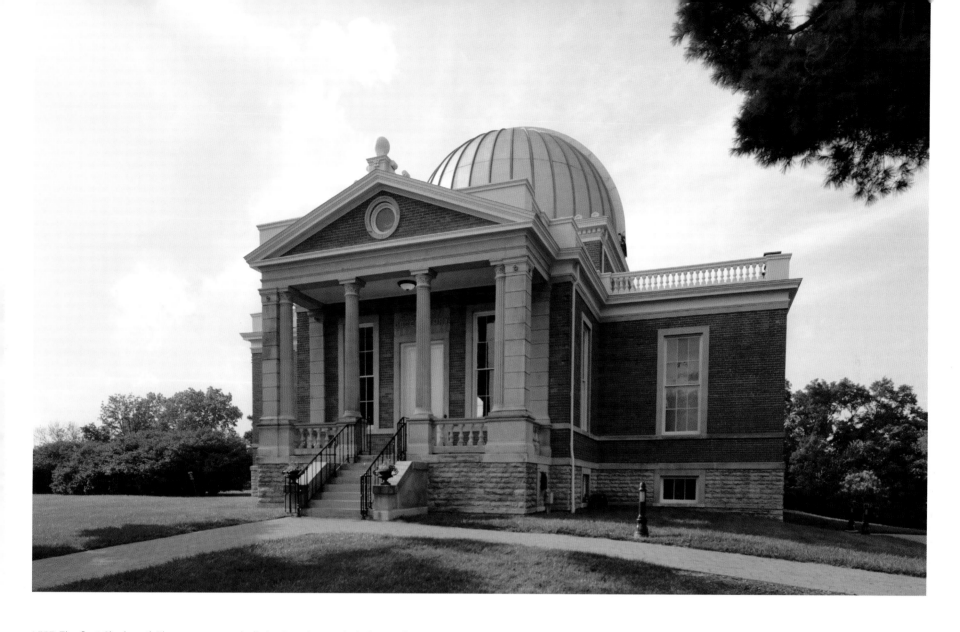

LEFT: The first Cincinnati Observatory was built by Ormsby M. Mitchel, a professor at Cincinnati College. His astronomy lectures did much to cultivate interest in the subject. Mitchel went door-to-door raising $25 apiece from supporters, totaling $7,500, to build an observatory on land donated by Nicholas Longworth. Former president John Quincy Adams presided over laying the cornerstone in 1843 on the crest of Mount Ida overlooking the city. Mount Ida was renamed Mount Adams in his honor. The telescope, an 11-inch Merz and Mahler refractor, was the largest in the Western Hemisphere in 1845 and is still in use today. The sooty, polluted air belched out from the city below made it difficult to see the sky, so in 1873, the Observatory moved to land near Hyde Park donated by John Kilgour. The area was renamed Mount Lookout. The new Observatory, seen in this photo circa 1925, was a Greek Revival design by Samuel Hannaford likened to a jewel box. The cornerstone laid by President Adams from the original building is visible in the back corner.

ABOVE: In 1904, the Observatory purchased a larger 16-inch Alvan Clark and Sons refractor that is now in the main building, known as the Herget Building. A second structure, the Mitchel Building, was added to hold the original 1843 telescope. It is the world's oldest working telescope. While he was director of the Cincinnati Observatory, Cleveland Abbe developed one of the earliest systems of weather forecasting in 1869, and was appointed the first chief meteorologist of the U.S. Weather Bureau. The Observatory is designated as a National Historic Landmark. The building and grounds are picturesque and nestled in a Victorian neighborhood, making the Observatory seem timeless. The University of Cincinnati has owned the Observatory since 1871. When there were some rumblings of UC selling off the land in the 1990s, the Cincinnati Observatory Center shifted its focus. Rather than a research observatory, it functions as a center for astronomy education.

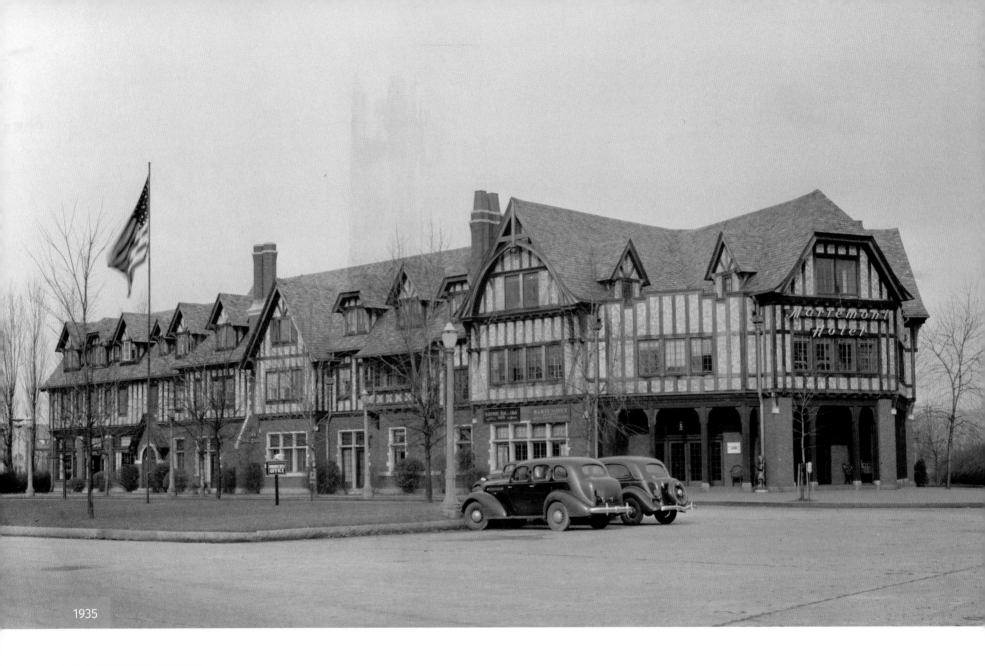

1935

MARIEMONT

Mary Emery's planned town was based on the English garden city movement

ABOVE: The village of Mariemont was the vision of philanthropist Mary Emery, who wished to create a planned town that also filled the social need for affordable and better housing. She enlisted preeminent town planner John Nolen, who in 1921 drew up a town plan inspired by English garden cities. He called it "a national exemplar," a prototype for others. They purchased 253 acres of farmland in Columbia Township, ten miles east of Cincinnati. The plan was a bit too ambitious to be realized. Streets radiated from a town square to clusters of low-cost apartments and open land for

building houses. The town square was intended to be a hub of activity with shops, a theater, and an inn, all in matching gingerbread Tudor Revival style. Only the Mariemont Inn, which opened in 1929, was completed in the first wave. Designed by the Cincinnati firm Zettel and Rapp, the V-shaped inn was supposed to stretch a block along both Wooster Pike and Madisonville Road. As pictured in 1935, it was completed only half that size.

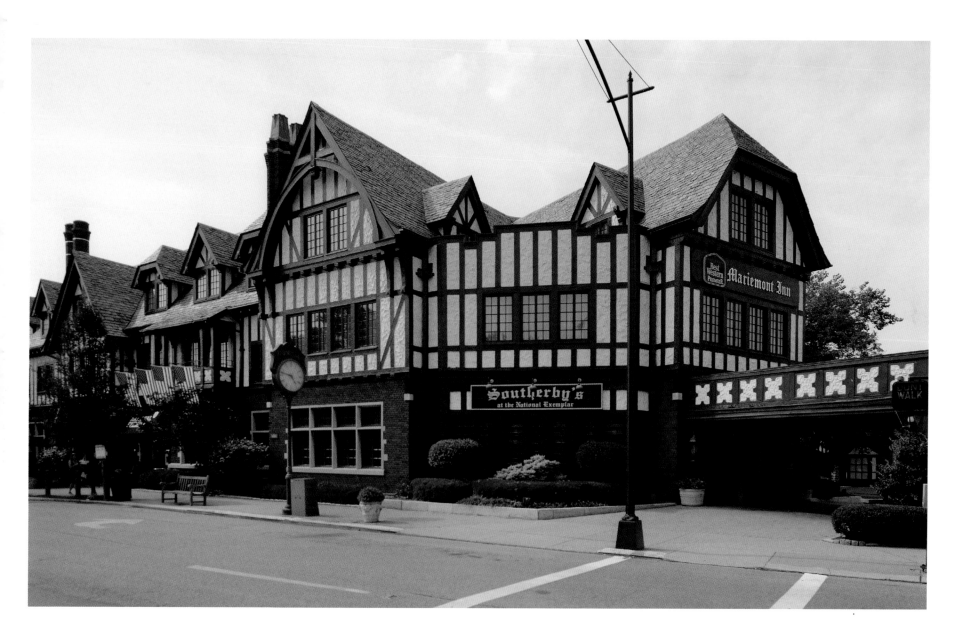

ABOVE: Mary Emery passed away in 1927, and the Mariemont Company was run by the Thomas J. Emery Memorial foundation until 1941, when the village was incorporated according to Ohio law. Further development filled out the village, and the town square finally got the Mariemont Theatre in 1938. Even newer builds, like Mariemont Strand completed in 1992, carry on the Tudor style, preserving the Old World charm of the town square. Mariemont is one of the few villages in the United States that has a town crier. The plan to provide affordable housing fizzled, though. The charming, picturesque community attracted wealthier residents instead. While the streets and homes are as lovely as ever and lush with green space, many of the residences are priced out of range for most people. The Mariemont Inn was sold in 1945, and then acquired in 1962 by the present owners, Spinnenweber Builders, Inc. Today, the cozy inn is under the Best Western banner. The village of Mariemont is recognized as a National Historic Landmark.

INDEX